CREATING
COMICS
from **start** to **finish**

Top Pros Reveal the Complete Creative Process

Buddy Scalera

IMPACT
CINCINNATI, OHIO
www.impact-books.com

DEDICATIONS

To Janet
Without you, none of this stuff matters.

To Danielle and Nicole
You are Daddy's dreams come true. Daddy and Mommy love you unconditionally, and we want you to explore your own dreams. Be yourself; we will love you no matter who you become.

To Dad and Mom
Thank you for pushing me to try harder and making me read something other than comic books.

Other fine IMPACT Books are available from your local bookstore, art supply store or online supplier, or visit our website at www.fwmedia.com.

15 14 13 12 11 5 4 3 2 1

DISTRIBUTED IN CANADA BY FRASER DIRECT
100 Armstrong Avenue
Georgetown, Ontario, Canada L7G 5S4
Tel: (905) 877-4411

DISTRIBUTED IN THE U.K. AND EUROPE BY F+W
MEDIA INTERNATIONAL
Brunel House, Newton Abbot, Devon, TQ12 4PU, England
Tel: (+44) 1626 323200, Fax: (+44) 1626 323319
Email: postmaster@davidandcharles.co.uk

DISTRIBUTED IN AUSTRALIA BY CAPRICORN LINK
P.O. Box 704, S. Windsor NSW, 2756 Australia
Tel: (02) 4577-3555

Library of Congress Cataloging in Publication Data
Scalera, Buddy
 Creating comics from start to finish / Buddy Scalera. -- 1st ed.
 p. cm.
 Includes index.
 ISBN 978-1-60061-767-6 (pbk. : alk. paper)
 1. Comic books, strips, etc.--Technique. I. Title.
 NC1764.S33 2011
 741.5'1--dc22 2010039542

Edited by Kelly Messerly and Stefanie Laufersweiler
Production edited by Sarah Laichas
Designed by Wendy Dunning
Cover art by Alan Evans
Production coordinated by Mark Griffin

ABOUT THE COVER ARTIST

In the mid 1960s, Los Angeles coughed up Alan Evans, a kid who freaked his parents out by drawing people starting with their fingers. Then came mazes on graph paper, imaginary maps, ads for the phone book, medical illustrations, car brochures, beverage packaging, digital photography, a break for lunch, *X-Men* for Marvel, animation, video compositing, film effects, and now design for virtual worlds and that cool trick where you trace around your hand to make a turkey for Thanksgiving. Alan now lives in the Pacific Northwest and wonders when it's gonna stop raining. Alan's artwork opens many of the chapters of the book and appears on the cover. See more of his amazing art at www.alanevans.biz.

ABOUT THE AUTHOR

Buddy Scalera is a writer, editor and photographer. He is the author of the popular *Comic Artist's Photo Reference* book and CD-ROM series for IMPACT Books, and he is also known for his best-selling series of photography CD-ROMs, *Visual Reference for Comic Artists*. He has written for many mainstream comics, including Marvel Comics' *Deadpool*, *Agent X* and *X-Men Unlimited*, and he also contributed to Marvel's all-ages series *Lockjaw and the Pet Avengers*. On the indie side, he has written and self-published several comic books through After Hours Press (www.ahpcomics.com) with business partner Darren Sanchez, including *Necrotic: Dead Flesh on a Living Body*, *7 Days to Fame*, *Bonita & Clyde* and *Parts: The SitComic*. Buddy's written over one hundred articles on comics for *Wizard*, *Comics Buyer's Guide* and *SPIN* magazine online, among others, and he was the creator and editor of Wizard Entertainment's Wizard World and Wizard School websites. Buddy has hosted and organized workshops and panels at major conventions in New York, Chicago and Philadelphia, and he served as programming manager for the 2009 Long Beach Comic Con in California. Visit his website at www.buddyscalera.com (email at buddy@buddyscalera.com).

AND THANK YOU TO…

- Mike Marts, Mark Waid, Chris Eliopoulos, Brian Haberlin, Rodney Ramos, Darick Robertson, John Cerilli and, of course, Joe Quesada and Stan Lee—all for making the time for interviews and for sharing so much of yourselves for this book.
- Jim McLauchlin of The Hero Initiative and Mike Kelly of POW! Entertainment for connecting me with Stan Lee.
- George Beliard of Marvel Comics for helping me connect with Joe Quesada.
- Dan Reilly for key reference materials.
- Fred Pierce for allowing us to use Valiant images.
- Stefanie Laufersweiler and Kelly Messerly for the top-notch editing on this project. You guys made every page and every chapter better than I could have done alone.
- Pam Wissman for opening the doors and welcoming me into IMPACT. You made all of this possible.
- Alan Evans for (yet another) great cover. It's good to be a team again.
- Designer Wendy Dunning, production editor Sarah Laichas, copyeditor Jeff Suess, proofreader John Kuehn, indexer Kathleen Rocheleau and production coordinator Mark Griffin.
- Special thanks to my transcribers Misha Stewart and Amy Jeynes.

ANOTHER **PRODUCTION**

CONTENTS

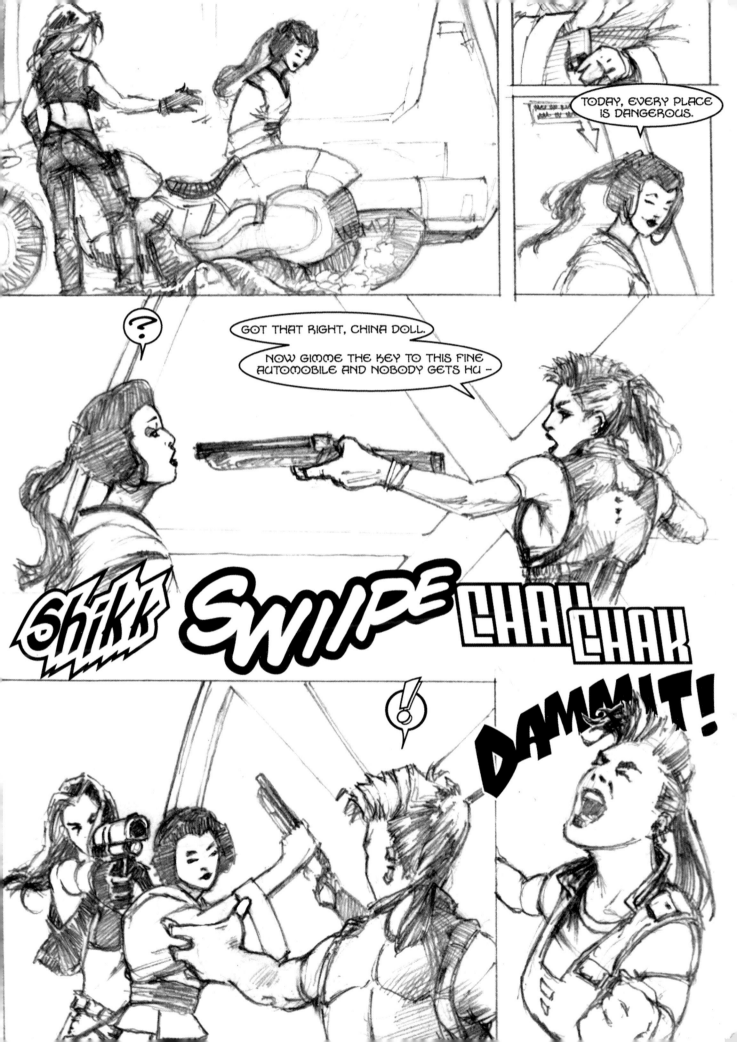

INTRODUCTION

"THIS IS YOUR LAST CHANCE. After this, there is no turning back. You take the blue pill—the story ends, you wake up in your bed and believe whatever you want to believe. You take the red pill—you **STAY IN WONDERLAND**, and I show you how deep the rabbit hole goes."

—Morpheus to Neo in The Matri*

You may not want to read this book. There's stuff in here that will change the way you read comics. I'm not kidding. Let me tell you a quick story, just to prove my point.

Back when I was starting college I became interested in film studies. This was way back before comics had gained the level of mainstream respect that they enjoy today, so if you wanted to learn about visual storytelling, film was the way to go. Like comics, you could tell stories and communicate with words and pictures, so film was an irresistible magnet for comic geeks like me.

In a lot of ways, film studies are a great way for comic book fans to analyze and understand the nature of visual storytelling. The two mediums—film and comics—have much in common. Of course, these days, many educational institutions teach comic book curriculum, so your learning options are much broader and more relevant.

Still, you may not want to read this book. It's going to do for you what film school did for me. It's going to ruin the mystique.

They warned us on the first day of class that the critical analysis of film will reveal the language of the medium. It will uncover the techniques, the business and the tricks of the art form. That kind of understanding and enlightenment strips away the magic to reveal how the trick works.

If you want your comics to remain magical, you should put down this book now. Go back to your X-Men comics and forget what you've read already. Go on with life. Do not go down the rabbit hole.

IF YOU'RE STILL HERE

If you're still here, congratulations. It's nice to have someone like you around. If you appreciate the overall analogy, you're about to become the magician's apprentice.

I'm not the magician, nor am I the apprentice. I'm just the guy who peeked behind the curtain, jotted down some notes and figured out how it all worked. The actual magicians are the people featured in the upcoming chapters.

I am, by training, a journalist. If you must know, I have a degree in journalism. I spent a few years writing for newspapers, a bunch writing for magazines, a handful writing political literature and speeches, and whatever else would give me a byline or a few bucks for a few words. It was all very interesting, but what I earned I squandered primarily on comics. In fact, one of my motivations for breaking into comics was to get free comic books. (It worked.)

So, since this will become relevant later, I broke into comics as a journalist. I wrote for different magazines, cutting my teeth on short news stories, moving up to features and eventually freelancing for most of the comic industry publications. I wrote for magazines like *Combo, Comics Buyer's Guide, Comics Values Monthly, Scarlet Street, Collector's Advantage* and other magazines that fellow comic fans enjoyed. All along, I was building my ongoing knowledge base of how the industry functioned (and, in many cases, malfunctioned). And getting free comics.

Like you, I was a fan, but somehow I managed to step over the velvet rope and sneak backstage. Much of what I wrote was from that giddy, fan-got-lucky perspective. Because, quite frankly, that's what I was.

At some point, I landed some freelance work at *Entertainment Retailing*, a magazine produced for comic book store retailers. It was published by Wizard Entertainment, which published *Wizard* magazine. I'd hoped for a way to break into *Wizard*, and this was it.

In 1995, after some time writing for various publications, I landed a staff job at Wizard. They hired me as their online editor, even though this whole Internet thing hadn't really taken hold. The Net was a very different place, and they brought me on staff specifically to launch a small site for the magazine on then-fledgling America Online. (Yeah, I was partially responsible for all of those disks that came polybagged in *Wizard* each month.)

Nobody anticipated the growth of the Internet, including us at Wizard. In fact, one of my bosses at the time assured me that they would still keep me on staff when this Internet thing went away. The exact quote was, "This Internet thing is just a passing fad, like pet rocks and hula hoops."

So I basically rode the wave, running this fad called Wizard World Online, until I could get my opportunity to break into the print magazine division as an editor. I waited and waited. And waited.

The Internet turned out not to be a fad, but rather a new paradigm on how we communicate. It became the center of life for many people, including many comic book fans. Wizard World Online continued to grow, evolving from America Online to the Web. For several years, I hung in there, interacting with comic pros. I'd talk with them about comic book storylines, upcoming events and business. Lots of business.

As a side project, Wizard World Online designer Rus Wooton and I created something called "Wizard School." It was a cool little site that allowed aspiring pros to get direct feedback and suggestions from working comic book pros. People like Mark Waid would review your complete manuscript and give you detailed feedback.

That's like getting dribbling lessons from Michael Jordan.

The reality was that I—like you—wanted to know more about the process of creating comics. It was a deeply fascinating world that was covered with a protective veil. I wanted to see what was underneath that veil, and Wizard School gave me that access. The more I learned, the more I discovered about the process and the people behind the pages.

Ongoing and persistent study of the comics industry was like attending film classes: The more I learned, the less magical it was. I began to understand and mentally map the creative process. It was no longer dreams and fantasies that magically adhered to the page; it became clear that it was men and women who worked long, lonely hours trying to create something exciting and engaging.

While at Wizard, the company launched an in-house independent comics line. Black Bull Entertainment was Wizard's foray into publishing ongoing monthly comics. They hired editor Glenn Herdling, who had several years of experience as an editor at Marvel Comics. Glenn literally taught most of Wizard about how comic books were created, trafficked and published. He taught many of us the basic tenets of storytelling, page design and even creative workflow.

Since the comics were written and drawn by mainstream comic book creators, it was like Wizard had imported an entire editorial office from Marvel and simply plunked them down in our office in Congers, New York. It was the first time that many of us had seen actual comics produced from the initial idea all the way to the page. The publishing of Black Bull did not last long. Despite the efforts of some talented creators (including Chris Eliopoulos and Mark Waid), it failed to gain enough traction in the direct market to take off independently of Wizard. But, it did give many of us a different perspective on how comics are made.

Over time, I wanted to touch the page myself. I wanted to understand what it was like to tell stories in this medium. Since I'd already been working in the industry, it was relatively easy to leverage my personal and professional connections to gain

experience. Once you're on the inside of any business, it's easier to move around and expand your experiences.

Since I was already a writer, it was easiest for me to break in and write some comic book stories. My first published work was independent and then self-published. Later, I broke into Marvel Comics writing small backups and inventory stories, and then eventually complete issues. And for one shining moment, I was on a monthly comic series for Marvel, co-writing *Deadpool* with my friend Jimmy Palmiotti.

My mainstream comic-book writing career didn't go very far, but I learned techniques and process from some of the best creators in the business. I literally learned how to write comics by doing it. Nothing quite compares to the experience of actually writing a script, having it edited and drawn, and then seeing the published result.

Glenn Herdling, Jimmy Palmiotti, Mike Marts and Chris Eliopoulos all took strong personal interest in tutoring me, which is why they are all referenced frequently in this book.

Later, I would learn more about print production, digital workflow and even lettering. Self-publishing comic books and CD-ROMs through After Hours Press gave me unique and lasting experience with production, publishing and the business itself. It's an eye-opening experience to study a profit and loss report (especially when almost all of it is loss).

Recently, I worked for a few years in Chris Eliopoulos' Virtual Calligraphy, which is a lettering and production studio with long-standing contracts with Marvel Comics. That gave me deep exposure into how Marvel's publishing evolved from traditional print publishing into a streamlined digital workflow.

WHAT THIS BOOK'S ALL ABOUT

So now we're here. It was important for me to share that experience with you for several reasons.

First, and most important, you need to understand that there are a lot of different career paths in comics. It doesn't really matter how you break in, the important thing is to break in. Understanding the complete continuum of the comic book workflow will enable you to identify the breaking-in point that works for you.

Many pages in each chapter of this book are dedicated to explaining how people broke into the comics industry. It's useful information that shows the broad range of shared and unique experiences. If you're a student of the profession, you should understand how the professionals got to become pros. See if you can imagine yourself taking that path, and it may be the first step in the right direction.

Second, and maybe less important, I wanted you to understand that the people in this book are not using it as a stepping-stone to propel their personal careers. In fact, it was probably costing them time and money to stop working long enough to be interviewed.

All the people in these pages are pros. They've already broken in. Look at the names, do a Google or Wikipedia search and look them up. These guys (and they all happen to be men) are at the top of their game. The information they provide isn't merely wishful thinking; it's real, actionable info that can help you launch or even accelerate your comics career.

Third, and probably least important, I wanted you to know who I am. It's a bit of ego, but it's also directly relevant to this book. There are times in these interviews where I will literally reference a personal experience with one of these creators. I will talk directly to you. Sometimes they call this "breaking the fourth wall," only I'm not using it as some sort of clever writing technique.

My writing style probably breaks ten different writing rules, but this book is written for *you*. I care more about sharing information, insight and motivation than I do about some stodgy writing rule. In this book, it's all about you.

Except for one of them, I have pretty much worked with each of these comic professionals on some level. It may have been on a printed comic or simply at a comic convention panel, but I have a relationship with everyone in these pages. I tried very hard to combine the basic interview quotes with existing knowledge about these creators to deliver something that's not just the usual rehash.

WHY YOU SHOULD READ ON

At the start of this introduction, I alluded to the fact that this book will ruin comics for you. That's still somewhat true.

But what you learn here will give you the kind of insight that helps you move from being a fan standing in line to get an autograph, to being the fan-favorite creator sitting behind a table signing that autograph.

Story—and the people who work together to make that story—can change worlds. It changes both the way people think, and the lens through which they see their world. Ideas, including *your* ideas, are important. They hold meaning and significance. If you've chosen comic books as a channel to express your ideas, then this is a great place to start.

Over the years, I've learned it takes a lot of people working together to get a great story to the page. Lots of coordination, planning and passion go into developing and publishing a great comic book story. Some stories take weeks, months or even years to nurture and coax to completion. Publishing comics isn't a sprint—it's a marathon relay race, so you have to pace yourself properly to pass the baton and win.

Above all, it requires passion. If you're not passionate about telling stories on the comic book page, this is your final chance to close the book. Because the stories that I tell you in these pages will quite possibly ruin the magic for you. When you read about how people break into the business, how hard they have to work to stay active, and the techniques they use to create stories...it will invariably change the way you look at the page. Once you see the magician practice his act, the stage show loses the element of surprise and wonder.

There is a price to pay for eating fruit from the Tree of Knowledge.

But once you have that knowledge, you will be better prepared for a career in comic book creating. Once you understand the complete continuum of work, only then will you fully appreciate what all of the artists bring to the creative process. It's not enough to merely know your specific task; it's important to understand how all of the interlinked gears turn to power the engine.

Read the stories in this book so that you can have a better understanding of what kind of personality is successful at creating comics. You'll notice a lot of similarities among the people I interview. They are all passionate about their craft, pushing themselves to explore new techniques that speed and improve the process and the product. They all respect their position in the process and the roles of others in that same workflow. They know the history and future of the industry, since they are all lifelong learners and students of the medium.

This book was not written to load you with technique-driven tips on inking or coloring or even writing (though you'll undoubtedly pick up some general gems of advice along the way). There are other books that focus on the intricacies of those specific jobs that will help you improve your skills.

No, this book was written to give you a better understanding of the people behind the brushes and word processors, telling you their stories so that you can begin to find inspiration and motivation when you're almost ready to quit. Don't quit. Nobody in this book quit, nor should you.

This book contains stories about people who tell stories. People who invent, manipulate and change worlds. Real and imagined.

It takes a rare combination of skill and talent to tell a good story. Talent for the ideas and raw ability; skill for knowing how to control the medium (in this case, the comic book page) and deliver it with true intended impact.

So, that's it. If you want to change the world, keep reading. There's stuff you need to know about how stories make it from concept to completion.

Take the red pill and step down the rabbit hole. I have a few interesting stories to tell you about the people who make comic books.

Buddy

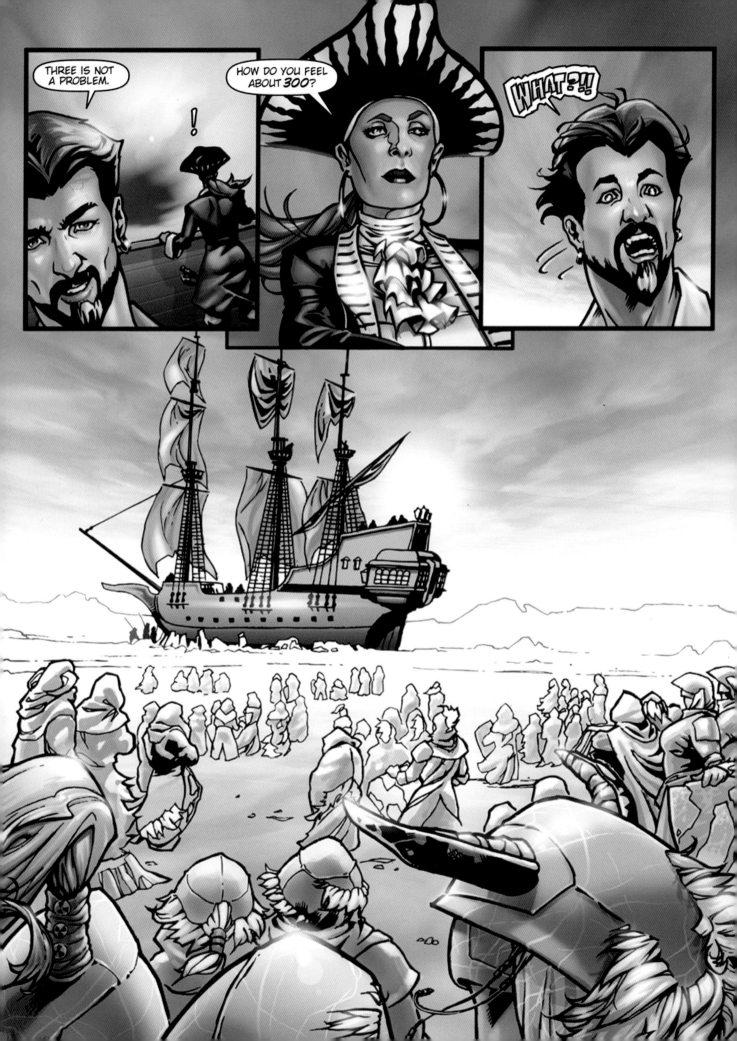

EDITING: The Eye of the Storm

Within the credits of a comic book are the names of at least a half dozen people, all of whom play a role in the creation of modern mainstream comics. You already know there's a writer and an artist. But that artist may only render pencils on the page, which means an inker steps in to add the kind of visual line weight generally needed for printed artwork. On this assembly line, there's also the colorist, who brings light, texture, depth and tone to black-and-white pages. And let's not forget the letterer, who is like the "writer's inker," bringing readable letterforms onto the page so that it complements—rather than conflicts with—the artwork.

In the middle of all of these creative professionals, there is usually one person who helps pull all of this together. Someone who can manage the diverse personalities, styles and needs of the creative staff. And despite the power wielded, this person is generally not the one who gets the praise or attention from the fan community. But when things go wrong, this person certainly gets the blame.

If you hadn't guessed already, it's the Editor. That's right, Editor with a capital E. The editor manages the creative workflow and all the pieces of what is typically an assembly-line system to create a publishable comic book. Editors are also usually responsible for the overall tone, consistency and content of the final product.

Editors—in virtually every publication type—wield immense power and responsibility. (Yes, I said "power and responsibility," and no, it couldn't be avoided.) Not only are they responsible for the creative wrangling of the comic book, they also must be masters of project management.

WORKFLOW OVERFLOWS

The editorial process is unique, personal and dynamic. Every editor and publisher has a system that works for them, usually based on years of trial and error. Just about everyone who's ever worked in creative services in publishing can tell you a story about a late night trying to get a book out in time. Those are the times when editors hunker down, get the work done and then try to figure out a better publishing process.

What works for a company like DC Comics may not work for, say, Image Comics. In DC's case, they have a fairly experienced in-house staff with many years of editorial and production continuity among them. They can look back on decades of print publishing experiences and recall what worked and what failed. Just about the entire staff works on location, under one roof, in New York City. (Nice offices, I might add.)

On the other hand, Image Comics—not a "new" company by any means—has a decentralized corporate structure. Not everyone is in the same building. Heck, they're not even in the same state. Plus many of their titles are created and edited by self-motivated teams that may or may not be getting paid a traditional salary or page rate. The actual central office—creatively named "Image Central"—has a relatively small in-house staff to traffic, edit and business manage their flow of titles.

Compare those with Dark Horse Comics, which has a small editorial staff that manages a fairly large portfolio of titles. Since many of those titles are licensed comics—including *Star Wars*, *Conan*, *Buffy*, *Aliens* and more—Dark Horse must consider the process of working with outside companies. Any production schedule must include time for licensors (the people who own and/or manage those cool movie-related properties) to review the comics in different stages.

So, even though editors often have similar job descriptions, the work environment dictates how they complete their job. Since this is a relatively small industry, editors sometimes jump from one publishing company to another. They cross-pollinate the talent, the work process and even the culture as they move about. The workflow illustration on the next page provides a very broad view of how many of these editorial processes work.

Now, wasn't that exactly how you pictured it in your mind? Well, maybe not, but that's how some comic books are made. It sounds like a lot of detail, and it is. But to experienced editors, it's all part of a giant, ongoing cycle. And what you see on the next page is the cycle for just one title; most editors handle multiple titles and creators at once.

Editing can be a high-pressure job that can also be hard to survive. Longtime editors usually have a process and infrastructure that they trust to work. If one step in this process falls out of place, it can easily throw off the entire show. This theme will be repeated often in this book, so it's worth understanding, especially if you plan a career in this business.

EDITORS: WHAT DON'T THEY DO?

Imagine a wheel. If the publishing process is like a spinning wheel, then the editor is the center hub. Of course, the spokes are the individual creators radiating from the hub, who help put the rubber to the road. It is vitally important that the editor has strong spokes, so that the wheel turns properly and the comic gets published.

Generally, the story starts with the editor and the writer. They usually collaborate to discuss concepts and directions for the character and storyline. It is a process that can be very quick, or it can drag out for weeks or even months. A writer who has an ongoing relationship with an editor may be able to dash off a few lines of description to nail down the next few issues of an ongoing series. This kind of relationship is usually built over time, as an editor and writer come to trust each other's visions and working styles.

In most cases, however, a writer and an editor must collaborate and share ideas until a story takes shape and direction. Even then, there are usually back-and-forth discussions and negotiations, since many of the major comic companies have interconnected storylines and shared characters. Editors are often required to be guardians

HOW COMIC BOOKS ARE MADE

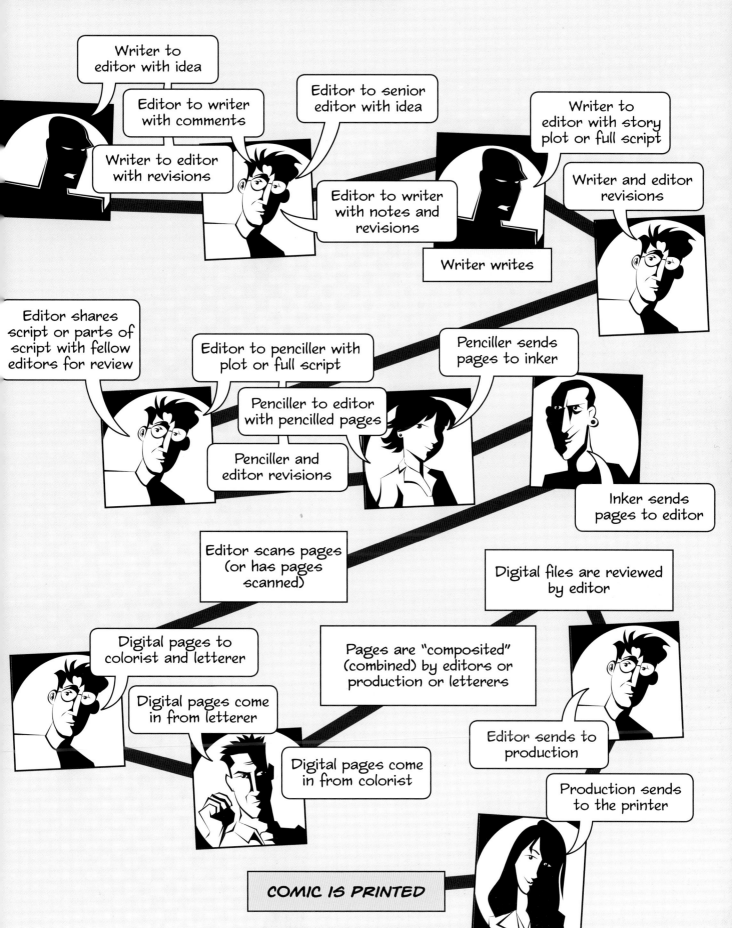

Generally, the **STORY STARTS WITH THE EDITOR AND THE WRITER.** They usually collaborate to discuss concepts and directions for the character and storyline. It is a process that can be **VERY QUICK,** or it can **DRAG OUT** for weeks or even months

of the story canon, so that characters and concepts are protected and nurtured. This means that great ideas are often shelved or modified to respect the storylines of other creative teams. So editors have to work closely with the writer, but also with the other editors on staff.

Comic book editors serve a variety of roles, depending on their position in the company. In most cases, editors work with the creative team to shape individual stories and story arcs. But even before that, the editor assembles the creative team that will eventually shape the individual stories and story arcs. But wait, even before that, the editor decides which proposals to read from individual creators, and who will eventually be assembled as the creative team that will someday shape individual stories and story arcs. (You follow all that?)

HOW IT'S ALL CONNECTED

Here's the thing about comic book editors: They work in an industry with slim profit margins and high expectations. They feel the business pressures of traditional publishing, but also the unique challenges of producing stories that feature serialized, licensed characters.

Consider these conceptual challenges. The editor of Spider-Man must have a strong understanding of the single, flowing storyline that has been produced nonstop since 1963. Not long ago, *The Amazing Spider-Man* #600 hit the stands and hinted at a future where another 600 issues could be possible. Those issues may not always be printed on paper, but there will need to be editors who have a keen understanding of the story arcs and major events in that ongoing serialized saga. In addition to the main title, *The Amazing Spider-Man*, the editor needs to understand what has happened and will happen

in spin-off titles, one-shots and crossovers that relate to Spider-Man and his supporting cast.

For example, if some major event occurred in, say, *The Spectacular Spider-Man* or *Web of Spider-Man*, the editor needs to know that so it doesn't contradict the storyline in an upcoming issue. And since most publishers utilize characters from other titles, cameo appearances must be consistent with how that character is traditionally portrayed. That means editors must also be familiar with other characters in their publishing universe if they want to play with other editors' characters. Similarly, the Spider-Man editors must work hard to ensure that Spidey and cast are portrayed accurately in other comic titles. They especially need to protect their core storyline, so that appearances in other books don't conflict with the developments in their own story.

But, like they say on TV infomercials, "But wait, there's more!" And there is. Editors also have to be mindful of how their characters are being used in other mediums, including film. Many mainstream consumers discover comic characters through the magic of movies. And while these celluloid superheroes tend to follow liberal "interpretations" of the characters, most comic book editors are keenly aware that what happens on the silver screen may eventually trickle back to the printed comic titles. For example, X-Men fans familiar with the bright, colorful costumes of their favorite mutants saw those accoutrements morph into black leather uniforms for the *X-Men* movies. They may not integrate movie concepts into the storylines of the comic book—but they might.

And thanks to animated TV shows, many superhero characters are seen by an even larger audience. Characters like Spider-Man are mass produced as action figures and merchandise. Most editors usually don't get involved with the

pajama and bedspread licensing of the characters they edit. But what they do in their comics may impact the company's ability to license out those characters. For example, if Marvel were to completely kill off a major character in the Spider-Man universe, it could affect the way licensors interpret the viability of putting that character on a lunch box or other kid-oriented object. That's a long way of saying that editors must also be mindful of the other ways that the publisher makes money with characters. A storyline that would blow away readers might also blow away a revenue stream that helps the publisher stay in business. Keeping the lights on is important since editing in the dark can be somewhat tricky.

THE BUSINESS OF ASSEMBLING CREATIVE TEAMS

We'll talk a lot more later in this chapter about the kinds of creative decisions made by editors. But let's pause for a moment to consider the myriad of administrative tasks that come with the territory. In later chapters, we'll explore the careers of other professionals in the publishing process. If those people are freelancers, it's usually part of the editor's responsibility to review their invoices and ensure those people get their contracted page rates. Although many editors in mainstream publishing companies have assistants, the editor is ultimately responsible for invoices and vouchers.

But before that happens, the editor usually works with creators to build a team that will collaborate on the comic. Because many popular professionals can increase sales numbers or simply create a better product, editors must often work hard to schedule projects. A highly desired pro who would be perfect for a specific project may not be available for months or more, so editors have to improvise and consider other talent.

In recent years, Marvel and DC have both created exclusive agreements with certain top creators. These arrangements help publishers and

GETTING PAID

If you're reading this book to step up from aspiring professional to working pro, then you are probably willing to work for cheap or even for free to prove yourself. Good for you. But you need to understand that this is an effective way to break into independent comics, not mainstream publishing. Indie publishers tend to work on relatively tight budgets, so they may offer a low (or zero) page rate, and maybe a percentage of profits. Or not.

Meanwhile, mainstream publishers like Marvel and DC usually pay professionals to produce pro-level work. Professional creators are compensated for their time, experience, talent, name recognition or whatever else. In most cases, there is an agreed-upon page rate. Depending on the contract, creators may also be working exclusively for a particular company. The deal may include a minimum number of projects per year or health benefits or something else entirely.

So what's the point of all this? For starters, if you are a new creator with few credits, you're probably not going to have much influence on your page rate. Marvel and DC will tell you the page rate. If you want to work for them, that's the rate. Later—if your career takes off and they can make money from your work—you may be able to negotiate better rates and terms. It's also important to understand that you can offer to work for free, but that's not really a big issue for Marvel and DC.

As a creator, focus your efforts on creating the best possible story. Learn about your industry, practice your craft and become a student of the medium. Make yourself valuable to a publisher by creating quality work that people want to buy. Publishers will be much more inclined to pay for your work because they know they can turn a profit from it.

Spotlight: Mike Marts

JOB: Editor

LOCATION: New York, New York

YEARS IN THE INDUSTRY: 16

HAS WORKED FOR: Marvel Comics, DC Comics, Valiant/Acclaim, Wizard Entertainment

CAREER HIGHLIGHTS:

- Has edited *Batman* and *X-Men*
- Current Batman group editor at DC Comics

ONLINE AT:

www.dccomics.com

http://twitter.com/mikemarts

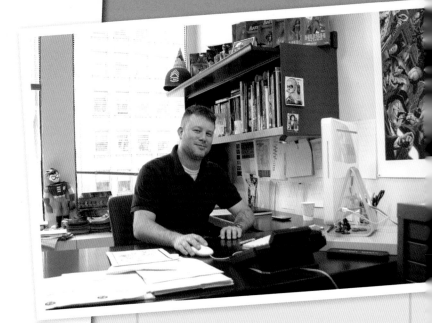

THE EDITOR'S OFFICE

Batman group editor Mike Marts at his workstation at the DC Comics headquarters in New York. Marts manages the Batman family of titles, which can be anywhere from ten to twelve monthly titles. Like many comics professionals, his office is lined with comic-related merchandise and has a Mac.

creators focus on the business of creating comics, which is the top-level idea. So that means, theoretically, creators don't have to spend as much time banging on doors to sell their talents. But it also helps the "distinguished competition" on both sides avoid losing a creator because he was offered a better page rate or a better project.

At Marvel and DC, there are talent coordinators (usually editors) who manage creative talent. They help busy editors view the landscape of available creators, including the ones with exclusive contracts. It's not uncommon for exciting projects to be shelved for months or years until a particular creative team is available. And it's also common to hear about creators who got their big break because the talent coordinators needed to fill a slot. Many times it is these editors/talent coordinators who review portfolios and read independently published comics with the hopes of discovering new creators.

In the early days, comic creators usually lived within driving distance of the Marvel and DC offices in New York. It wasn't unusual for top creators to complete their work and deliver it in person to the editor. But now artists are all freelancers working from their studio, or home office, so editors and talent coordinators rarely see the creative teams. And although a comic book convention is great for fans hunting down rare books and autographs, it is also the opportunity for creators to connect, network and drum up new freelance work. Many classic comic book titles and stories were launched as pitches at comic book conventions.

AN EDITOR IS BORN
(AFTER A LONG, HARD LABOR)

Like other highly successful people in the business, DC Comics editor Mike Marts always had a clear idea of the fact that he wanted to build a long career in comics. "I was always into comic books since an early age … not only the stories,

but also the business of comics and how they were made," says Marts. "And I was always aware of who the artists and writers were and who was working on what title, and who's good and who wasn't."

For over fifteen years, Marts has been at the creative epicenter of some of the comic industry's biggest published titles. And, like many other top industry editors, he broke into comics as an intern. But before that, he had started taking college classes in English and journalism, which helped him understand the basics—and the advanced nuances—of storytelling. His concentration in school had pointed him in the direction of writing, Marts says, "so I always kind of assumed that I would try to be a writer first and foremost in the comic book field."

While in college Marts worked at a local comic book store near his home in New Jersey, where he was surrounded by plenty of source material to draw from as he worked on his comic book writing. A Marvel reader since his youth, he stuck with the familiar and regularly sent writing submissions to Marvel. He'd receive rejection letters within a few weeks of submitting. "It was just a basic form letter … not really saying too much about why it didn't work or whatever," says Marts. "It was disappointing, but at least I knew that that entity out there was responding to me, and I knew that there was a chance. If they were responding to me, then there was a chance."

A few years into college, while working at the comics store, Marts became friends with inker Mark McKenna, who was working for Marvel and DC and told Marts about Marvel's internship program. "Suddenly I saw this as the way to get in," Marts says. The internship was a way to learn the system, make contacts and forge lifelong relationships. (We'll see again in other chapters the internship as a stepping-stone for people to break into the industry.)

"It was right around that time that I stopped thinking about breaking in as a writer," says Marts, "and I started to imagine the possibilities of what it meant to be a comics editor." In college he'd been learning plenty about media-related editing, but the mechanics he picked up would help him no matter what he was editing. "Newspaper and magazine editing aren't all that different from comic book editing," he says. "I kind of knew what I'd be getting into."

Most people can recall pivotal moments in their careers. Marts can remember the exact day he started his internship at Marvel: June 6, 1993. "It was a very important day to me," he explains. "It was the beginning of what really became the rest of my life. Professionally, careerwise, it lead me to meeting all the friends and family that I have now."

For Marts, his internship was the first big step in a long career. He went from the guy who worked summers in his local comic book shop to a fledgling comic book professional. "You have to understand that even though it is an unpaid internship, it's a highly coveted spot and it's extremely competitive to even get in there in the first place," explains Marts, who earned college credit for his work that summer. "There are so many people wanting to get into the comic industry that they will take any opportunity they can. An internship at one of the big companies is a big deal."

And then, when his internship was coming to a close, "I didn't want it to end," he says. "It was the party I wanted to keep going into the night."

Marts worked hard, networked and landed a second internship with Marvel. This visibility to Marvel's operations opened new doors and new connections. "It wasn't something that usually happens," says Marts, "but the editor that I was working for, Nel Yomtov, for whatever reason liked me, and he maybe saw something in me and he made it possible for me to do the second repeat internship."

Marts fully leveraged his two internships into a Marvel assistant editor job when he graduated. This was, he admits, hard work that required a lot of networking and planning. Later, he worked in the marketing department at Wizard Entertainment, which helped him build his network of professional associates, and then he took an editing job at Valiant/Acclaim.

Marts moved around the industry smoothly, always impressing people with his dedication, skills and talents. Eventually he returned to Marvel, editing second- and third-tier titles with promising creators. Over time, Marts impressed the leaders at Marvel and they rewarded him with better titles, which attracted bigger-name creators.

After about three years, Marts had climbed to the top of the editing ladder and was promoted to editing the X-Men franchise, one of the crown jewels at Marvel. He had edited X-titles over the years, including *Bishop*, *Gambit*, *Deadpool* and others, but in 2002 he took over the entire X-Universe. Later, he would move to DC Comics to take the reins of Bat-Universe.

WEARING MANY HATS

According to Marts, comic book editors also play many roles in the process of creating comics:

TALENT SCOUT

"One of the first hats you're wearing is the talent scout or the coach or manager—it's finding and assembling the talent. Finding out which is the best talent for each specific project and getting them together," says Marts. "Sometimes your first choice doesn't work out. Sometimes the first choice is too busy or isn't interested, so you've got to have a list of potential candidates who are going to work out."

STORYTELLER

"Once you have the team in place, then you wear the story hat. That's when you get the writer to come up with the best possible story," Marts says. "A lot of times with monthly comics, there's already a lot in place for the writer to build upon—whether it's past continuity or a specific

story event that they're taking place in—so you kind of throw the writers those essentials, those things that are already in place, and then give them an idea of where you want them to take a story. Maybe there's a specific end point that you want to get to. Maybe there is a specific character that you want to show up. With every story, there's different goals that you want to try to hit."

ART DIRECTOR

As an art director, Marts says, the editor is "managing the artists, making sure they're following the script well and drawing it correctly."

PROJECT MANAGER

And then the editor acts as a project manager. "There are the office workings, making sure that the script gets to the artist, the pages get to the letterer, and making sure legal sees this and that. And making sure the creators get paid," Marts says. "There's a bazillion different things that take place in the office that most people wouldn't ever think of … those teeny, tiny little steps that are important in the creation of the comic."

PROOFREADER

"Then you have the proofing hat that you have to put on," says Marts. "When the book gets towards the end of its cycle and it's getting ready to go to the printer, you've got to make sure the characters are all behaving how they would usually behave, make sure there are no curses in the script, make sure things are spelled correctly and read in a nice way, make sure the characters are all colored correctly and pages are colored consistently, make sure no balloons dropped out of the final proof—things like that."

PSYCHIATRIST

In addition to their official duties, editors are often a friend and psychiatrist to creators. Since so many artists work in their own studio—which may be just a room in their house—they sometimes find themselves insulated from the rest of the world. Yes, there's technology and the telephone, but many creators miss the camaraderie of normal professional interactions. At

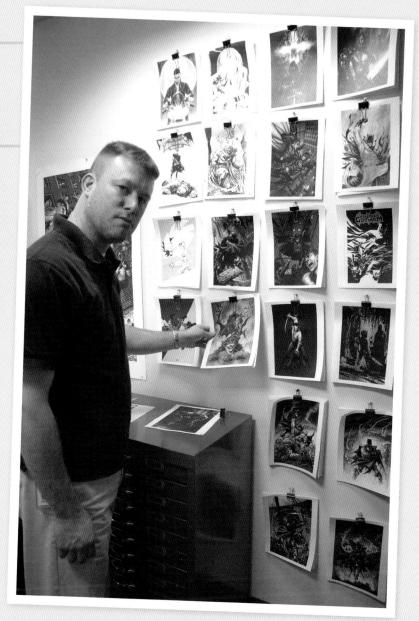

work, most people get the fulfillment of talking
shop or just swapping weekend stories. But for
work-at-home creators, there can be a feeling of
being disconnected from the world. Editors may
be the lifeline to these creators.

In other ways, editors sometimes have to
help "talk someone off the ledge." That is, if
a story isn't going well or the art isn't com-
ing together the right way, creators who are
passionate about their work can sometimes
get anxious, angry or frustrated. A good editor
can help diffuse and calm a creator who might
be ready to quit a project. It's not part of the
written job description, but ask any editor, and
they can tell you stories of how they've had
to talk someone off the proverbial ledge. (Just
ask my editor Kelly. She had to talk me off the
ledge as I was writing this chapter. Buy the
first round, and I'll tell you the whole sordid
story.)

CONTROLLING THE CHAOS

At the time of this interview, Marts was the
group editor of the Batman titles. This means
his team of editors put out approximately
sixteen issues per month, including *Batman*
and *Detective Comics*, which are two of the most
important comic titles in comic publishing his-
tory. His team is directly responsible for all of the
Bat characters, spin-offs and relevant crossover
events. It is a responsibility that Marts takes
quite seriously.

As proof, Marts showcases the editorial proj-
ects thumbtacked to his wall. Displayed are the
dozen or so comic book projects in production,
including the covers and interior pages. It's a
neat, logical workflow that hints at the myriad of
creative activity going on inside the office. Comic
book editors live in a constant state of controlled
chaos that can produce great work on time or
collapse in blown deadlines. If one spoke in the
publishing wheel doesn't function properly (i.e.,

is late), the whole process gets wobbly and can
cause the wheel to go careening off the road. If
the vision in your head is that of crashing and
burning, you're starting to get the idea. Editorial
work can sometimes feel like a slow-motion
car crash.

Many editors build processes to manage these
complex workflows. While most editors build
their own processes, the intern program at the
major publishers means that many editors learn
the system from the editors before them. "The
system is something that evolves over time. I
might introduce new things to my system every
once in a while. Some things work, some things
don't," says Marts. He is always looking for better,
quicker ways to work. "Sometimes a new editor
will say 'Well, how about this?' And if it's some-

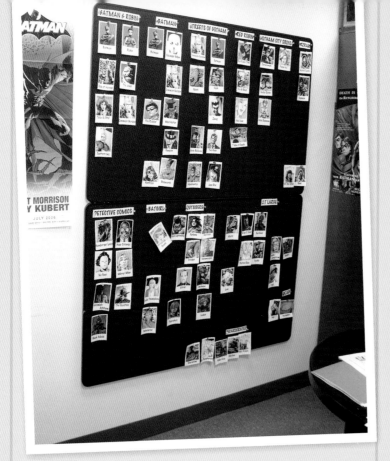

KEEPING IT ALL STRAIGHT

On another wall, Marts maintains a visual guide to the Batman universe, which has literally hundreds of characters. In the summer of 2010, when this photo was taken, Marts was managing multiple heroes and villains with top creators like Grant Morrison and Tony Daniels.

thing I haven't thought of, and their idea works for our system, I'll introduce that into the process," he says. "It's not something that comes just from me. I've learned little things from bosses I've had in the past."

MESSAGES, MEETINGS AND MADNESS

Since editors tend to be busy people, it is often difficult for them to keep up with all of the demands. Freelancers often complain that they cannot get in touch with an editor, even if they are working with them on a project. Marts is a rare exception. As an editor, he tries to get back to everyone who emails or calls him. As daunting as it sounds, he even tries to clear his inbox every day, if possible. "I think some of that comes from being a freelancer for a short period of my life. Freelancers know what it's like to wait on a phone call, and know that there is a human

presence out there who cares for you and will get back to you," he explains. A lot of times when I am getting back to the person, the answer is 'no,' which is OK. I'd rather have someone be a little disappointed and hear 'no' than to never hear back. Everyone should know where they stand; everyone deserves a response. That's part of my system."

It is a system that works. Marts is consistently a favorite editor among comic book professionals. Top creators often mention his consistency and professionalism as one of the reasons they choose to work with Marts.

When asked, Marts can quickly outline the daily routine of being an editor. For starters, there's email. Lots and lots of email. So every morning, Marts works his way through his inbox to solve the myriad problems and questions that popped up overnight. And, yes, questions pop up overnight, since so many full-time comic book creators keep vampire-like hours.

In the morning, Marts and his team of assistant and associate editors also take to the phones. "There will be phone calls, depending on what the emails were and what the problems are. If it's with a writer to work out a situation, or an artist who needs to correct something on a page, sometimes you're talking a guy off a ledge, or that kind of thing," Marts says. "There's a million different problems that can happen—some can be solved by a quick email and others require phone calls—so you do some phone calls."

Like other publishing jobs, comic book deadlines are driven by the calendar. "Depending on what day of the week it is, I'll have different meetings," says Marts. "Monday mornings I have a group editors' meeting with my boss. Tuesday morning I like to meet with my Batman group and go over everything there. Wednesday afternoon, I've got a scheduling meeting on all my books. Wednesday late afternoon, we have a meeting with the president and publisher. And then there's always a bunch of unannounced, unscheduled ones that just kind of creep up and come about."

Seeing multiple comic book issues through different stages of production requires that

*Editors must balance their current needs with their future needs. The creator they reject today may be the **HOT TALENT** they want to work with next year. So often "no" is the answer for today—**NOT NECESSARILY FOREVER.***

Marts be ready for anything, all the time. "Then there's all the things that come up just with the individual issues that you're working on … The days kind of change from one to the next but the steps are always there," he says. "The proofing of a book, or reading a new script that comes in, doing corrections on a script, making sure the issue's getting read by all the appropriate people."

Friday afternoons, he says, are always the craziest time. "Friday is essentially our deadline to get books off to the printer, so it's always that mad rush to make sure that the book in question is all done and correct and ready to go out to the printer," says Marts. "And of course it's always down to the last minute, but that's part of the fun."

SAYING "NO"

Editors are often gatekeepers who are tasked with selecting new talent and identifying new projects. The power to say "yes" to a creator or new idea is what puts comics on the stands. Saying "yes" to new projects is fun, since delivering good news is always more pleasant than delivering bad news.

As the point person for freelance artists and writers, the editor must also be prepared to deliver both good and bad news. And no matter who you are, it is always challenging to deliver a rejection. Editors must balance their current needs with their future needs. The creator they reject today may be the hot talent they want to work with next year. So, often "no" is the answer for today—not necessarily forever.

Marts admits that in the beginning, delivering rejection was difficult. "I don't like to give false hope. It's disappointing giving someone bad news, but giving someone false hope, kind of twisting things a little, you can potentially do more harm in the long run, either to the person you're talking to, yourself or to the relationship with that person," he says. Saying "no" has gotten easier with time, though: "You usually try to make it not just a simple 'no,' but a 'no' with something else. It's a 'No, sorry, we don't have any work right now, but I liked your work, and check back with me in two months.' Or, it's a 'No, I don't have any work, and I think you have to work on A, B and C before I can give you some work.' It's an attempt to add something constructive to a 'no.'"

For freelancers, the rejection from an editor after they've invested time and energy in their pitch can be devastating. Some people take it very hard and very personally, but a good editor can sometimes use it to inspire the creator to try harder and resubmit with a new portfolio or idea. Many seasoned comic creators point to this rejection or feedback process as essential to their professional development.

So Marts, like other top editors, has become skilled at offering constructive criticism. It's the kind of input that helps the next generation of creators hone their skills, build their portfolios and develop as the next generation of creative architects. The "no" that many young, aspiring creators hear is not unique or unusual; all pros know that rejection is part of life as a freelancer. In fact, many freelancers would rather just get the rejection so that they can move on and apply their full attention to the next project.

So, while "no" is difficult to hear, it's an answer we all hear. And that answer is better than none at all.

IT COMES DOWN TO STORY

There are a hundred small and large decisions that an editor makes every day.

Actual grammar and punctuation are important, but "that's probably about five percent of my

job," says Marts. "It's an important part of the job, but a very small part of the editor's job."

One of the biggest parts of the job, Marts says, is story. "These are comics which have been going on for years, decades sometimes, and they'll be going on long after I'm not involved anymore, so knowing the history and the continuity of the characters is important," says Marts. "Knowing 'story' itself, knowing what makes a story good, what makes a story bad, the different mechanics of a story, what pacing is, what momentum is, how to end a story, how to develop characters—those are all extremely important parts of the process."

Granted, Marts has an advantage. As a journalism major in college, he had the opportunity to study story structure, pacing and the writer's voice. Plus, being a lifelong comic book fan has enabled him to tap deep into comic book continuity. But Marts cautions that people who hope to become writers or editors need to expose themselves to deep, relevant study of the writing craft. "Maybe a few people could learn writing and editing just by reading comics," says Marts. "But usually it requires studying and learning. There's dozens of good books out there about what it takes to write a good story. It's not just going to happen by reading comic books."

Marts, like many other top editors, is a student of storytelling. As part of his formal and informal educations, Marts studied story structure, plot and character development. And despite the obvious differences between comics and other forms of media, including film, there are still core concepts that transcend almost all creative storytelling. Because it's part of his everyday life, Marts has a keen eye for plots, twists and cliffhangers.

"If you don't know comics and you don't love comics, you might be a good editor, but you won't be a good comic book editor," says Marts. "You've got to be a reader, you've got to know the product, be aware of what's going on. You have to be aware of trends, be aware of artists and writers. It's a constantly fluctuating business, with people switching sides and people taking on new projects, and that's extremely important. You have to be aware of every aspect of that side of the business. You have to know stories inside and out."

Marts offers a glimpse into his daily routine of helping different freelancers work together to tell a single comic book story. "I've got a regular writer who works on a title, so he's already got certain things that are in place and moving—storylines and characters. We'll sit down and talk about what's going to be different for that specific issue, or how that specific issue is going to move the story forward by several beats, so we have a few goals in mind, a few

THE FREELANCER'S TRIANGLE

A recurring theme in the comic book publishing industry is the concept of a freelancer's "triangle." If the freelancer can excel at at least two of the sides on the triangle—made up of reliability, talent and attitude—they stand a good chance of maintaining a career in comics.

According to Marts, working speed can also be helpful. Tracking his portfolio of favorite freelancers, Marts always works with people who can turn around quality work under tight deadlines. "Speed can be worked into reliability," says Marts. And a freelancer with all three things going for them will last longer in the industry that someone with fewer. "A creator without talent might be nice and turn stuff in on time, but they're not going to sell your books, and after a while you're going to have to part ways," Marts says. "The guy who's not reliable might be the nicest guy in the world and the best artist in the world, but if you're only getting two issues a year out of him, that's not helping out either."

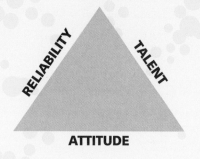

things that we want to hit," says Marts. "We have a general sense of what the conflict is going to be—whether it's a threat in the form of a villain or an obstacle or whatever, we've got an idea of what the issue's about. Depending on who the writer is or what our time frame is, I may ask for an outline, maybe a scene-by-scene outline, or 'beat sheet' is what I call it."

Once that's done and approved, the writer comes up with the script. "These days most writers will write in what's called 'full script,' which is a page-by-page, panel-by-panel breakdown of the action with all the accompanying dialogue," says Marts. Once that's in, Marts makes his notes and requests any changes. "Hopefully there's only one revision," he says, and then the revised script goes to the artist, who, depending on his pace, will send in a certain number of pages per week. As the pages come in, they're getting sent off to an inker.

"Just about the time when most of the inks are done, I'm getting ready to send the script to the letterer with scans of the inks," Marts says. "Shortly after that, we'll have a lettering proof, ready to be routed to a proofreader or to the story editor—if I have [an appearance by] Superman, I'll give a copy to the Superman editor. Simultaneously, the colorist is finishing up his work on the book—I'm doing some coloring corrections with him, I'm doing some lettering corrections with the letterer."

When the lettering and coloring are complete, the in-house production staff combines them and gives the editors an initial proof, so they can then review it for mistakes or inconsistencies. "Once all's said and done and a half dozen people sign off on it, it gets sent off to the printer," says Marts. Usually the next day, the printer sends a more final proof of what the book will actually look like in its printed form. "We'll give that the OK, then a week and a half later, it gets delivered to our office, bound and printed," he says. "What's funny is, at that point and time I've almost kind of forgotten about that issue because as soon as I sign off on it and it's off to the printer, I've taken it out of my brain and reserved that space for the next issue that's coming up."

ACCORDING TO MARTS

On seeking printed perfection:

"Each issue you put out is a learning experience. Very few issues that go out are 100 percent perfect. If you're lucky, most of them are above average on all levels and something you can be very happy with and proud of. Each issue that goes out will have something that you can look at and examine and say, 'I could have done that a little bit better' or 'The writer could have done that a little bit better,' so you draw on that past experience from past issues and apply that to each new issue that you put out."

On an editor's role:

"The editor's job is to be the guy behind the scenes. We're not really looking for praise. We're looking to assemble the best team possible and put out the best comic possible. If things go right, we'll get none of the credit, but that's fine. If things go wrong, we'll get all the blame, and that's fine too. It's just kind of part of what the position is. We're not looking to be superstars; we're not looking to be the best known people in the comic book industry. We're looking to make superstars out of our artists and writers, to make our artists and writers the biggest names in the comic book industry."

If you kept up with that, congratulations, you may have the talent to eventually become a comic book editor. But let's not forget, editors juggle multiple comics a day. "That's the cycle of one monthly comic," says Marts, "but in any given point in time, an editor probably has eight different cycles going on at the same time all at different stages of production."

PROS AND CONS OF THE JOB

As glamorous as an on-staff editorial job may seem to an outsider, it's still work. Marts, like many other American workers, has to slog to work every day and make it all happen. Unlike many of the other roles featured in this book, the editor is usually the person who needs to be in

the office as much as possible, as a central figure in the creative and production process. And despite what you see on TV, commuting to New York can be a tough grind.

But, according to Marts, there are parts of his job that make the challenge of the daily commute worth the effort. "There is absolutely nothing that comes close to the thrill of the Friday afternoon of getting a book off to the printer," says Marts. Managing to see another issue off to the printer is always a huge thrill. "Sometimes you're moving so quick to get things out the door … that sometimes I think I've figured out how to bend time," he adds with a laugh.

Another reason to love what he does is discovering artists whom the fans come to appreciate as much as he does. "I love finding an artist, knowing that I enjoy the artist, but then giving him or her work and seeing other people enjoy that artist as well, and realizing that whatever I saw in that artist was legit, that it wasn't just me," says Marts. "That's extremely gratifying."

The worst part of his job, he says, is getting everyone on the same page. "Usually with the creative process, there's a lot of different cooks in the kitchen. Whether it's the writer, the editor, the editor-in-chief, the publisher, the artist—everyone's got great opinions, great ideas, but they don't always mesh, and they don't always get along," explains Marts. "One of the things that annoys me the most is when I know that we're all going towards the same end result, the same goal, but we're coming about it in different directions. Sometimes it takes a while to realize we're all headed for the same thing, and once you realize that, it's easier to get there and then you've got the teamwork moving. Sometimes the obstacles can come up because we're dealing with a bunch of creative people. It can be frustrating."

Despite the frustrations, Marts manages to pull together all the elements so that he can release the dozens of titles his team produces yearly for DC Comics.

WHAT'S AHEAD?

Like most jobs in the publishing process, editorial tasks have evolved to take advantage of

KEEPING ALL BALLS IN THE AIR

Comic books are a unique and exciting artform that attracts all kinds of creative individuals, but they are based on commerce, so it is important to be consistently creative. After all, comic books are simply a branch of the comic book business. And a business needs to make money.

To publish a single issue takes more than hard work and determination. It requires organizing everyone's schedule so that the creative pieces fit together to get pages to the printer, so that it makes it on the stands by the advertised date. But editors rarely work on just one comic. So, an editor may be working with twenty or more creative people at once, all the time juggling all of their needs against the needs of the publishing house.

Every editor has a different organizational style, but the end result has to be the same: The book must come out on time. And the one after that, and the one after that. "The cycle," says Marts, "is endless."

new technology. In the old days, comics were written and then typed on a typewriter. Scripts were mailed—and then later faxed—to editors. Handwritten and typed notes were exchanged until a plot or full script was ready for the artist. And, you guessed it, the script was either mailed or faxed to the artist. Some artists came to the office and others worked in the bullpen, but it was a strictly paper-based operation.

Computers have obviously revolutionized the process of writing. These days, it's rare to find a writer who continues to peck out scripts on a typewriter. In fact, it's just as rare to find any creator who isn't somehow connected to the

> "There is absolutely nothing that comes close to **THE THRILL** of Friday afternoon **OF GETTING A BOOK OFF THE PRINTER**."
>
> —Mike Marts

Internet. As such, editorial departments have evolved with the times.

Many editors at Marvel and DC have relatively good-quality Macintosh or Windows-based computers on their desks. Like most office workers, comic book editors communicate through several software solutions, including email, chat, word processing software and File Transfer Protocol (FTP) applications.

Like many old-media print channels, comic book publishing is evolving. In the old media model, comics were printed and shipped. Most comic fans picked up their comics at the local comic book shop. It was a time-honored tradition that bred friendships, communities and collaborations. Many industry professionals, including Marts, can trace the launch of their careers back to friendships they made in comic book stores. In many ways, the comic book shop location is dependent on physical, printed comic books, but stores may adapt to new digital advances.

Comic book creation comes down to telling stories. Throughout history, storytelling has evolved to take advantage of different available technologies. The Internet and other electronic advances have made it possible for publishers to produce their content in digital formats.

Since getting into comics professionally, Marts has seen his share of technology growth. When he started, comics were almost completely offline workflow. Sure, most writers had already moved from typewriters and longhand to some sort of computer-based word processing. But pencillers drew on boards, which were inked, then lettered, then scanned and then composited with color guides. Even though the industry has evolved to leverage new tech, Marts believes that creators may adapt easier than the companies. "Adapting to new technology is tougher for the companies than for the creators and editors working on the comics," says Marts. This is in part because innovative creators can quickly adapt to hardware and software upgrades, taking advantage of the latest techniques.

The editors will have to make adjustments in how they work as technology changes, but, says Marts, "I think it's one of those things where ten years from now we'll look back and say some of those changes weren't that tough." He recalls how they had to adjust to the advent of digital lettering and coloring. "I look back now, and those changes are just a routine part of the way my day runs," Marts says. "It's not that big a deal."

And more changes, he says, are inevitable to survive. "Especially in terms of the way a book is formatted and the way it's put together, especially if we're moving towards things like downloadable comics," says Marts. "Those are moves I hope we make. We have to make those moves for the industry to continue to be successful. There'll be steps that we have to take, but in the long run, I don't think that they'll be that difficult."

ADVICE ON BREAKING IN

To aspiring editors—or really anyone looking to break into comics—Marts admits that networking is almost half the battle. "On the one hand, you've got to have the expertise and the know-how and the talent and the abilities," he says, "but the other half, it really comes down to a combination of networking, connections, availability, timing and luck. Those are all things you can't control. The other half you can control: your abilities, your talent, what you learn."

But, when it comes down to it, who you know can mean the difference between getting in and getting left out. "It's so important to make connections, to always act professional, to try to meet the right people in the right spots at the right time, and to use those connections

"It really comes down to a **COMBINATION** of **NETWORKING**, **CONNECTIONS**, **AVAILABILITY**, **TIMING** and **LUCK**. Those are all things you can't control. The other half you can control: your abilities, your talent, what you learn."

—Mike Marts

and that networking to your advantage," says Marts. "It's an extremely competitive field, and if you're not trying your hardest to get in there and stay there, there are a dozen people behind you who are willing to take your spot."

In business and in life, first impressions are lasting impressions. It's repeated so often in business that it's almost cliché. Marts focused heavily on how he was perceived among his peers and people in the industry.

"That first impression you make upon people should be professional and intelligent," says Marts. "A lot of people in the comics business—or any business—just don't know how

to do that juggling act, that balancing act of being professional and pleasant to deal with, and persistent, but nothing so persistent that you become 'that guy'—that pain in the neck, the person that when they call up, or walk in the room, everyone's like, 'Ugh, not THIS guy again.'"

You've got to be yourself, he says, "but you have to be yourself in a professional way and really be aware that every move you make, every step you make, could be something vitally important to your future career."

And kindness counts. "You want to be kind and fair to everyone you meet in the industry, even if they piss you off a lot or even if they end up burning you, because the same people you're meeting on your way up, you could meet them again on *their* way up," says Marts. "I've met people who were interns who people made fun of or got picked on. And I saw those interns become vice presidents in the industry. It pays to be professional and kind to everybody." 🌢

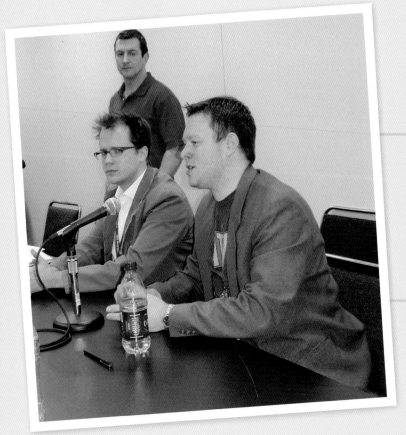

Mike Marts is a popular panelist at comic conventions around the world. Here he talks about his work on the Editors on Editing panel at the 2009 New York Comic Con. Seated next to him is Marvel editor Nick Lowe. In the background, former Marvel editor Glenn Herdling moderates the panel.

MAKING COMICS GO DIGITAL

In the past couple of years, the online experience has changed dramatically. Digital comics are no longer a novelty. There are literally thousands of comics published in digital form distributed online. Many are original stories, including Marvel's early work in motion comics. DC Comics launched the experimental Zuda Comics in 2007, which was a way of showcasing new creative talent without the financial risks associated with print distribution.

DC's Zuda—which is now defunct and evolving into something new—brought an element of mainstream credibility to online comics, which had been percolating in the periphery of the industry for years. Independent publishers and creators had been posting digital comics online, but Zuda helped drive more mainstream readers online to explore original content.

These days, many e-comics are stories that were originally created for print, but have moved online. Both DC and Marvel's digital online subscription services are early models of the inevitable future of publishing. Even now, the early players are aligning with companies like Comixology, Graphic.ly and others helping to shape this new electronic landscape.

This has forced open the doors for business models that require users to pay for e-content, not simply get it for free on an advertising-supported marketing model. This is significant, since many content producers—including traditional print publishers—are struggling to earn profit from the content that they create. The all-free-all-the-time model is not working for publishers that have to pay writers and artists to create original content. But many Internet users are reluctant to open their wallets for the subscriptions and other content that they never had to pay for in the past.

John Cerilli, vice president of content and programming for the Marvel Digital Media Group, and the entire Marvel Digital team manage online content using carefully planned publishing schedules. Marvel.com is the hub of activity for Marvel Comics, but Marvel Digital is actively engaged in the channels where fans are. "One week it's Twitter, one week it's Facebook, one week it's a subscription service, one week it's advertising," says Cerilli. "It's in constant flux, and I think what we were able to accomplish back then was certainly a precursor for some of the models that you're seeing online now. Which is just give them good-quality content."

Still, challenges remain. Apple's iTunes Store and Amazon's Kindle Store are examples of content distribution models that are having encouraging success. Most users know that content is easily pirated and shared online. Yet, despite this, users are still purchasing ever-increasing amounts of content from online retailers. Attractive pricing models for digital content have made it difficult for traditional brick-and-mortar retailers to compete with online retailers.

In the comics industry, the big question is how digital distribution will affect traditional comic book shops. As this book was going to print, Marvel was starting to provide content to new devices, including the Apple iPad, and DC was also in the process of launching its e-comics line, which actually included an element of profitability for the local comic book retail shop. All of this, of course, will morph and evolve as time passes, but these recent developments highlight the speed of change inherent with new media and Internet technology.

"We've gotten to this point now where the digital delivery method is being much more widely accepted, and people are comfortable with it," says Cerilli. "All we keep hearing is, 'We want more.' And we're going to try to give them as much as we possibly can."

For more on the future of online comics, the history of Marvel's digital publishing and vice president of content and programming John Cerilli's thoughts on what will happen to traditional print comics, go to http://creatingcomics.impact-books.com.

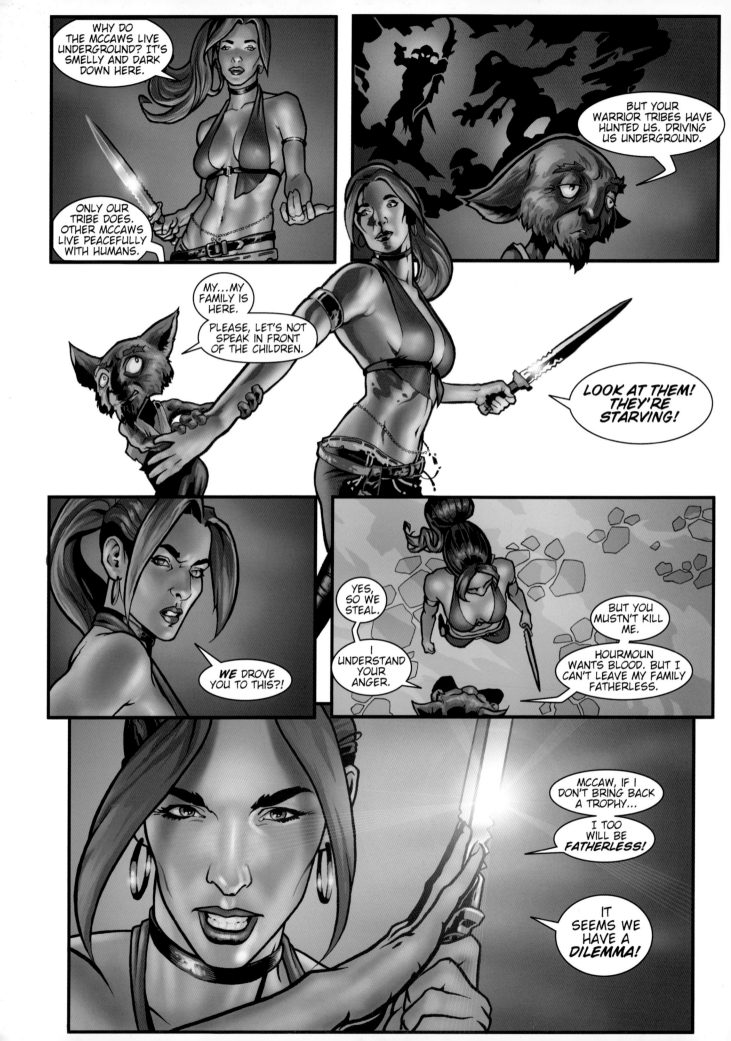

CHAPTER 2
WRITING: The Idea, the Blank Page and How Comics Are Born

In comics, it's the art that grabs you first, starting with the cover. There may be a superhero in danger or the promise of a major secret revealed, the kind of thing that wrings every bit of strength from serialized stories. Big, loud, splashy art combined with the kind of written hyperbole that would only work in comics.

On a quieter cover, art can also grab you with its subtlety. This works especially well when every other book on the rack is shouting for your attention. It may show the bowed head of a beloved character walking off with only two words, "I quit" or "It's over," or any number of pithy but powerful pieces of prose that force you to pause.

Open the book, and again, it's about the art. Some readers buy on art alone, knowing that they'll get enough visual enjoyment from the pages to warrant a purchase. Others shop by writers, since they are, theoretically speaking, the primary storytellers. Since art without story can only go so far, writers have their own draw. Their plots and scripts are the foundation that gives the artwork a flowing and relevant story. People who buy based on writer are going on faith that the story will pay off in the end.

In this way, comics are like big-budget Hollywood movies. We see the previews, which are all corn-syrup-fortified retinal candy. But if the story is poorly constructed, predictable or even (gasp) dull, it renders the preview's special effects meaningless. They become effects without emotional connection.

Comic book art, great as it may be, is given story substance and relevance by the writer. And like the movie, the story must draw you in, so that you are no longer watching a movie, but rather living and breathing the story. If you live the experience, you'll feel it in all the right parts, making the special effects fulfilling and not just empty calories.

THE POWER OF STRUCTURE

Writing comics seems simple from the outside. People who read comics—heck, even people who don't—often think, "That looks fun, I could do that." And sometimes they try and realize quickly that writing comics isn't quite as easy as it looks.

The idea that a story is "formulaic" means that it's been distilled down to the basic parts. Typically, it's not a compliment to say that a story is formulaic, since in that case it's suggesting that the writer is assembling a story that's dull and predictable. Yet, most mainstream storytelling has some sort of formula that makes it work. Actually, it's a series of formulas that, when mixed together, create something new and interesting. There are writers in comics who have built careers upon tweaking one or another formula to discover something new and interesting, yet completely comfortable and familiar.

Unlike other mediums, which reinvent year after year, mainstream comics are often based slavishly on previous issues. At Marvel many of the stories have been running one long serialized thread since they were first launched in the 1960s. Many of Marvel's flagship titles, including *Fantastic Four*, *The Amazing Spider-Man* and *Daredevil*, have been leveraging ideas and story trajectories that were conceptualized as early as 1961.

So in terms of "formula," yes, formula can be a bad thing. It can mean that a story lacks originality. But not always. In fact, it's the basic formula that made these characters attractive to readers. So attractive, in fact, that readers desire modern retellings of the original formula. It's like comfort food for the fanboy brain.

Stories that are derided as being, well, "comic booky" misappropriate the power of structure and formula. Formulas are distilled down into

Formulas That Worked

Comics are packed with basic story formulas that managed to attract an enthusiastic and loyal audience—some so compelling that they've hooked generation after generation of readers. Even more surprising, many of these core stories managed to survive multimediums. Comic formulas and characters have leapt from the page to television, film, newspapers, novels, radio shows, Broadway shows and even Web comics.

Here are some of the longtime classics with workable formulas that continue to be referenced, revived and revised.

Superman. Originally published in 1938.
Key concepts: Last son of a dying planet lands on Earth with "powers and abilities far beyond those of mortal men." Bullets bounce off him. Dual identity with the bumbling, wimpy Clark Kent. Love triangle between Clark, Superman and daring ace reporter Lois Lane. Same basic costume since first appearance.

Batman. Originally published in 1939.
Key concepts: Rich boy witnesses the death of his parents, is raised by family butler, grows up to fight crime using fists, fear and funky gadgets. Bruce Wayne is inspired after seeing *The Mark of Zorro* with his parents, just before their murder. Seeing a bat makes him realize the psychological power of bats.

A lot has changed over the years with these and other characters. Often the changes are subtle, but to fans who know the formula, these are dramatic changes. If not for the universally accepted origins of these characters (also known as formulas), these changes would just be part of a dynamic storyline. But understanding and then challenging the formula, writers can ignite, annoy and enthrall an audience over many, many years.

WRITING A MULTI-ISSUE ARC is like a giant math program wrapped in a creative writing wrapper.

something that's dull and unimaginative, which generates stories that seem like rehashed plots and snippets of stuff you've read before.

Comic book writing legend Mark Waid understands this formula for writing comics. He understands the advanced concepts of conflicts and resolutions, and generates stories that remain surprising and original. Waid sweats plotlines and dialogue, which means his writing avoids the failures of formulaic writing and embraces originality and creativity.

In the hands of a seasoned, hard-working professional like Waid, the formula is not a crutch. It's something to be played with and tweaked.

Knowing the secrets, Waid sidesteps traditional writing formulas and keeps readers off balance and constantly surprised. Waid mixes character-driven and plot-driven narratives seamlessly for a holistic and fluid writing style. He can tweak even the most tired of characters and situations.

Stay tuned, true believer. There'll be more on Waid and his approach to the medium later in this chapter.

THE STRUCTURE OF 22 PAGES

Writing comics also requires a strong sense of story structure. As simple as it may seem, writing a single issue is challenging enough. But writing a multi-issue arc is like a giant math problem wrapped in a creative writing wrapper.

Fantastic Four. Originally published in 1961. *Key concepts:* A scientist, his girlfriend, her little brother and a test pilot are bombarded by radiation, which causes them to manifest personality-related super powers. They offer themselves up without a secret identity as a superhero "family." Like all families, they bicker, break up, make up and generally love each other.

Spider-Man. Originally published in 1962. *Key concepts:* A nerdy kid gets bitten by a radioactive spider, granting him the proportional strength of a spider. Despite the wish fulfillment of getting cool superpowers, Peter Parker's life is plagued by constant hang-ups, and he failed to prevent his beloved uncle from being murdered by a criminal that he could have stopped. As a result, he uses his powers wisely (i.e., "With great power must also come great responsibility").

Daredevil. Originally published in 1964. *Key concepts:* A kid raised by his single father, a professional boxer, is splashed by radioactive materials (there sure was a lot of this radioactive stuff around in the 1960s, right?). The accident causes permanent blindness, but the boy develops hypersensitive senses that enable him to "see" the world in new ways. Despite being blind, he goes on to get his law degree, puts on a costume and fights crime.

Let's just say that you're a comic book writer and your editor asks you to outline a five-issue story arc. Congratulations! You're going to flesh out a story that will, not coincidentally, fit nicely into a collected trade paperback.

How does a writer do it? Well, no two writers or editors do it exactly the same way. But with a little bit of structure and some awareness of formula, a writer can craft an amazing and unique story that will stand the test of time.

Or they may write complete drivel, since writing is not at all as easy as it seems. Stay with me here, we're going on a little ride.

A basic story is usually 22 pages. Some stories go 23 or 24, but if you're a new writer, odds are you're going to be chiseling out 22 pages, not a page more or less. And if you are a new writer, you'll probably be writing a story that's (hopefully) exciting and compelling, but it's unlikely that they will allow you to do anything truly formula-changing. That's reserved for the top writers, like Mark Waid, who I will be getting to in a minute. Promise.

Of those 22 pages, you need to tell a beginning (about 4–6 pages), a middle (about 10–12 pages) and an end (about 4–6 pages). For a longer story, such as our five-issue story arc example, it doesn't matter how many pages you tell for your basic three-act structure, you just have to end each issue on page 22. That's it, because if they give you 22 pages, you'd better fill them. Not more than 22, not less. And since it's a serialized story, you need to end the issue on a cliffhanger. You need to give the reader a compelling reason to come back next month and plunk down their money to buy the next issue.

And don't think that cliffhangers are just for the last page. No, you need to give the reader a reason to keep turning the pages of the complete issue. Many writers build in a mini-cliffhanger at the bottom of every page, especially the right-hand pages, since those odd pages are the ones that people have to physically turn. (Well, they have to physically turn them now, but in the future, there may be a different structure, based on the digital delivery of comics that we'll probably see eventually.)

THE COVETED (OR CURSED) CROSSOVER

A crossover is an industry term for a story-related event that allows normally unrelated characters to interact. It can be an inter-company crossover, such as DC's Batman and Superman teaming up, or a larger event where characters from different publishers cross paths, such as Batman with The Darkness (Top Cow).

A crossover can be a dream or a nightmare, depending on who you ask. If you're a writer, this could be a dream come true, particularly if you can co-develop an interesting storyline that actually works on some creative or commercial level. On the other hand, a crossover can be a major headache for creators, especially if it's a company-mandated crossover that affects multiple published titles. That could mean a carefully plotted storyline has to change to accommodate the needs of this shared crossover storyline.

Multiple creators, editors and storylines can be challenging to juggle, especially if the crossover event has far-reaching consequences for the characters.

Now, let's say you've written those brilliant 22 pages and left them on a cliffhanger. Great. The next step is to make that—and all the other 22-page issues in the series—fit into a cohesive story arc. So, the three-act structure that I mentioned before must now get applied to the complete story. The first two issues (approximately) are Act 1, the second two issues (or so) are Act 2, and then the fifth issue is the big climax for Act 3. Depending on where the editor wants to leave

the characters and story, then an epilogue may be needed to pull it all together.

Now, that was a relatively basic exercise to demonstrate how complex it can be to plot out a comic book story. Things can get even more complicated, since writers are often asked to include certain story elements or participate in a crossover event, such as the *Civil War* story, which affected nearly the entire Marvel Universe.

Hopefully this gives a bit of insight into the "easy" job a writer has crafting comic book stories. The best writers just make it look easy on paper.

THE WRITER'S CONTRACT

It's been said that there is an unspoken contract between writers and the people who read their stories. You see, as the cliché goes, you can't judge a book by its cover, which in most cases is true. In comics, you can look at the cover and scan the pages to tell if you might like the overall completed product, but you still can't tell if you're going to enjoy the story until it actually ends.

So here's where this concept of a "contract" comes into play. If you're a reader, you have an unspoken understanding with the writer that suggests that you'll join him on a storytelling journey, if the story pays off in the end. This is especially important in longer works of fiction, since you, as the reader, need to invest more of your time, money and brain. If the writer doesn't deliver a good story—breaking your contract—then it's unlikely that you'll waste your time on future stories.

This sacred contract between writer and reader is a valuable and coveted relationship. For writers, it means that they have an audience that will (hopefully) follow them to different projects, even if they're offbeat, unusual or downright bizarre. Since they deal in such long stories that may span over many books, comic

book writers depend on their loyal audience to stick with them as they maneuver through different creative projects. The more the writer fulfills the story contract, the more likely it is that the audience will take a chance on challenging and daring new projects.

Since he broke into the comics business in the 1980s, Mark Waid has been keeping up his end of the contract. No matter where he goes and what he writes, Waid manages to bring his audience with him. In 2010, Waid was promoted to CCO (chief creative officer) of BOOM! Studios, a fast-growing independent publisher with a portfolio of original and licensed properties, after serving as the company's editor-in-chief.

Even though Waid has recently assumed editorial leadership duties—which he has many times in his career—he continues to craft some of the most compelling, honest and popular stories in comics. His byline has appeared in hundreds of

MANY WRITERS BUILD IN A MINI-CLIFFHANGER
at the bottom of every page, especially the right-hand pages, since those odd pages are the ones that people have to physically turn.

comic book titles published by Marvel, DC, Image, CrossGen, Event Comics, Black Bull Entertainment, Acclaim/Valiant, and more. Waid is part of a small cadre of writers who enjoy an ongoing literary contract with their readers. It's a good thing too, since Waid's name has appeared on hundreds of mainstream and independent comics over the years. Publishers and editors know that not only can they rely on Waid to deliver a quality story on a deadline, but they can count on thousands of sales from Waid's devoted fan base.

FROM FAN PRESS TO FAN FAVORITE

Like several well-known comic book writers, Waid broke in as a journalist in the fan press. In 1984, Waid became a reporter for *Amazing Heroes*, an industry magazine published by Fantagraphics. At the time, *Amazing Heroes* reported on mainstream and independent comic book activity, which enabled Waid to build strong contacts and network into an associate editor job at DC Comics.

His first writing work, interestingly enough, was a Superman story that he pitched to then-editor Julius "Julie" Schwartz at DC. Although Waid didn't get writing work again for several years, it was the proverbial foot-in-the-door that he needed to network his way into future opportunities. Like many people who break into comics, Waid had his eyes on the long-term prize, so he worked hard to forge meaningful relationships, which he leveraged later in his career.

As an associate editor at DC, Waid worked under Brian Augustyn. Together, they pumped new energy into the Flash. Concepts introduced during Waid's *Flash* run from issues 62 to 129 are still being discussed today.

As Waid began to break in, he developed and nurtured a reputation for delivering good stories on time. He offers advice for writers looking to break into comics. "Never over-promise, never over-commit, never say that you can do something that you can't do just because you're afraid of not making the contact or not keeping the opportunity open," he explains. "If you establish a reputation for being unreliable right off the bat, then you really are screwed."

Over the years, Waid has been able to write some of the top characters in the business, no matter what company he happens to be writing for. From the Flash and the Justice League at DC to the X-Men and Spider-Man at Marvel, Waid has been there, and been there consistently.

Many creators can tell you painful experiences of market shifts that have them on top one day and scraping for work the next. It's a sad reality that the market sometimes just isn't buying what the creators happen to be selling. In that case, creators may ride it out until the market comes full circle, or they evolve with the times.

Waid has managed to ride it out. Year after year, he knows how to interpret characters, stories and crossovers in a way that keeps fans buying books. He's a true student of the medium, reading and learning constantly from the past and present.

And, like many writers, Waid saves a lot of comics. The fact that so many mainstream comics are rooted deeply in continuity means that writers—especially those writing monthly titles—usually have a strong working knowledge of previous storylines. It's no surprise that Waid professes to have an enormous comic book collection, which he has had to move around the country, as he's explored opportunities at different companies that wanted him on staff.

CHANGING WITH THE TIMES

When Waid and many other top writers were breaking in, the Internet was just starting to take form. Fans and pros were beginning to congregate online to discuss their favorite characters, new stories and the pros who were developing the comics.

For many working professionals, message boards were a unique and interesting way to gauge reactions to their latest work. After a comic was on the stands for a few days, it was not unusual to surf over to *Wizard* magazine's online resources or to check out the Comic Book Resources website. People were talking and interacting with some (not all) creators.

But before that time, most communication was coming directly from fan letters. Yes, back

"You **NEVER SLUM IT**; you've always got to **SWING FOR THE FENCES**."

—Mark Waid

in the old days, comic readers would compose their thoughts on paper, place a stamp on it, mail it to the publisher and hope that it got printed. It was a much slower process, but one that was clearly understood by most people in the process. Publishers often considered fan letters as they produced their next title or decided which ones to cancel.

In the earliest days of fandom, well, there was no fandom. There were comics readers and collectors, and sure, you could call some of them fans. But in accepted comic book history, there was little more than clusters of people who loved and saved comic books. Most people got their comics from newsstands and drugstores. Their collector's passion was supported and commercialized in the late '70s and early '80s, when comic book conventions and the comic book direct market were being developed.

So why is this all so important in a chapter about writing comics? Because early comic book writers had little concern for backward continuity. Comics were produced on cheap paper, intended to last a month or three on the newsstands. Like magazines and newspapers, they were considered periodicals that would soon be forgotten when the next issue arrived. The vast majority of printed comics were discarded (not even recycled!) as the next issues arrived. Readers may have saved their favorite issues, but it was a bit uncommon for people to amass large collections, especially ones that spanned multiple titles. Also, comics were considered youth entertainment, so most people got rid of their collections when they hit a certain point in adulthood. This scarcity of back issues would eventually lead to collectible values and skyrocketing costs associated with Golden Age comics.

Because comics were intended as ephemeral entertainment, writers were concerned more about the stories they were creating today, rather than the stories that were produced months and years before.

Until Stan Lee began writing tightly serialized comics at Marvel, including *Fantastic Four* and *The Amazing Spider-Man*, backwards continuity was barely considered. Writers just focused on (hopefully) writing the best possible story that month. If that story didn't work, they could always come back the next month with a better one.

But as fandom began to gain traction and fans organized conventions, there was a way for people to find and read back issues. Enterprising fans could actually amass a complete run of their favorite series. They could start to share their opinions with other fans, and many began to read (and even write for) fan publications. Today this seems perfectly normal and logical, but in those early days of comics fandom, this was unique and exciting. Because the Internet had not yet become mainstream and commercialized, these diehard fans actually had to work to meet each other, subscribe to publications and share their ideas. Over time, much of this conversation moved to the Internet and to comic book conventions.

The comic book stories that were intended to last a month or two were taking on new lives, thanks to passionate fandom. The idea that comics were temporary and transitory was fading fast. Real fast.

In fact, people like Waid were passionately involved in their fandom. The fans who studied comic history, memorized facts and studiously collected comics were quickly becoming the next generation of writers. These writers cared about the past continuity. It mattered to them and the people they befriended at conventions. So the comics they wrote were not going to be the passing issue of the month. No, they were writing to be part of the story canon. It was a minor shift that started small, but evolved into the way comics are created today.

This new generation of comic book creators was proud to have their names printed in the credits of the comic book, especially if they had a

Waid with Comic Book Resources executive producer Jonah Weiland at the 2009 Long Beach Comic Con, where they sat on a panel together. The CBR website (www.comic-bookresources.com) is one of the major news and information hubs for the comics industry.

large following from their involvement in fandom. Comics were still sold on the strength of the characters, the cover or the interior art, but now comics were also being sold on the writer's name as well. (That's all part of that writer's contract we discussed earlier.)

"Certainly back when I was reading comics, we weren't picking up stuff based on creators' names as much as we were just picking up Daredevil or Fantastic Four or Superman or whatever our favorite characters were at the time. That's what the companies were selling," explains Waid. "The paradigm has really shifted where now the companies—even the majors—seem to be as much in the business of selling creators as they are the characters."

To many writers, this is quite exciting. They can generate a fan following that will help them launch new titles and keep their existing projects alive. But now, the expectations are higher. If you write something today that gets published, you can count on someone, somewhere saving that issue. Forever. Nobody's bad work is ever forgotten. Nope, it gets reviewed, saved, discussed, referenced and shared. Nothing goes away, and that means pressure for modern comic book writers.

"It's even more important now that the work be really good. I mean, it was always important that the work be good, but it's like the bar is higher because now the entire Internet is scrutinizing every line you put down on paper and every keystroke you make," says Waid, who has generated hundreds of comics. "Everything that you do is going to be in print forever."

DEFENDING YOUR WORK

In the comics biz, Waid is not only known as being a good writer, he is known for being an opinionated one, too. Over the years, he has created some of the most exciting comic book stories ever written. Not surprisingly, that kind of creative delivery comes with a certain amount of in-the-trenches battle with co-creators, editors, publishers and artists. And despite his friendly and upbeat personality, Waid is not shy about fighting for the best possible comic book product.

All comic book creators have tales about ideas and stories that started off well, but got changed or "improved" by editors, publishers or even co-creators. Waid believes that one of the reasons he's survived is because he has been willing to stand up and fight for the best possible product.

"At the end of the day, as a freelancer, all you have is your work. All you have is your byline and your résumé. I know entirely too many people in this industry who are more talented than I am, and who are brighter and smarter, and just better all around, who cannot find work because they spent so much time working for crappy editors or bad publishers," says Waid, who has had to work hard to protect the integrity of his work. "They were good soldiers and they did what they were told to do because, you know, they're professional and they're doing their job and they're doing what their editor wants them to do. But then they look back and they've got a body of work of three or five years that's mediocre stuff, because they weren't allowed to cut loose or because their work was constantly compromised or they were constantly screwed around with. OK, great, that means you've made a friend with one editor, or you're known as the 'get-along' guy. That doesn't do you any good, because five years from now, the next editor doesn't care how many beers you had with your editor three years ago or how sweet a guy you were. What they care about is whether the work was any good."

Of course, it took Waid many years to achieve this level of success, which gives him some flexibility to defend his work. So, should a new creator getting a first break at Marvel or DC go toe to toe with their editor? "No! God, no! Are

"I honestly think the **GUYS WHO DON'T DEFEND THEIR WORK** tooth and nail from an early point in their career are the guys who are bringing me my pizza tonight."

—Mark Waid

you kidding me? No!" Waid responds. "No, I can do this because I have a body of work and a reputation to fall back on. However, along those lines, one of the reasons I seem to be characterized as outspoken is because those times when I feel like the integrity of the work I do is being messed around with, I will pipe up. I mean, I can't advise a new talent coming into the industry, obviously, to pick a fight; that's foolish. You can't win every battle, and you've got to pick the hills you're going to die on."

Waid also believes that this is one of the reasons that certain creators succeed and others fade away after short careers. "I think some of it is just the X-factor. I believe in good luck and I believe in bad luck. I don't believe you can cultivate one or the other; I don't believe that there's any sort of cosmic force in play, but I do believe that just like 89 percent of getting the job is networking, there's also a huge body of work where studies show that timing is everything," Waid says. "But beyond that, the guys who, early on, don't show a level of reliability, that doesn't help their career. I honestly think the guys who don't defend their work tooth and nail from an early point in their career are the guys who are bringing me my pizza tonight."

BEING RELIABLE UNDER PRESSURE

Every creator knows that this industry is a deadline-driven business that depends on every person in the process to maintain deadlines. If one person falls off deadline, it can have a domino effect that causes everyone down the line to miss theirs. Work can sometime stack up fast for popular talent, which causes other books to be potentially late.

Waid learned early on that deadlines are important, especially for writers, since without

a story, there isn't going to be much of a comic. Reliability was something that Waid learned in his two years working as an editor at DC. "Sitting on that side of the desk made it abundantly clear to me that, as an editor, one of the things you're most looking for from a free-lancer is reliability," he says. "There's always time to go back and spruce up dialogue or fuss with pencils and inks a little bit, you know, a little bit later in the process. But as an editor, I want it to be good, but I also want it in on Friday if you said Friday, because I've got everything else stacked up against it—I've got the next guy in the food chain waiting for his piece of the assignment."

Like many successful comic book creators, Waid can relate to the challenges of the other people in the production process. Again, his years of editorial work gave him useful insight about the entire workflow. "You're not the only guy in the food chain," Waid explains. He uses his editorial experience at BOOM! to illustrate the interconnected workflow. "If a book from BOOM! is going to come out in May, that means automatically I can build backward from there a production schedule. If it comes out on May 15, and it's got to be at the printer by April 15, then that means it's got to be finished with production by April 8, which means—you get the idea," says Waid. "You work backward [to organize the workflow]."

And every deadline—made or missed—affects the next person in line. "If the writer is late to start with, then that means the penciller gets less time to do his stuff, or it means that the colorist somewhere is shafted down the line, because it's a production line," he says. "If you throw a monkeywrench in the middle of a production line, everything just grinds to a halt."

It would seem obvious that this basic concept of avoiding monkeywrenches in the machine would prevent anyone from ever being late on the production line. Waid, of course, knows that

real life constantly gets in the way of deadlines. "I don't know any comics being published today that are ahead of deadline," Waid says. "We are constantly racing the deadline; even the best-intentioned of us always end up, you know—no matter what my production schedule looks like, I always know that, still, at the end of the day, I'm racing to get something done."

He points out, though, that a comic book that's slid slightly off-schedule these days doesn't exactly bring the firestorm that it once would have. "If it's a week late or something, that's not the end of the world," he says. "On a corporate level, it's not like the old days when there were all sorts of printing penalties to be paid for books that shipped late. In the '60s and '70s, it would cost you money if the book was late by a week or so because the printer would charge extra because you were taking up extra time on their end by racing a book out."

TECHNOLOGY AND THE WRITER

Over the centuries, the way people have shared stories has evolved with available technology. From the earliest cave paintings and stories over campfires, people sought out ways to share ideas and stories. Technological evolutions in printing, especially the Gutenberg press, changed the way people shared and received stories.

New technologies, including the Internet, are challenging the ways stories are shared. In other parts of this book, we discuss how new technologies affect the actual production and design of comic books, including advances in lettering and coloring. Technology is even changing the way people consume comic book stories.

Yet, interestingly enough, technology has had a less dramatic effect on the way comic book writers are actually writing their stories. Yes, there are new software packages that help format scripts and outlines. And there are better voice recorders and gadgets for writers who speak their ideas into devices. And, no doubt, the invention of email has made it much easier to share and submit scripts.

But the primary input device continues to be the humble QWERTY keyboard, which connects to some kind of word processor. And right now, there's very little current technology that will change the process of typing words onto a screen.

"On a writing level and on an art level, the technology has changed, but we're still using the same basic tools. I'm still using a keyboard," says Waid. "It doesn't mean that I write faster, necessarily, than I would on an Underwood typewriter, but it means I work better because I have more time to go back and finesse and fuss, and now I know that every word I put down on paper doesn't have to be carved in stone. It's much easier to make changes and edit yourself on the fly when you're using a word processor."

The Internet has made researching easier, too. "When we started writing, you would have to go to the library to look stuff up, or you would just have to rely on what you know, or you would have a big giant shelf of reference books you'd pull from," says Waid. "Now, everyone is an expert on everything all the time, which is good, and it's great that if I'm writing a story about a nuclear-class submarine, I no longer have to go spend an afternoon at the library doing my research on it and finding out what little I can. Instead, I can go on the Web, and within an hour I can find out everything you'd possibly need to know."

WORKING CLOSELY WITH COLLABORATORS

Like many creative endeavors, comic book creation can, and usually does, involve the collaboration of many creative and non-creative professionals. The majority of professional mainstream comic books today have multiple names in the masthead. Waid wears many hats in his role at BOOM! Studios, but when he is a writer, he usually has a more focused role. In that role, his day-to-day contact is usually with whomever is editing his work.

"You interact mostly with the editor, at least if you're working on company-owned characters," explains Waid, "or if you're working on basic DC or Marvel stuff, or if you're doing work for hire for other companies. That's because the editor's job is essentially to be the producer. The editor's job is to put the various talents together and make

sure that everybody is creatively on the same page and they're telling pretty much the same story. So, [it's] very important to stay in touch with your editor to find out what you can and can't do, what you should and shouldn't be doing, to get honest feedback about your material."

As noted earlier, Waid has worked for large and small companies, including places where he's done creator-owned comics. "If you are doing your own stuff, then you're staying more in touch with the artist than anyone else. Even if you're doing company-owned stuff, I still encourage people, especially guys breaking in, to stay as close in touch with their collaborators as they can because—this is something editor Christopher Priest was very fond of saying, and he was absolutely right: If I sit down to do a short story, it's my story. If I sit down to do a prose story, it's my story. If I sit down to do a comic book story, as a writer, the moment I start typing, it's not my story anymore; it's our story," says Waid. "It is a collaborative medium, whether you like it or not."

THE REGULAR WORK OF WRITING

As noted earlier, breaking into comics is no easy task. And once you're in, you have to constantly prove that you're worthy of the work assigned to you.

"If you're trying to sell something—if you've never worked with that editor before and you're trying to break in—you're pursuing the editor; you're showing them the other work that you've done, [whether] it's in comics or on the Web or if it's black-and-white stuff that you published," says Waid. "Again, that's always the best way to break in as a writer … have some comics work of yours out there, even if it's self-published, even if it's just Web stuff. Because at least it shows that you have a facility with the craft."

Once you've landed an assignment, Waid says, "The way the story process works is you sit down with your editor, you talk about the general direction for the next six or eight months of the book, and you talk specifically about the things that you would want to do this issue." How you move forward from there depends on the editor. "Some editors will want to roll up their sleeves and get

in there and co-plot with you and knock ideas back and forth," Waid says, "and some editors will just let you fly by the seat of your pants and they'll look at the finished script and they'll come after you and give you a million notes. Whatever way makes the best comic is fine."

Making a story work usually means multiple drafts are in order. "Be prepared to have more than one draft of your story at work, and be prepared to make two or three or four different drafts as you go," Waid says. "Ideally, the closer you're in contact with your editor at all stages, the more that lessens the necessity to have to rewrite stuff, because ideally you want to get a general thumbs-up on your idea before you start …. That way you won't have to spend a week writing a story where Superman goes to Venus, and then have your editor read the story for the first time and go, 'What is this Venus stuff? He can't go to Venus.'"

Remember how we started this chapter talking about formula? Initially you may have equated "formula" with lazily constructed, unimaginative stories. In some cases, that's true. But in the hands of a well-polished and thoughtful writer, formula helps drive the structure of a story. It can guide the outline and pacing to tell enough of a story in 22 pages that the audience will feel satisfied and want to come back next month for another 22. Formula in the hands of a professional is not a crutch, but rather a way to articulate a lean, tight and relevant story to readers. Waid, of course, is an expert at all three, which is why after all these years he maintains a loyal fan following.

Waid reveals the basic approach a comic book writer may take to create a mainstream story. "You need to have the basic, broad strokes of your story worked out with your editor ahead of time," he says, then map out a standard 22-page issue page by page.

"Sit down with a piece of paper and write the numbers 1 through 22, and then just write down in short bursts what happens on every page," Waid suggests. "Figure out what your plot is, figure out basically that there's one important thing happening on every page, and figure that at the

bottom of every page you want there to be some compelling reason to turn the page and see what happens next."

That is the best time to flesh out how a story is going to unfold, page after page. "At that point, it really is like clay; you're just sort of molding it," says Waid. "You kinda have an idea what the direction of it is, but ... you've got to be willing to get in there and roll up your sleeves, and be willing to mold it and shift it and move stuff around and lose stuff and come up with new ideas. That's unquestionably the hardest part of the job. But that's the next part of the process."

FINDING YOUR PROCESS

Read enough books on writing and you'll notice two things: 1) Nobody does it exactly the same way—everyone's writing process is completely different and custom to their personal habits; and 2) You have to do it to get it done. If you don't write it, it won't get written.

Waid offers direct and actionable advice for writers, especially writers who have multiple things to write (as many comic writers do). "Here's how you do it; here's how you keep that many plates spinning. You have to learn to trust your process," he says. "A lot of guys are great at getting up at nine o'clock in the morning and sitting down in the chair and not getting out of the chair until five or six o'clock at night, and by the end of that night they've done twelve pages or whatever it is they do. That's a very clockwork way of working, and it works for them, and that is great. If that is your process, I salute you."

For other writers, though—himself included— there are other ways. "On the other hand, there are guys like me who can't do it every day. I want to, but with me it's more that I have to wait until I get the right idea. I have to let things percolate in the back of my head," Waid says. "A typical work week for me is two or three days of not actually writing, but a lot of thinking and a lot of making notes and a lot of scribbling in margins, and then all of a sudden in a great burst of energy, I just sit down and bang out eighteen or nineteen pages in a row."

It took time for Waid to accept how he writes, instead of lamenting it. "The amount of time I spent in the first ten years of my career beating myself up for that process, as opposed to what I'd always been told was the right, proper process— which was to sit down and put your ass in the chair and write—that's time I'll never get back," he says. "That's time and energy that I spent beating myself up that I will never get back."

Waid's continued success in writing comics shows that his methods aren't merely madness. "The reality is, I've done a thousand comic books since then; clearly I'm doing something right, you know? Clearly the process is working for me," Waid says. "I may not be completely happy about the fact that a lot of the process seems to be being paralyzed by fear that I'm never going to come up with the next idea. You know, a lot of the process is the worrying and the sweating and the lying in bed at two o'clock in the morning, going, 'Oh my God, I've run out of stuff to say.' But guess what—that's part of the process, so you kind of have to learn to embrace it."

The important thing, Waid says, is to knock out the pages, however you do it. "If writing a lot every other day works better for you than sitting down and trying to crank out something every day, then [do] whatever it takes," he says. "As long as you're actually getting work done, it's fine."

THE PRESSURE TO BE CREATIVE

Writing comics for a living is a lot like going to school every day, except instead of getting grades, you're getting money. This may be a dream come true for most writers, but it still comes with real job pressures.

Comic book fans can be a fickle and mercurial group. Often books that should sell do not, and books that nobody expected to sell take off. It's hard to predict what will be the next big thing in any creative medium. Films may flop, books undersell, magazines fold—and sometimes comics just don't find an audience. Many comic writers work month to month, trying to release enough material to pay the rent and keep their career moving forward. It's a dangerous life,

especially since most writers do not get company-provided health benefits.

So, in an industry where people have to buy your work this month and next month and the month after that, it's important to give readers your best story every time. "You never slum it; you've always got to swing for the fences. I know it's easy to say, but it's true," says Waid.

If your heart's not in an assignment, Waid says, you're better off walking away before you start. "I've turned down assignments before where the money has been good or the profile has been good or whatever, but I'm not connected to that character; I'm not connected to that property, or I don't feel good about the editor or the level of guidance I'll get. You turn that stuff down," Waid says, though he admits it's harder (and not always financially agreeable) for fledgling writers who don't want to turn down the work. "It's easy for me to do [now that] I'm up and running, but it's hard to do when you're starting up your career."

As a longtime freelancer, Waid knows that comic book writing is not a nine-to-five, low-stress job. "Nothing even close! If that's what you want, they're hiring at Walmart, ya know?" says Waid. "It is a constant, constant flood of emails and phone calls, and if you are making a living at this, it means you are writing more than one thing at a time. You have to be, or else you're not making a living at this."

That requires a lot of plate-juggling, Waid says, and being ready to switch gears and projects at any given moment. "Despite your best intentions, you can get up in the morning with the idea of, 'I'm going to spend today and tomorrow working on Spider-Man,' and by noon, you realize that your editor on some other project has called because the penciller is working faster than you thought he was going to work, and suddenly he needs five pages of *Brave and the Bold* or whatever," Waid says. "And that's the constant plate-spinning and juggling you have to do."

Waid compares the pace to the dramatic train scene in the 1986 Rob Reiner film *Stand By Me*, when four friends realize as they are crossing a bridge that a train is speeding toward them.

"It's like every day, they're halfway down the train track on the bridge, and all of a sudden they look and they hear the train coming and they've gotta run off the trestle," he says of the scene, which ends with the boys bolting down the track, barely escaping with their lives. "Every day of my life is like that!"

And, unlike some other creative pursuits in the comic book business, creativity doesn't always thrive with a crowd around. "You had better love a fairly solitude-filled existence as a comic book writer," Waid says. "As an artist, you have the luxury of working in a studio. As an artist, you can sit there with five or six other guys in the room and yak all you want, and be able to draw at the same time, and the best guys are able to do that. With a writer, much different—can't do that."

Mark Waid, circa 1996, dressed as the Golden Age Flash for a costume party at Openers, a New York City pub.

THE BEST AND THE WORST

So what does Waid like most about writing comic books professionally? "What I like best is the idea that when everything is clicking, when you've got a good editor who is helpful but is not impeding what you want to do, when you've got an artist who is on the same wavelength as you creatively—then the possibilities seem limitless," he says. "You can write something that you feel strongly about, and within six or eight weeks, it's out and the whole world can see it. There's not another medium like that where the immediacy

FULL SCRIPT STYLE

Waid usually writes "full script," which means all of the dialogue and description are included in the submitted script. This can be helpful for artists, particularly since they will know what the dialogue will be and can draw the appropriate character emotions. Art usually comes back to the writer to help offer the letterer direction on balloon placement. Dialogue may change based on what the writer sees in the panel, particularly if some part of the story is unclear. The script for *Irredeemable #12* is a great example of how Waid formats his script so that the artist knows what has to happen on each page.

is so strong and the ability to do it your way is so generally uncompromised—again, when it's working well."

In other forms of entertainment, it may take a much longer time before your creative product makes it to the audience, and there may be many more cooks in the kitchen. "In any other medium I'm working in, be it television or movies, it's a months- or years-long process, and everybody gets a vote, and everybody gets to come change whatever they want to change, and at the end of the day you're lucky if 40 percent of it is actually yours," says Waid.

Comics—at least before the Internet and blogs were born—were "as close as you can get to standing on a mountaintop and just yelling through a megaphone and everybody's going to listen to you," Waid says. "It's not quite the same now, but you're still able to tell stories with an immediacy and with a personal investment that you really can't anywhere else. That's what I like best about it."

And what does Waid like least? "The vulnerability that you have when you're working as a freelancer for other companies … there are so many things that can go wrong to screw up a comic book," he says, "and the number of things that can go wrong is so much exponentially larger than the number of things that can go right."

Waid mentions a spinner rack in his office that houses every comic he's ever written. "It's busting at the seams, this thing," he says. And while it no doubt shows off an impressive body of work, Waid also sees it as a reminder that his work is never really done, nor guaranteed. "Overall, I feel like I've had a successful career," he says, "but it kinda does make me flinch that I can go in and pick any five comics at random, and of them, maybe one or two if I'm lucky are as good as I really wanted them to be when I sat down for the first time and wrote Page 1, Panel 1." ◗

PAGE TWO

PANEL ONE: MEANWHILE, NEAR THE HELICOPTER, QUBIT AND KAIDAN ARE RUNNING FRANTICALLY UP TO BETTE AND GIL. GIL'S LYING ON THE GROUND, WRITHING IN PAIN; BETTE'S KNEELING NEXT TO HIM, CRYING, IN SHOCK.

QUBIT: GIL!

QUBIT: Bette, what HAPPENED? What does Orian WANT?

PANEL TWO: QUBIT SHAKES BETTE BY THE SHOULDERS, BUT SHE'S UNRESPONSIVE--WIDE-EYED, BUT STARING BLANKLY, HER FACE TEAR-STREAKED, JUST IN SHOCK.

QUBIT: Bette, are you WITH us? SAY something!

QUBIT: Terrific. She's in SHOCK.

PANEL THREE: MEANWHILE, KAIDAN EXAMINES GIL'S BACK WOUND. GIL MOANS, IS BARELY CONSCIOUS.

KAIDAN: And Gil is bleeding OUT. I can put pressure on the WOUND, but--

GIL/small: ...nnNNnnhh...

PANEL FOUR: AT QUBIT'S COMMAND (HE'S EXAMINING GIL), KAIDAN RUNS TOWARDS THE OFF-PANEL FIGHT.

QUBIT: That won't FIX it! Go get VOLT!

QUBIT: GO!

PAGE THREE

PANEL ONE: VOLT'S STILL HAMMERING ORIAN WITH STAGGERING AMOUNTS OF ELECTRICITY, BUT ORIAN SEEMS LARGELY UNDAM-AGED. HIS SKIN IS SIZZLING AND BURNING A LITTLE, BUT HE'S ADVANCING ON VOLT NONETHELESS.

VOLT: IS THAT ALL YOU'VE GOT?

ORIAN: I haven't even really STARTED.

VOLT: I WAS TALKING TO MY TEAMMATE!

PANEL TWO: WHAM! SURVIVOR HITS ORIAN HARD, FELLING HIM.

ORIAN: Oh.

PANEL THREE: AS SURVIVOR AND ORIAN GO AT IT TRADING PUNCHES, KAIDAN RUNS UP TO VOLT, WHO LOOKS EXHAUSTED. (HE'S NO LONGER THROWING LIGHTNING.)

KAIDAN: Tagging IN.

VOLT: What? NO! You don't know what you're DEALING with!

KAIDAN: I'LL CARRY MY WEIGHT! Qubit NEEDS you!

PANEL FOUR: SHE UNLEASHES THE TENGU, WHO LOOKS LIKE A MIGHTY SAMURAI WARRIOR EXCEPT THAT IT HAS THE HEAD OF A CROW. (SEE ISSUE TWO, PAGE ONE FOR REFERENCE ON KAID-AN'S POWER AS SHE CONJURES UP GHOSTS LIKE THIS.) THE TENGU HAS A SWORD IN EACH READY TO DELIVER A DEATH BLOW. SEE IMAGES FOR REFERENCE:

http://tiltedperspective.com/images/Tengu.jpg

http://www.canit.se/~tengu/tengu/tengu2.jpg

KAIDAN: [Dialogue to come--a snippet of the Tengu story as recited by Kaidan]

PENCILLING: Sketching Worlds One Page at a Time

While we love a writer for the story, we need an artist to visualize it into sequential art. Otherwise it's not a comic.

Not all comic artists interpret sequential art the same way. There are many ways to approach the page with a sequential story. A two-panel page is just as much a comic as a sixteen-panel page, although they will look remarkably different, especially interpreted through the pencils of different artists. That's part of what makes art so interesting.

In comics, the artists—specifically pencillers—are called upon to be the quarterback of the process. As in football, a lot of people work together to deliver something specific. If they don't, the play falls apart. But if everyone runs the play properly, the quarterback can deliver a touchdown. Quarterbacks often get a lot of the credit for the score, since they're the ones holding the ball after the snap. This is largely true for comic artists as well.

Many people have to work together to deliver a comic that people want to buy and read. But, ultimately, many decisions are made at the point of purchase, right there in a comic book store, as someone eyes the art and asks, "Do I want to enter this world?"

A great comic penciller knows how to interpret stories so that they grab the reader and give him a reason to buy. The best pencillers have fans who will buy their books no matter who writes the issue. A motivated fan base can be extremely valuable to the bottom line of publishers.

So, when it comes down to it, comic artists are really the rock stars of our industry. People form long lines to get sketches, autographs, even just a few minutes of conversation with their favorite artists. The visual art they create can sometimes transport a person to faraway lands, deep into outer space, or just as far deep underground. It's these visuals that will make the difference between a person putting a comic back on the shelf or making an actual purchase.

CREATING THE COMICS YOU LOVE TO SEE

In the comic book business, many of our most celebrated creators are the pencillers. And there's a reason for this. Like any medium, there are certain elements that make comics unique and special.

We share storytelling through movies, TV and novels, but the comics medium is distinct in form and presentation. At the core is the story, which forms the foundation of the narrative. But after that, the comic story is almost completely reliant on the panel-to-panel and page-to-page flow of the narrative.

In prose books, our eyes track back and forth across the page. It's the very nature of typesetting that enables us to scan quickly across words to absorb the narrative. If the word layout and typesetting changes, it actually interrupts the flow of the narrative. Sometime this is for effect, but if it is not, it can be distracting, taking the reader out of the narrative.

In movies and television, the story is linear and fixed. The video format cannot be sped up or slowed down for the pleasure of the reader. The very nature of film does not encourage user interaction; in fact, it discourages it. (Now, we're not talking about interactive video, like the stuff we see on websites. That's more of a hybrid of video game interaction and video source files.)

Video games are an entirely different medium that (usually) require the user to actively maneuver and influence the narrative. In many advanced games, the user is required to traverse scenes that enhance or progress the story. But this too is different from comics in that a single video game can go on indefinitely (or at least until the hardware conks out!). But for so many reasons, games are not comics.

Videos, books, games and comics are all lumped into a single family of similar mediums. To the casual observer, they may all seem remarkably similar. But to enthusiasts, there are clear differences. In comics, these differences make comics so compelling as a form of communications.

In comics, the casual buyer can tell a lot from flipping through the pages. You don't get to do that in video games, films or even books. (OK, you *can* with books, but with many of them you just don't get much from that little flip-through.) In other mediums, you can look at the screenshots, but you really don't get any context. You get the images that sell the product the best. And the same goes for movie and video game trailers. They all look great, but as we all know, they're not always as good as the trailer.

And that's one of the reasons that comic book artists are like the rock stars of our industry. They are often the only reason people must buy (or not buy) a book. You can stand at the racks, open a comic and tell immediately if the book will appeal to you. You can see the actual story. It's not some marketing department's interpretation of the story—it's the actual story. Right there in your hands. And a casual reader—who may know little or nothing about the writer's past work or the character or even the other members of the art team—can actually make a decision to buy or not buy.

WHAT YOU SEE IS WHAT YOU BUY

How do people decide what comics to buy? Well, there are critical clues that inspire or discourage a purchase. Consider this: If today you're in the mood for a bombastic action movie type of superhero thriller, you're going to be grabbed first by the cover of the book. When you open the pages, you're expecting to see superhero-style storytelling. Big, powerful art that stresses the dynamic motion embedded in the story. You won't actually read the issue, but you will check out the storytelling and art. *Spawn* and *Jughead* will not easily be confused, even to the most casual reader.

If this is the kind of comic you want, it's unlikely that page after page of talking heads will compel you to put your money on the counter. In mainstream action comics, conflict is often resolved visually. Even "quiet" scenes that progress plot are composed in a way to be visually stimulating.

On the other hand, you may be in the mood for something more introspective. The graphics for *Eightball* or *Love and Rockets* give the reader a clue that the story probably isn't going to hinge on a major explosion or a super power. In this kind of story, showing a series of talking heads isn't necessarily a bad thing. In fact, a story here probably relies more on dialogue and plot than on the external visualization of conflict.

Stories like this are created to highlight different visual elements. For example, the art may be designed specifically to highlight minute details, including mundane elements of everyday life. Here, a massive superhero power may seem oddly out of place, since it doesn't match the expectations and desires of the reader.

A professional comic artist can often send you a clear signal about the way this story will actually unfold, helping you make a decision about your purchase. The best artists know how to control their craft, exciting you to buy a story you might not otherwise consider.

IT ALL BEGAN WITH A BEAVER

It's usually pretty easy to look back on a career and examine someone's published work. The real challenge is to trace a career back to the days and hours before there was an actual career, to understand the untold hours spent sitting alone behind an art table.

Darick Robertson is a good example of someone who worked for years honing his skill, only to find that breaking in required more than just talent and skill. It required persistence, hard work and determination. Robertson didn't break into comics at the top, doing the comics that he's known best for, including *The Boys*, *Transmetropolitan* and *Wolverine*.

Robertson spent his late teens launching *Space Beaver*, a small creator-owned project that found an audience as part of the funny animal, black-and-white comic boom of the mid-1980s.

"This is when I was seventeen or eighteen. So when my friends were going to keg parties and getting into college, I was staying up until three in the morning drawing *Space Beaver*," says Robertson.

A light parody of *Star Wars* and other popular science fiction, the series became his portfolio, showing that not only did he have real talent, but he had the tenacity to produce a substantial and improving body of work.

"That was my way of getting out of my life, and I wanted it really badly," says Robertson, who was ready to move on from menial jobs and out of his parents' house. "I didn't want to go through a whole life just working in fast-food restaurants. I dreamt of the day I could have my own apartment

photo by Aaron Munter

Spotlight: Darick Robertson

JOB: Penciller (inker, writer)
LOCATION: San Francisco, California
YEARS IN THE INDUSTRY: 20+
HAS WORKED FOR: Marvel Comics, DC Comics, Image
CAREER HIGHLIGHTS: *Wolverine*, *Transmetropolitan*, *Conan*, *The Boys*, *Punisher: Born*
ONLINE AT:
www.darickr.com
www.flickr.com/people/darickr/
http://twitter.com/darickr

*"When my friends were going to keg parties and getting into college, I was **STAYING UP** until three in the morning **DRAWING** Space Beaver."*
—Darick Robertson

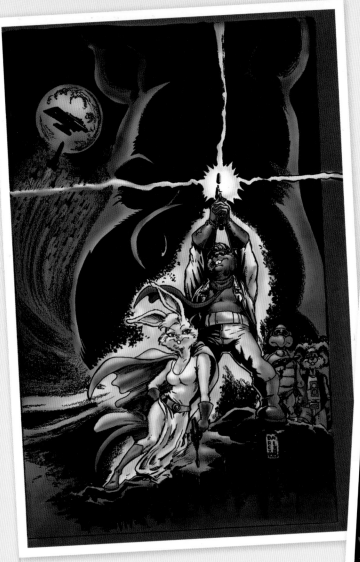

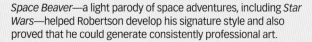

Space Beaver—a light parody of space adventures, including *Star Wars*—helped Robertson develop his signature style and also proved that he could generate consistently professional art.

and draw comics. I thought, 'If I can get my own little house or my own little apartment and draw comic books, I'll have really made it.' I've done way better than I thought I was going to do in those days as far as where I'm at with all of it now, but I didn't expect this. I just worked toward it."

Space Beaver was published originally by a comic store owner who liked Robertson's work. The Ten Buck Comic line published only one title—Robertson's—but it was a decent seller, running nearly eleven original issues, and a twelfth that was printed in the trade-paperback collected edition. But *Space Beaver* did more than

just generate money—it proved that Robertson could turn out professional-quality pages on a consistent basis.

PAYING THE BILLS AND PICKING UP THE BUSINESS

For several years, Robertson haunted the comic book circuit. He worked at fast-food joints to earn just enough money to buy art supplies and keep a roof over his head. "I used to go to conventions and sell sketches for ten bucks apiece, and I put a lot of work into those sketches, just so I could have gas money to get home from the convention sometimes."

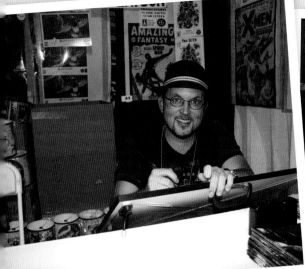

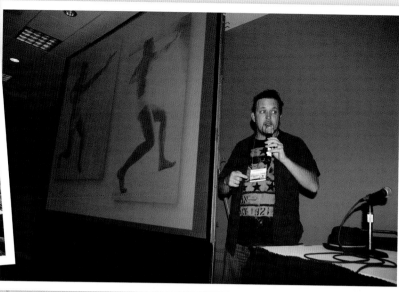

Robertson generating fan sketches at a convention. Despite long lines and complex requests, he works hard to create memorable sketches for fans.

Robertson at the Long Beach Comic Con in 2009, talking to aspiring artists about how he utilizes photo reference. Coincidentally, on the screen are photos from my book *Comic Artist's Photo Reference: Men and Boys*.

Robertson also worked at Diamond Comic Distributors, which was at the time one of several comic book distributors, and his local comic book store. This exposed him to the comics that were getting published each week, inspiring him to work harder at his own craft. "Really early on, I would go out to Diamond Distributors and I used to unpack books at like two o'clock in the morning off the back of a truck for Wednesday shipments—because I was up, you know, doing artwork. So I'd put down my pencil, get in my Pinto, and drive out to Hayward [California] and help them unpack books until five o'clock in the morning, and sort stuff for the next day," he says.

Putting in time in different areas of the industry, whether unpacking book boxes or working behind the counter at comic book retailer Tibor's store once in a while, gave the young artist a broader understanding of the business.

"I learned a lot about the retailing end of things, and then I worked out of the distributor, so I understood how the books come from the printer to the distributor, and the distributor has to sort them out into everybody's individual store boxes, and it was interesting!" Robertson says. "This guy's only ordering ten, but this guy's ordering fifty ... that guy wants more now, but he can't get them because he only ordered ten, and ... I kind of figured out how it all works and got

a really up-close view of it, even though it was sweeping the floors and sorting back stock."

He kept his artwork with him at all times, Robertson says, "because they liked comics too, obviously, so I'd show them what I was working on. And they were like, 'Oh, this is cool!'" He recalls a joke made: What if he finally someday got his big shot at Marvel, and they stuck him on something like *Dino-Riders*? Robertson's response would become part of his artist's philosophy.

"And I just said, 'Well, then I'm going to draw the best damn *Dino-Riders* comic I can!' You know? I thought about it and I thought, 'You could do a lot with *Dino-Riders*!' It's a cool comic if you handled it right," says Robertson. "And that's sort of been my attitude all along: It's not the material, it's what you do with it."

He cites Frank Miller's pivotal drawing and writing work on *Daredevil* as a prime example of how far a committed artist can take—or, in *Daredevil*'s case, rescue—a comic. "*Daredevil* was a joke when Frank Miller started working on it as penciller. And then ... they [Marvel] gave it to him [to write], like throwing him a bone; they didn't think anything was going to come of it ... Look at the incredible work that came out of that!" says Robertson. "But what if somebody had just sat around and went, 'Nah, Frank, you're a penciller;

FREAKSHOW

ISSUE 1 OF 3

TEEN & UP

SERVER · LANZING · SUITOR

can't recoup their money," says Robertson. "You gotta have all twenty-two pages ready to go, and they've gotta be at the printer when they're due; otherwise the train stops. And you can't pull that emergency cord unless you really need to."

He attended comic conventions to sell *Space Beaver* and to network, but also to get ongoing feedback from working professional artists. "I'd meet all these people—Art Adams, Erik Larsen—and I'd show them my work and let them, you know … I didn't like it, but I'd let them butcher it. I'd just listen as they tore it up," says Robertson. "Some people were nicer about it than others, but they didn't see any reason to take it easy on me. So they'd tell me what was wrong with my work, and I'd resent it and go home and prove 'em wrong! You know: 'I'll show them!'"

And he did show them. He continued to work on his side projects and improve his portfolio. After a few false starts, he eventually landed an opportunity to do some fill-in work at DC Comics. It was a small project, but it got him noticed by Marvel, who put him on *The New Warriors*. Recognizing the opportunity, Robertson leaned hard against the art table and cranked out *The New Warriors* for over two years, garnering a reputation as being a good heads-down, get-it-done artist. "It was a great time to be doing *New Warriors*," Robertson says, "because all the Marvel heroes appeared in it at one point or another, so I got to draw all kinds of different Marvel characters."

His reliability and enthusiasm led to several more significant projects, including his sixty-issue run on *Transmetropolitan* for DC's Vertigo imprint. Once that ended, Robertson sampled many different projects at both Marvel and DC.

I don't want you writing.' And what if Frank took 'no' for an answer?"

SCHOOL'S IN

All this time, Robertson was accumulating knowledge about both the creative and business ends of the industry. He took home lessons that would stay with him for years, particularly about meeting deadlines so that books would ship on time every week. "It costs people money if you're late. They can't sell your book if it's not printed. They don't have anything to sell," says Robertson.

And "almost done" never cuts it in comics. "If they've paid you X number of dollars to get twenty-two pages done and you've done eighteen, and they've paid you for those eighteen and they're waiting for those last four, they

He's one of very few creators who has had exclusive contracts at both Marvel and DC, a feat that's the Holy Grail for many freelancers. Being exclusive can often lead to plum assignments and, in certain cases, health benefits. For freelancers, health benefits can be quite expensive, so the exclusive contract is highly coveted.

THE PEOPLE RULE

The comics industry tends to attract a lot of enthusiastic people who are appreciative of the opportunity to create this unique form of entertainment. Unlike other businesses, people rarely fall into comics without seriously applying themselves and devoting significant energy to their craft. There may be certain careers on the business end that require advanced college degrees and outside work experience, but the artistic side is all about the final product. It doesn't matter what your background and pedigree are—if it's not on the page, it's not going to sell.

As such, most people who work in comics tend to express gratitude for their good fortunes. They're appreciative of the fact that a cash-paying fan base enables them to work on fan-favorite properties. Many creators know that they could explore careers outside the comic book industry, but choose to work here rather than advertising or commercial art. Comics are a choice, but it's hard work to remain actively employed in the business.

That said, the comics industry is a mixed bag of very different personalities. Business people mix with the creative folks, which can create friction. Nobody claims that working in comics is perfect. As for Robertson, "I like the people. Somebody posted on Facebook the other day a very true thing: It is probably one of the best industries as far as the people go."

Robertson also loves the strong community that's part of this business. "The thing I like most is the people and that, community-wise, there's a real community within comics," says Robertson. "I see that when someone gets sick; people rally around, giving them money or having some kind of an auction … Everybody kinda knows everybody."

On the flip side, the business is made up of many different people with different priorities. "What I like least? Same thing I don't like about most industries: Greed corrupts quality," says Robertson, and good ideas can get sidelined for compromised ones anticipated to be bigger moneymakers.

"It was a pretty depressing thing to have a shot to draw something I really wanted to do

DON'T JUDGE A BOOK BY ITS COVER ARTIST

The cover artist is often not the interior artist. Superstar artists on covers (or interiors) can bump low-selling books back into profitability (this is a business, after all). And they can push strong sellers over the top in terms of sales numbers. That's the power of the cover and the reason why top editors like Stan Lee and Joe Quesada always made sure they reviewed the covers of Marvel books.

Young creators often set out to become cover artists, only to find that it's not quite as easy as it seems to break into this coveted position. After all, being a cover artist seems like it would be a lot easier than, say, pencilling twenty-two pages a month. And in many ways, it is. But the reality is that many popular cover artists prove themselves as interior pencillers first, honing their craft and storytelling abilities over time while building a marketable fan base that helps them juice sales numbers of specific issues.

Look around at some of today's top cover artists. All of these top creators have been interior artists at one time or another, and many continue to do sequential work:

J.G. Jones • Amanda Conner • Brian Bolland
Alex Ross • Michael Avon Oeming • Frank Miller
John Byrne • Neal Adams • Joe Quesada

If your goal is to be a cover artist, work on your sequential art. Not only will you sharpen your skills as a visual storyteller, you will build up important editorial contacts and develop your personal fan base at the same time.

and have somebody else come back and say, 'Change it all, because we smell more money if you change it,' rather than saying, 'This is good, and what got us here was doing good work,'" Robertson says. "That was a very sobering reality, because then I had to realize, 'Oh, yeah, I don't own this. This is not my book. This is not my character. I do have to do this. I signed a contract to say I will do what you tell me to do.'"

DEADLINES TRUMP DAYS OFF

Like many of the professionals interviewed for this book, Robertson acknowledges that working in comic books can be stressful and challenging. After all, publishing is a deadline-driven industry that has dozens of different people working on the same product.

"Like right now, I'm in a position where I would like nothing more than to just take a couple of days off, but my circumstances are such that I just blew off my birthday like it didn't happen," says Robertson, who was too busy finishing up writing and drawing the Dark Horse Comics one-shot *Conan: The Weight of the Crown* to party. "I agonized over every stinkin' page because I really wanted it to be great … I got up at 7:30 yesterday morning and turned it in at nine o'clock this morning. I worked all twenty-four hours until it was done."

Time to celebrate, right? Wrong. You see, I happened to interview him the day he wrapped up *Conan*, and his mind was already on his next deadline. "I got about four hours of crappy sleep, I got up at quarter to two, I came downstairs here, and I'm drinking coffee and talking to you," he told me that day. "As soon as I get off the phone with you, I'm going to start inking *The Boys* #38 as fast as I can because they're waiting on those pages."

And, like many successful creators, Robertson is constantly being offered new opportunities, many of which he must turn down due to deadline pressure. At conventions, writers and publishers often approach his artist's alley table to offer him interesting creative projects. But since he's committed to current work, like Dynamite Entertainment's *The Boys*, he must make serious adjustments to his personal life to accommodate for dream projects, like his current work on *Conan* for Dark Horse.

Of course, Robertson remembers when he struggled to get his career off the ground. So, passing on dream projects can be, well, nearly

TOUGH CHOICES AND LATE NIGHTS

For most artists aspiring to break into comics, a pencilling job—*any* pencilling job—is a chance to show your talents. But what happens when work is too much of a good thing?

Say you're a young penciller who accepts your first assignment, which leads a Marvel editor to give you some try-out work on a second- or third-tier superhero title. Then DC asks you to do a fill-in book on, say, *Robin*. While you're working on that, Dark Horse emails you about doing a *Star Wars* miniseries. You love *Star Wars* and jump at the project.

Awesome, right? Well, yes and no.

Fans are starting to notice your work, but other editors are noticing that you can turn out pages pretty consistently. So, Marvel calls back. And instead of a third-tier superhero title, you're offered a *Fantastic Four* issue or an *Avengers* fill-in. And then DC calls and you're going to work on a *Justice League of America* one-shot.

Don't think it can happen? Think again. It happens all the time. Imagine you're the artist in this scenario. What do you do?

If you've already accepted the *Star Wars* miniseries, you have to complete it. Not only did you make a commitment; you're working with an editor at Dark Horse who may be your next editor over at DC. Plus, the industry is small, so if you bail on one project, everyone will know.

But what do you do? Turn down the *Fantastic Four* or the *Avengers*? Pass on *Justice League*? If you're like many creators, you're going to work like heck to do all of them. Forget sleep; you're in the big leagues.

Want to break into comics? Get used to crazy deadlines and late nights.

"I AGONIZED OVER EVERY STINKIN' PAGE

because I really wanted it to be **GREAT**."

—Darick Robertson

impossible for him. He approaches it in a Zen-like manner and with a good sense of humor. "I have a bad habit of overloading my plate and biting off more than I can chew, and thinking that just because I think I can, I can," he says. "And then reality sets in, and I know people are waiting. Meanwhile, I've got to figure out how I'm going to get nine pages of inks done, when nine pages of inks should take me nine days, [and] I've got two days."

It's a never-ending cycle of pages in, pages out. "I compare it to Sisyphus pushing his rock up the hill every day, and then it comes down the other side. Just the process of changing my circumstances is such that … that's a job in itself," says Robertson, who thinks taking on only the familiar in comfortable amounts will squelch the artist within. "Otherwise you're just staying in your status quo if you're not constantly pushing to try something new. I have to do the work to show that I can do the work."

Robertson's constancy—in both turning out good work and being on books that sell strong numbers—has opened new doors. He was recently given the opportunity to write and draw Conan, one of the all-time great fantasy characters.

"I wasn't getting a lot of offers to write stuff, but I just wrote and drew something, and it sold well," says Robertson, referring to the Conan issue he wrote and drew. "I did the *Conan* [one-shot] and it took me six months to get one issue done, but it's done and the orders are coming in and we outsold the monthly book, so … you know, that's good … I tried something, and it worked. And it's work I'm proud of."

Instead of taking on new work and facing overlapping deadlines, Robertson says, "I

Robertson's cover art for *Deadpool #51*, which I co-wrote with Jimmy Palmiotti. Robertson also handled the interior pencil art, which featured Deadpool's sidekick, Kid Deadpool (a.k.a. PoolBoy). The cover is a homage to the first appearance of Robin in *Detective Comics #38*.

could've said, 'Hey, I've got *The Boys*, I'll just ride this out,'" but "I love working on *The Boys*, and I don't want to lose that either, so meanwhile I'm doing the best I can to keep that on time."

Doing the work is what gets the work done. That's a common feeling among many of the top creators in the industry. The only way to have work published is to complete the work, turn it in and start the next project. Like Robertson, most top creators have a strong personal work ethic and an internal compass that sets them on their career path.

HAVE PEN, WILL INK

For many comic book artists the move from really good amateur to fully paid professional is the ultimate dream. And why not? Once you land that sweet deal doing pro comics, you can say

goodbye to compromise and hello to calling your own shots. No more dismal day jobs. It's just you in your PJs and the art table.

Well, not exactly. In fact, most artists—including Robertson—talk about the very real compromises associated with being a professional comic book artist.

Many people breaking into the business do not fully understand the assembly-line process associated with creating modern mainstream comics. It's a form of publishing, which means there are very real deadlines. The assembly line breaks up the process among many different people so that certain steps can happen in parallel, rather than in sequence. If one person is working more slowly, then another person must work more quickly to maintain the schedule of the book. It's a time-honored process, but it does set certain restrictions on individual creators.

Some professional artists are frustrated by the way an inker interprets their pencils. After all, the inker is an artist too, so there's a level of creativity that gets applied with a layer of India ink. In fact, many inkers bring their own personal style, which can significantly change the final appearance of the art. And even though it may be done by one of the best inkers in the business, the art is still changed. Typically, the penciller will not even see the final inks until the book is completed and published, which is disappointing for some artists.

When he first broke into comics, Robertson was producing *Space Beaver*. Not only did he draw the comic, he also wrote, inked and lettered it. This level of hands-on control enabled Robertson to exert nearly complete control over the final product.

Later, as he broke into mainstream comics, Robertson would offer to ink his own pencils. Despite his experience in inking, he discovered that not many pencillers were afforded that opportunity. In fact, he was actively discouraged by one of his editors. "I actually had a former editor at DC tell me once some of the weirdest advice I ever got: I was showing him the piece I wanted to pencil and ink, and he said, 'You don't ink!' And

it was when I was doing *Transmetropolitan*," says Robertson.

He handed the editor some of the *Transmet* covers he had inked himself, and said, "I really want to ink more, because I like to have more time with my work, more control over the finished work, and the more I do it, the better I'll get at it."

The editor's response? Don't do what you don't do. "And he said, 'You're a solid penciller; everybody likes your pencils.' And I said, 'But I do more things,' and he goes, 'Don't get all distracted by wanting to take on inking!'" says Robertson. "And I thought, well, that's the silliest thing I've ever heard. It's like Homer Simpson saying to Lisa, 'Well, you tried, honey, and you failed, so the lesson there is: Never try.' You know? That doesn't make any sense to me at all!"

Not surprisingly, as time went on, Robertson worked with dozens of different inkers. No matter what books he's drawn, Robertson's signature style shines through. Like many of his contemporaries, Robertson's pencils are distinctly his own. As he's matured as a creator, he's moved further away from the creators who influenced him in his youth into someone who is influencing the next generation of artists.

Despite this, Robertson's work definitely looks different under the shadow of a variety of inkers. Compare his pages on *Deadpool*, *The New Warriors*, *Spider-Man* and *Wolverine* with something like *The Boys*, which he inks himself. Inkers all bring their own art style to the page. Even inkers who do "tight inking" make some inevitable changes to the art.

At the time of this writing, Robertson was working his way through dozens of issues of *The Boys*, which started at DC Comics before moving over to Dynamite. It continues to be a strong-selling title that will likely keep Robertson pencilling *and* inking for several years. Even though his career is long from over, *The Boys* represents a personal artistic vision that enables Robertson to control the visual integrity of his published work.

TECHNOLOGY: THE ULTIMATE JOB CHANGER

Like many people who create comic books for a living, Robertson has seen technology change several elements of the business. In the beginning of his career, email and the Internet didn't exist, which meant that many artists had to move to New York. Marvel and DC Comics were both based in Manhattan, and that was how young creators could connect with editors.

Even though he was beginning to gain traction in his career while on the West Coast, Robertson moved from his life in sunny California to set up shop in Brooklyn. Even though it was challenging to pick up and move, Robertson knew it was important to make connections on the East Coast. "Living on the East Coast definitely got me my career at Marvel," says Robertson, who says he was in the right place—and around the

Robertson generated this powerful and moody variant cover art for Top Cow's *Witchblade #135*.

right people—when staff shake-ups occurred and opportunities arose.

"I got to hear what editors really thought because I was there. I'd come drop my pages off in person, and I'd have a personal relationship with the people that were actually publishing my book, which was very different. I'd go out and drink with these people and hang out with these people afterward," says Robertson, who became a visible presence on the New York comic book scene. "It's interesting to know them in person

Robertson has been the primary artist on the long-running series *The Boys*, which he co-created with Garth Ennis. *The Boys* is a mature, creative and engaging take on the super-hero genre.

and face to face because you hear things and you see things and you get a different perspective on what their lives and challenges are like. It's a lot of the reason I try very hard not to let anybody down. I know that somebody's job is in trouble if I'm not doing mine."

With his reputation for a solid, reliable work ethic, Robertson was able to move back to California with his family. But unlike when he was starting out, technology bridges the continental gap between him and his editors.

"It's better now. Technology makes it possible for me to basically create everything in-house. I don't have to FedEx as much," says Robertson. But with the conveniences modern technology affords comes the temptation to push beyond pencilling toward completion. "When I'm working with an inker and I've got to get them pages, it's sort of frustrating because I could be just finishing them up on my own scanner and putting

them up on an FTP server, fully inked and formatted and ready to color and letter, and I don't have to leave my house," Robertson says, "which gives me more time to actually get the work done and put more into the quality of the work, which is what I'll push the deadlines for ... mostly if I want to be better and better each time."

Even though he earns his career making a physical printed product, Robertson is enthusiastic about new technology. Like millions of others, Robertson embraces his Apple iPhone for his personal and professional life. "I'm still losing my mind over how this is an example of technology

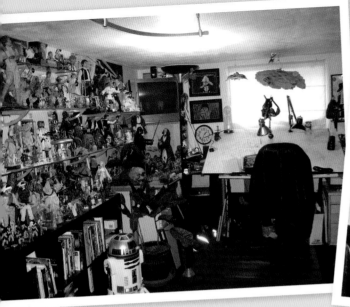
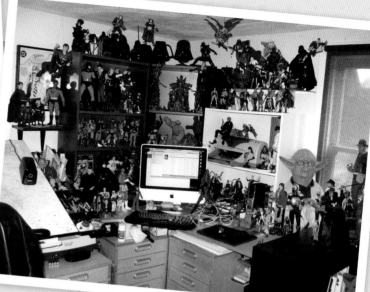

WATCHING OVER THE ARTIST AT WORK

Robertson is also a serious collector of action figures. His office is adorned with hundreds of action figures, many of which he has made by hand himself.

making life better for me as an artist," he says. Example: To make a valley scene in *Conan: The Weight of the Crown* more idyllic, he wanted to draw in some dragonflies—only he didn't have any references, until he Googled for images on his phone. "I had a high-res dragonfly on my iPhone within three seconds! Clicked it open, drew me a dragonfly! I just sat there drawing off my phone," says Robertson.

"That's, like, mind blowing to me. When I was a kid I had cardboard boxes filled to the rim with photocopies that I used to try to organize into a file cabinet, and it just took forever. And I would never have the energy to get up and look through all of it to find that one shot," Robertson says. "Or I had stacks of books—well, I still have stacks of books—I had stacks of books for reference. Just the fact that I can put all of that information on my phone that will also play me music and let me make phone calls? That's insane! And I can take photographs with it, and I can make high-res movies, all with this one device! That's what blows my mind."

In terms of communicating with the rest of his creative team, Robertson says email is the way to go. "I don't have to be awake at a certain time in order to exchange information with my editors on the East Coast. I can take care of things in the middle of the night, I can leave messages for them in the morning, I don't have to worry about the phone ringing when I'm asleep," says Robertson, who works with creators all over the world, including *The Boys* co-creator Garth Ennis, who lives in Ireland.

Before everyone was on email, people communicated with ancient devices like telephones, which were connected by cord to the wall. "In my twenties in my apartment, I used to sleep next to my phone that had a fax machine, and even if I went to bed at six o'clock in the morning and the phone started ringing at seven because it was ten o'clock on the East Coast, I'd answer. So I'm sure I had many conversations in those days where I was very bleary talking to an editor or whatever," says Robertson. "I couldn't afford not to pick up the phone. Technology has made that much easier. If someone wants to work with me, they get my email, I get their email, I can respond at my leisure. That's made a big difference. Communication is much more available. I can work worldwide now—and I have."

COMICS COME INTO THEIR OWN

Robertson is proud to be part of a business that today is having such a huge impact on pop culture, while still managing to remain in large part "a humble industry."

"I think the best thing I did was **SELF-PUBLISH**. You wanna do comic books? Then sit down and draw your damn comic book; don't wait around for someone to give you money or tell you how great it is. Do your damn comics and **GET 'EM OUT THERE**."

—Darick Robertson

"Comics have finally come into their own as far as the mainstream zeitgeist goes," he says. "It's a lifestyle now. Liking comics is no longer uncool. In fact, it's geek chic, which is going through its own little trend right now."

Comics are even getting their primetime due by way of the hit TV show *The Big Bang Theory*. The sitcom's main characters frequent their local comic book store—which Robertson is impressed looks like a real one—every Wednesday to buy new comics. "That was unheard of! You never saw that on a mainstream primetime sitcom, where people read comics," he says. "People want to know those characters. They tune in every week to be around these guys. So that fan has now become part of the zeitgeist."

But, says Robertson, even when the trends shift, the high quality of today's comics and many of the character-based movies coming out now will ensure that fans stick around. "I think there's great stuff coming out right now, and for once the stars are aligned for this industry, where we're getting all this attention, but everything's good! It's all good-quality stuff," says Robertson.

He's especially impressed with the way Batman (*The Dark Knight* in particular), Iron Man and Spider-Man have translated to film. "The stories are consistent, the character names are right, they've been cast well, they're directed well, the people directing the movies love the characters— and it shows!" Robertson says. "And then people can go to the movies and feel okay about liking superhero stuff. It's not so nerdy. Hugh Jackman [as Wolverine] is cool. So it's interesting that suddenly it's OK to like comics. So what we've all been aware of since our teenage years—I'm in my forties, and now it's OK to like what I like."

GETTING WHERE YOU WANT TO BE

At an early point in his career, Robertson was fortunate enough to have a strong mentor, who continues to be a voice of conscience in the back of his mind. Whenever Robertson considers a shortcut, he hears the voice of his high school art teacher Stanley Grosse, challenging him to do better. Grosse gave Robertson the best bit of advice he ever got, which was: "If you're going to be a cartoonist, be an artist; don't be a half-baked cartoonist."

"Every time I think, 'Ah, I don't have to finish this background; I can let it slide,' I'm like, 'That's being half-baked.' I have to really push—is this good? Am I being an artist? Am I living up? You know? That's probably the most education I got was from Stan, but Stan pushed me to take myself seriously and believe in my own work and practice," says Robertson. "It really comes down to that. The best school in the world is not going to make you produce. They might push you, and you might get a grade out of it, but if you don't want to create artwork, you're just not going to."

As for people who want to break into comics today, what advice would Robertson give? "It's so different than it was when I broke in that I have no idea how people get into comics anymore," he admits. "I would say self-publish; I think the best thing I did was self-publish. You wanna do comic books? Then sit down and draw your damn comic book; don't wait around for someone to give you money or tell you how great it is. Do your damn comics and get 'em out there. At least you'll have something in hand to show somebody [who says], 'Hey, what do you do?' 'I do this.' Boom. Show 'em. Hand them a stack of comics."

INKING: It's More Than Just Tracing

If the comic book industry formed a four-man rock band, the writer would be the lead singer and score half the hot chicks. The penciller would be the lead guitarist and get the other half. (Assuming, you know, they were into that sort of thing.) Off to the side, keeping the ever-important rhythm and beat, would be the drummer. The drummer would have to be the colorist, respected for the way he rocks the band with the perfect beat.

Then there's the inker, who would be the bass player in the group. Is there any more underappreciated musician? Despite the fact that the bass guitar gives rock songs depth and resonance, there's just not a lot of love for the bassist.

The members of the band know exactly what the bass player brings to the musical mix. And often more than anyone else, an experienced lead guitarist appreciates what the bassist can bring to the sound. The spotlight may shift back and forth between the lead singer and the lead guitarist at a show or in a video, but real musicians know that a talented, hard-working bassist is critical to the overall sound of their music.

Like bass players, inkers are often underappreciated artists who seem to fall just outside the spotlight. But in recent years, fans have come to realize what pros have known all along: Inkers are important.

HOW INKERS CAME TO BE

They're called inkers for a reason. They apply ink, right? Well, that's partially true. But there's quite a bit more to it than that. Of course, it didn't help that in the cult-hit classic *Chasing Amy* the inker was unfairly maligned as not actually being an artist, but rather a "tracer" who simply applied ink over a real artist's pencils (see sidebar).

In reality, inkers play an important role in the way comics are visually presented. And this is why they deserve your respect as essential creators, not "tracers" (which, by the way, is not a fresh joke to repeat to inkers; believe me, they've heard it).

In the early days of print production, comic books were viewed as juvenile ephemeral entertainment. Comics were to be consumed and discarded like sweet candy treats. Many of the artists themselves were relatively unconcerned about the overall quality and longevity of the published product. Indeed, even publishers were primarily interested in producing enough product on the least expensive paper just to give kids something to buy.

Cheap paper meant that there was little nuance in the printing process. Finely hatched lines were muddy and unreadable, bleeding together to make one smudgy image. As such, bold, clear lines became the best way to draw comics—not just comic books, but also the stuff in newspapers and magazines. And since delicate shading—the stuff that current art aficionados often love—was impossible, the weighted line became the way artists could suggest weight, light and curves.

A plain, flat line is just that: plain and flat. And in certain illustrations that's what the artwork requires. But the mind is smart, interpreting three-dimensional depth from a few two-dimensional visual cues. A stroked line that gets thinner and thicker can trick the eye into seeing depth. In the early days, comic book artists drawing figures in pencil could not render with enough pressure for the art to pop on the page, especially when color was introduced. Inks were applied to bring out the true line form, which also helped create a natural separation between

CHASING INKERS

Filmmaker Kevin Smith wasn't the first guy to jokingly refer to comic book inkers as "tracers," but he was probably the first to do it on the silver screen. In his 1997 movie *Chasing Amy*, the director included characters who portrayed comic book professionals, one of whom was an inker. In one scene, a young fan rudely referred to the inker as a tracer. For most people, it's just a line in a movie. But for people who know comics, it was a knee-slapper (now, over a decade and countless repeatings later, maybe not so much).

Oh, and if you're a fan of comic book movies and you haven't seen *Chasing Amy* yet? For shame. Not only is it rich with comic book references, it includes cameos by several comic book creators. Watch the DVD so you can catch glimpses of Joe Quesada, Michael Allred and even Kevin Smith himself, who went on to become a darn-good comic book writer.

colors, especially on costumed heroes with a brightly contrasting color palette.

Over time, this visual combination became not only a printing requirement, it became the aesthetic language of how readers expected to see comics. Consider for a moment the way Western culture reads text: left to right, top to bottom. Of course, this is the exact opposite in many Eastern cultures. In our traditional view, they read books backwards. It's the same with inked comic book pages: Our eye is accustomed to seeing a bold line and interpreting it as the binding of the image. Readers are familiar with a line that binds the drawing of a character or building, but those lines don't exist in real life, or typically on comics that have painted pages. It's part of the artistic

Spotlight: Rodney Ramos

JOB: Inker
LOCATION: New York, New York
YEARS IN THE INDUSTRY: 20+
HAS WORKED FOR: Marvel, DC Comics, Acclaim
CAREER HIGHLIGHTS: *Transmetropolitan*, *52*, *Green Lantern*, *Toe Tags*, *Gravediggers*

interpretation that we've come to expect on the page of a traditional comic book. Inked lines are a design element that readers subconsciously incorporate into the overall visual story.

There are some comic books that print pages right off the pencils. For some publishers, this may be a simple economic decision (one less creative person to pay). But for others, shooting off the pencils is intended to provide a slightly different visual experience, since people are so accustomed to reading comic pages that have been embellished with inked lines.

Many mainstream publishers recognize the incredibly important role that inkers play in the creative process. Talented, reliable inkers are often in great demand from editors and pencillers who know what they want to see on the page. In this way, inkers have evolved from being uncredited support staff to valued, respected professionals among fans and pros alike.

FALLING INTO COMICS

Rodney Ramos never really set out to be an inker, much less turn it into an ongoing career.

"When I started out, I spent most of my time just drawing from life and painting from life, working on illustrations … you know, like classic illustration pieces. Mostly how I fell into [comics] was purely by accident," explains Ramos, who has worked on hundreds of comics, including *Transmetropolitan*, *Green Lantern*, *Batman* and *52*.

Like many young artists growing up in the New York metropolitan area, Ramos was fortunate to discover many interesting artistic opportunities and resources. While attending art and design school in New York, Ramos began taking morning and weekend art classes, where he met Mark Texeira. Texeira (or Tex, as he is known by many fans) worked for DC Comics as a penciller at the time and took the young Ramos under his wing, helping him to accelerate his art education with real-world experience. This experience would include supporting Texeira on comics he was pencilling. As an assistant, Ramos would assist by adding background pencils and other detail to comics like *Ghost Rider* and *Warlord*.

Tex also exposed Ramos to Marvel Comics' legendary team of correction artists known as Romita's Raiders. This elite group of aspiring creators was tasked with making corrections on comic book art, since (back then) returning art to pencillers and inkers was time and cost prohibitive. So, under the watchful eye of the venerable John Romita Sr., these art apprentices would work in the Marvel offices for six months to a year and be exposed to all types of comic book art. Artists working for Romita would often be called upon to do minor art corrections, like fixing a hand or face that didn't look quite right. These artists not only improved the final published comic with their minor tweaks and details, the group also served as a farm team for Marvel's next generation of art talent.

Rodney Ramos never really set out to be an inker, much less turn it into **AN ONGOING CAREER.**

It was considered a great opportunity and privilege to learn directly under Romita, and many professional creators began their careers this way, in the Marvel Bullpen. Because Ramos showed early talent, he was able to get training under Romita at a very young age.

But comics is a tricky business to get into, and Ramos almost pursued a job outside the industry just to survive. "I've had opportunities to work doing advertising and doing whatever, but comics saved me. I could have been working in the post office for the last twenty years, which is what almost happened," says Ramos. At age eighteen he applied to be a postal clerk and got the job, but luckily for comic book fans everywhere, he never made it to his first day. "I had just shown my stuff to John Romita and I was waiting, and I didn't think that was going to happen. So ... I'm sitting in my parents' house and the phone rang," explains Ramos. "And [his mother] says, 'There's some guy named John Ro-might-a from Mar-val...,' and I'm like, 'Whaaa?' I run over to the phone and it's John, and he's like, [funny, gravelly voice] 'Hey kid!' I'm like, 'John?' and he's like, 'Yeah, listen, the spot's open for Romita's Raiders. It doesn't pay much, just minimum wage,' and I'm like, who cares? He said, 'If you still want the job, come in on Monday.'"

Ramos did go in and worked hard at the job. The exposure and experience opened new doors for the young artist, who hoped to leverage his talents into becoming a penciller or even a painter. "I ended up inking by accident. I ended up inking some stuff, and then I got an issue of *Punisher* to ink. I wasn't the greatest of inkers at the time, but I remember [comic book artist and inker Josef "Joe"] Rubinstein saw it and he said, 'You know what? You kinda missed your calling as an inker. You've got some stuff coming there. There's something there,'" says Ramos. "So I started taking more ink work, and I went from there, just kept inking stuff. I started at Marvel pencilling for a couple of years, and then I went to Valiant and pencilled for a while, and it wasn't until after Valiant that I started really shooting for the inking stuff. I just kind of fell into it."

For a guy who fell into inking, Ramos takes his role seriously. He recognizes that inking takes time, dedication and artistic talent. "If you're an inker, you're an artist. You should be able to draw everything. You still have to understand what you're doing as an artist. When you sit down with another person's piece of art, you have to be able to understand what they were doing drawing-wise to ink it," he says.

Knowledge beyond the pencilled drawing is key. "You can't sit there and say, 'All right, I'm going to ink this figure,'" says Ramos. "If you don't have an understanding of how the muscles work or how clothing flows over a body, you can put down lines that make absolutely no sense. You have to have an understanding of structure; you can't just draw the figure in any form or way, willy-nilly. You have to understand anatomy; you have to understand lighting; you have to understand composition, understand how things work in a panel."

TWO SCHOOLS OF THOUGHT

According to some popular artistic theories, there are two ways to approach inking over pencilled art. The first is for the inker to remain true to the penciller's linework. For the most part, this can be the safest route for the inker, especially if a penciller delivers tightly rendered pencil lines, with shading and line weights already indicated. There are pencillers who prefer this conservative approach to inking. Certainly, if they are looking for a very specific artistic look and feel, their inker can help them achieve that clearly articulated vision.

The other popular approach is for the inker to add an extra layer of artistic interpretation. This, of course, changes the final artwork into something that's more interpretive and collaborative, but nonetheless different. For many working professionals, this extra layer of interpretation is actually encouraged and welcomed. The artistic values brought in by an experienced inker can take the final art in new and creative directions. Many inkers are actually sought out by professional pencillers because of their artistic and creative input on the artwork.

Like many professional inkers, Ramos makes many **LARGE AND SMALL DECISIONS** regarding the artistic look and feel of a particular comic. According to Ramos, a professional inker **MAY EVEN NEED TO CORRECT** minor anatomical problems with the artwork.

Some talented inkers can approach from either direction, sometimes matching styles for a particular project. Either way, inkers are often recognized and celebrated for the visual contribution they provide to a given piece of art. Fan publications often show artwork in various stages of completion, which highlights the style in which the inker approached the particular page.

MAKING CHANGES (OR NOT)

Like many comic book creators, most inkers are freelancers. So they get their assignments from an editor, who typically matches the best talent for the project. Ramos receives most assignments over the phone or by email. Typically, pages are mailed to him with some instructions on deadlines and occasionally artistic direction. Inkers usually communicate with the editor on specific questions, rather than talking directly to the penciller. This helps the editorial team maintain control and clarity of the project.

Like many professional inkers, Ramos makes many large and small decisions regarding the artistic look and feel of a particular comic. According to Ramos, a professional inker may even need to correct minor anatomical problems with the artwork. "Sometimes I'll get pages and go, 'OK, this hand isn't right, I'll fix it a little bit,'" he explains. "I try not to change too much, and I try to keep to the style, but if something's quirky, I'll try to change it."

While some inkers would be happy to fix minor details in the artwork, because the comic book industry is largely a freelance business, not all inkers can take the time. Professional freelance artists must maintain a fairly consistent and rigorous schedule to earn a living (plus, many of these people pay for their own health insurance), so a steady flow of pages coming in and going out can be essential for a freelancer's financial health but leaves precious little time to dwell on projects.

When it comes to inking and correcting anatomy, "the job takes longer, and that's bad, particularly when you're under a deadline," says Ramos. "So I don't really like to make the changes unless it really is bad anatomy and it doesn't work with the style."

Many artists exaggerate or distort images for a specific visual effect. That is, it may not be textbook-perfect anatomy, but it works on the page. Ramos views the art holistically. "Some artists just have that kind of a style where you look at it and you go, 'This works for what it is,'" says Ramos, "and you don't have to make changes to it."

THE DREADED D-WORD

Just like any part of the publishing business, the comic book industry lives and dies on deadlines. Miss a deadline and it could cost a

Near the end of Acclaim (formerly Valiant), the company experimented with different non-superhero projects, including their crime line. Ramos worked with writer/artist Mark Moretti on the *Gravediggers* crime-noir comic miniseries.

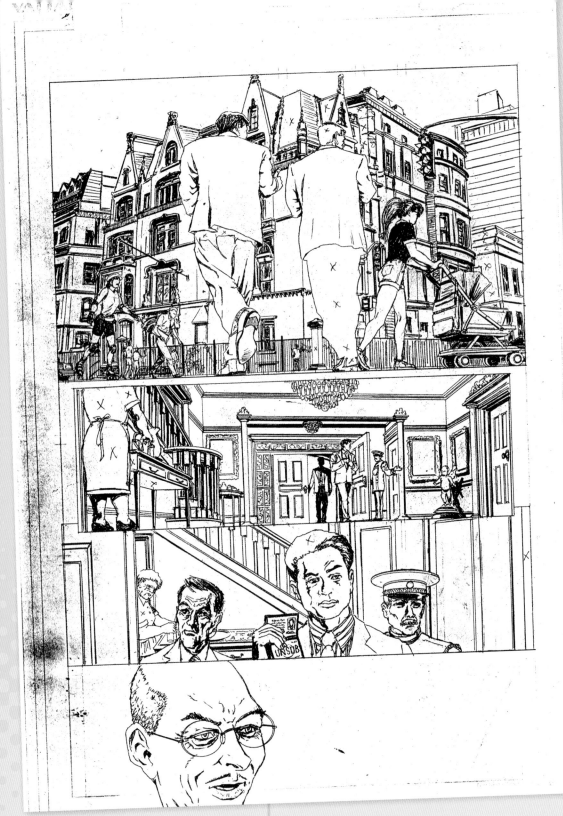

GETTING THE INKS IN SYNC

Ramos adapts his inks to the style of the artist or the project. His realistic and textured ink work on *Gravediggers* was intended to highlight the realism of this crime-noir miniseries with Mark Moretti.

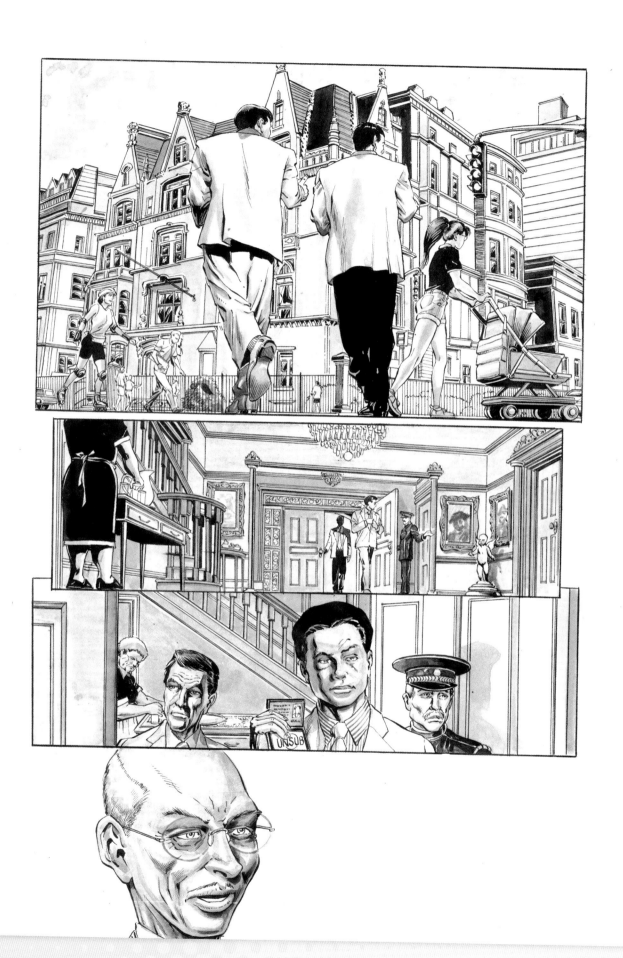

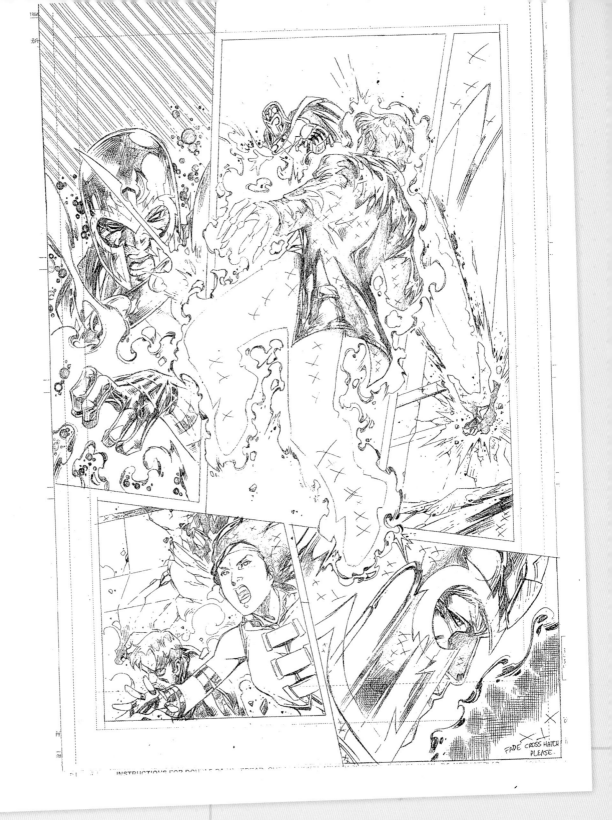

"X" MARKS THE SPOT

In *X-Force #95*, Ramos inks over popular artist Jimmy Cheung's tight pencils. To understand how pencillers communicate to inkers, check out the small note at the bottom of the pencilled page. Sections with a small "x" indicate where the artist wants solid blacks inked on the page.

X-Force #95, page 12 ™ and © Marvel Entertainment, LLC. Used with permission. For more on *X-Force*, visit www.marvel.com.






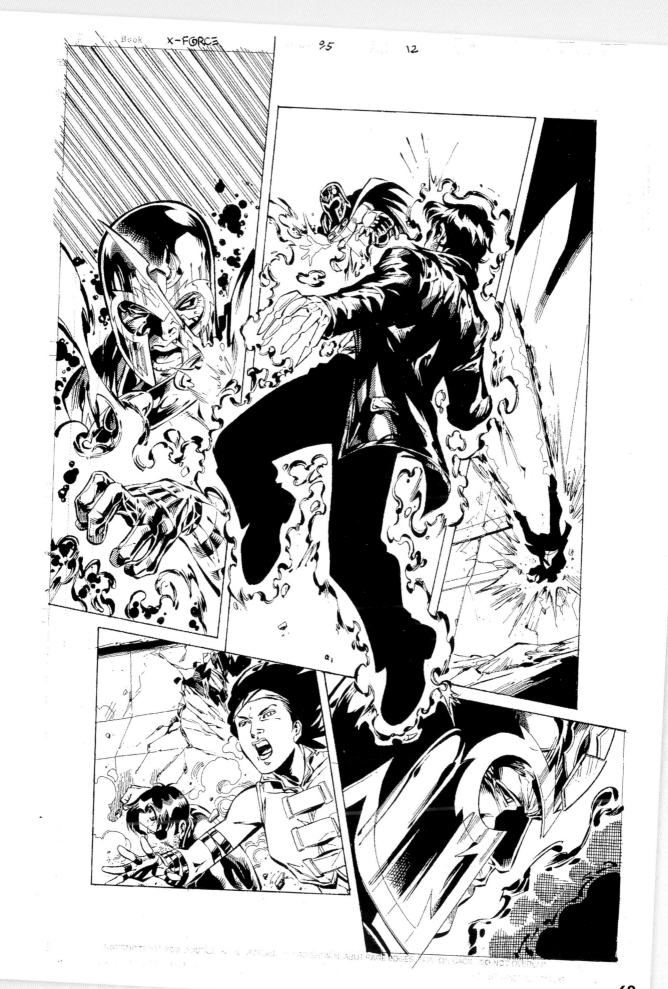

AN INKER'S TOOLS

Inking tools change according to the needs of the project. "One book could be brush, one book could be quill and brush, one book could be a mix of whatever it is that's going to work to capture what they're doing," says Ramos, whose tools of choice are shown. Rapidograph pens are good for straight-edge lines on backgrounds, such as for buildings and cars. Ramos favors Kolinsky sable brushes, which he uses for linework and large areas. These brushes can give a fluidity that's organic or structured. "It's very flexible depending on how you use them," he explains. Crow quill nibs come in different types, either flexible or rigid. "They are very good for linework and textures on everything organic, such as figures and landscapes," Ramos says. Erasers—kneaded and hard—are good for general erasing and cleanup on the pages. Rulers and templates with circles and curves are useful for drawing a good mechanical line for backgrounds or anything that has a structured shape.

publisher significant sales by setting in motion a domino effect that knocks more and more deadlines off track.

Inkers are sort of plopped in the middle of the entire process. By the time they receive their portion of the work, the comic has already been written and edited and then sent off to the penciller. These primary steps can take weeks to months in the overall life cycle of the project. When the inker is called in, it's usually pretty clear if the book is running on time or if it's in danger of being late.

"But no matter what it is, whatever project it is, you have accepted that deadline and you have to produce that stuff when you told the person you were going to produce it," Ramos says. "Because that book has to make it to the printer, and everybody on that assembly line has to be able to finish their job. You have to remember that there's a colorist behind you who has to get

pages so he can get the book out on time and doesn't end up having to rush too much either. It still has to go through final approval with the editor and production before the final file is sent out to the printer, printed up and sent to the stands."

Like other artists in the workflow process, inkers may even be asked to work extra fast or extra late to help maintain a deadline or to get one back on track. "You're in the publishing world. The book has got to get out," says Ramos. "I kind of prided myself while I was doing my regular work that if I had time and could lend a helping hand, I'd take a few pages and help get a certain book out on time."

Pressure comes with the territory. "There were times when I was doing emergency jobs helping out, and I'd get pages and the book would be due in the stands next week—literally the next week, which is insanity," Ramos says. "No book should be produced under such crazy pressure, but they are. It's going to happen every now and then."

Ramos describes an all-too-common scenario in comic book publishing. "You get a call: 'Hey,

> "It's up to freelancers to understand their limitations when something occurs and to have the strength to be able to call up the editor and go, 'Look, I'm not going to be able to make this deadline.' **AN EDITOR WILL LOVE YOU TO DEATH** if you're more honest with him and you keep in touch with him than if you avoided that phone call."
> —Rodney Ramos

I've got three pages, can you help out on a couple of pages?' 'Sure.' Then you get another call: 'Hey, I've got this thing that's running a little tight. Can you help out a little bit, as long as it doesn't interfere with your regular book?'" says Ramos. "And I'd say, 'Yeah, I can fit this in.' There are times when you can do a lot of work and not even blink twice. There are times when you slow down a bit and you don't try to overload yourself. You know what you can handle."

For Ramos, this type of pacing is all part of the overall professionalism required to be a good freelancer and team member. "Professionalism to me is you do a good job, you have fun with it, try to bring something new to it, or you try to bring something that is solid and fresh to it," he says. "But other times professionalism means making your deadlines—seriously making your deadlines. If you can't make a deadline, you're no use to anybody."

Many cannot handle the pressure of working on comic book deadlines. They may accept a project, but realize soon that it's not going to be completed on time. Communications with the editor, according to Ramos, becomes hugely important. "Somebody might get sick, or somebody just can't finish the job, or somebody's having a hard time ... It's up to freelancers to understand their limitations when something occurs and to have the strength to be able to call up the editor and go, 'Look, I'm not going to be able to make this deadline,'" Ramos says. "An editor will love you to death if you're more honest with him and you keep in touch with him than if you avoided that phone call."

INK ON THE HORIZON

As the industry continues to evolve toward a more digitally based future, inkers like Ramos are considering how their role will need to morph to match the trends. The obvious answer would be for inkers to begin inking digitally, but that's not quite as easy as it might seem. Unlike other parts of the creative process—like coloring and lettering—digital inking has not evolved with the latest computer hardware and software.

The reality is that the inking process is dependent on how much detail the penciller includes on the page. Many pencillers are highly specific about their lines, line weights and shading. These are the kinds of books that are better suited for a digital future. It's already possible for trained artists to find the lines, ink them effectively and prepare the book for the next stage.

Yet many pencillers are aware that the inker, a fellow artist, will help enhance their pages with inks. So they may leave some things up for interpretation. Plus, the penciller can work faster, knowing that someone will be shading in areas of black or helping to add line weight around figures and other forms. Without this creative partner, the penciller may have to spend more time creating clear, dark lines that will be picked up by the digital art team.

So as publishers look to speed up the process and lower creative costs, digital inkers are experimenting with different computer-based techniques that will maintain the quality of work that is required to sell professional comics. As with lettering and coloring—and now, to some degree, pencilling—the pioneers of digital inking will soon develop creative and commercial techniques that force evolution in the art of inking. ❥

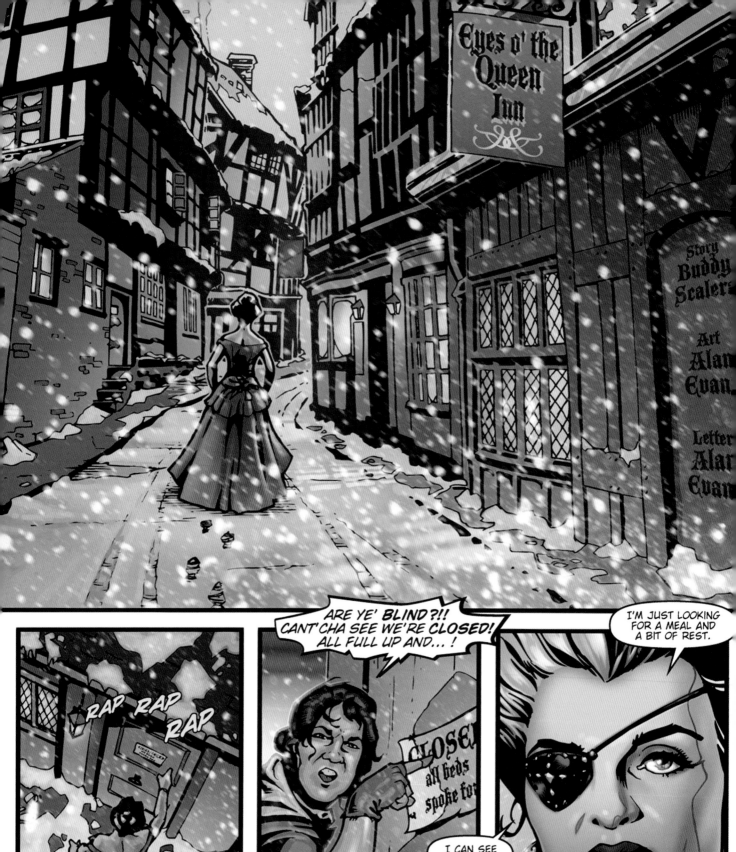

LETTERING: Getting in the Last Word

In the most basic, straightforward description, a letterer places the words on a comic book's pages. Letterers migrate text from a script to the comic book page, where readers view the words on the page and "hear" the story in their head. Lettered words may include dialogue, captions, sound effects and other auditory representations, and comes in standard containers we're all familiar with: word balloons, thought balloons, caption boxes, sound-effect forms or other visual elements.

As people become familiar with the visual language of comics, they are able to understand the way the actual words should be interpreted, that is, "heard" in the context of the story. This shared visual language enables writers to convey sound in the print medium.

Which, if you think about it, is pretty amazing.

So why aren't more letterers hailed as amazing? Sure, they don't write the stories, but their work absolutely affects how stories are read. Their artistry may not be as flashy or obvious as what you see in the pictures, but their abilities (or lack thereof) can help make or break your comic book reading experience.

If you've ever seen a badly lettered page, then you know how important it is to do it right. A good letterer will place balloons strategically, as to guide a reader's eye across the page to enhance and support the visual storytelling. A good letterer will gradually unfold a great story—and, if he's doing his job well, you won't even notice he's there.

WORDS ON A PAGE THAT YOU'RE NOT SUPPOSED TO NOTICE

Words are a visual code that we are taught when we are very young. The alphabet is simply a series of shapes that represent a language concept.

In most writing, words are given fairly straightforward treatment on the page. That is, a headline is larger than the body text. The body text is generally of uniform size and spacing, which strips away distractions. This grid-like layout makes it easy for people to absorb large and small bodies of text.

In comics, the words are part of the visual story. Words may be presented in grid-like lay-outs, but they rarely follow a rigid flow. Instead, words are placed strategically and artistically to complement and guide the flow of the artwork. To maintain narrative integrity, containers bind the edges of the text.

Over time, a visual shorthand has developed, enabling readers to subconsciously understand the "sound" of the words.

All of this is part of the craft of lettering, which is like writing—but not exactly. You see, writers write. They tell the story, which usually involves words and pictures on a page mingled together to articulate a story. We call these people writers, which makes perfect sense.

Let's start from the beginning. Writers write their stories before the stories are drawn. They often write them on a computer and then send the story off to the editor, who gives it to an artist. The artist interprets and draws the story. It all makes sense up to here, right? Writer writes, editor edits, artist draws.

After the art is sufficiently complete, the letterer then takes certain parts of the story script and puts it on the comic book art. That task is NOT—I repeat—NOT writing. It is the process of transferring basic, unformatted text from one medium (the computer screen) and making it art on the comic book page. And although it's not creative the way a writer is creative with a story plot or dialogue, it is creative in the way the words interact with the other artwork on the page.

Let's step back and compare comics with other forms of printed media. In books, the text is not really part of the art. The idea is to find a text size and font that is pleasing to the eye so that readers can breeze through a page with the least amount of effort. The font may vary based on certain story needs. For example, text may be italic or bold to stress certain words. In other cases, certain words may be larger, especially at the beginning of a chapter or for a title. But, for

BALLOONS SPEAK VOLUMES

A standard word balloon may indicate someone just talking, but the size and design of a balloon and the words within say many different things to the reader.

the most part, books and magazines follow a rigid, line-by-line flow that remains fairly consistent throughout the story.

Now, stepping back to comics, we use the same letters of the alphabet to form the same words. But in comics, words are part of the visual story. We are not bound by a rectangular grid, like in a book or magazine. Our words are free to move about the page (as long as the "unfasten seat belt" sign is lit). Although they are not part of the drawn artwork, they are certainly part of the artistic presentation of the comic book story. And this is why we have letterers.

Letterers help tell the comic book story. As noted with our sound-effect examples, we need letterers to help interpret the writer's words. That's because writers may be good at telling a strong story, but that doesn't necessarily mean they will be good at making the art on the page. So the writer relies on the visual artists—including pencillers, inkers, colorists and letterers—to visualize the story.

As an artist, the letterer makes key decisions about how to structure the word balloon, where to place it and how to break the lines. From the outside, it may not seem like much, but it is an integral part of a comic experience. Don't believe me? Just compare how a page of comic art looks when it is lettered in a software package like Microsoft Word or one of those cheap "make your own comic" software applications. It looks funky, but not in a good way.

Like other artists, letterers have a style that sets them apart from other lettering professionals. As a casual reader, it may not be obvious to you—and with advances in digital lettering, it's becoming harder to discern different styles. But they do have styles, and it is not unusual for writers and pencillers to request a specific letterer. The letterer can help bring a specific look and feel to the complete package, so the creative team will often work closely with the editor to select the correct letterer for a book project.

THE INVISIBLE LETTERER

In an industry where everything is about getting noticed, Chris Eliopoulos is trying his best to go unnoticed.

Ever since Stan Lee declared the *Fantastic Four* the "World's Greatest Comic Magazine!" virtually every comic book published has been mugging for the spotlight. The newsstand is crowded with splashy covers, splashy splash pages and even splashier hyperbole.

And no wonder. With hundreds of comics to choose from each week, it's imperative to grab the

THINKING OUT LOUD

A thought balloon may indicate someone having an internal dialogue. Outwardly no words are spoken, but there's certainly a "voice" to those words.

MEANWHILE, BACK AT THE RANCH...

A caption may offer some narrative guidance. In many cases, nobody in the story is saying the words, but the information is important to propel the story forward. Without the caption, the writer may not be able to effectively tell the story.

SOUNDS YOU CAN SEE

A sound effect is a visually significant artistic interpretation of an auditory event.

fleeting attention of the average consumer. In the world of comic book retail, hooking readers with an eye-catching cover can mean the difference between skyrocketing sales and cancellation.

So with all this pressure on getting noticed, why does Eliopoulos take pride in being unnoticed? Because he's a letterer.

"If people are paying attention to the lettering," says Eliopoulos, "you're not doing your job right."

So, as noted earlier, lettering isn't about reminding people that they're reading a comic book. Good lettering allows the reader to become absorbed by the story. "My job is to be invisible and just help the writer and artist tell the story they're crafting," says Eliopoulos.

As an example, Eliopoulos references the movie theater experience. If the audio track in the theater is too loud, it may distract you from the actual movie, which would be counterproductive. So it is important that the projectionist set audio outputs to the appropriate levels, which will help people concentrate on the actual motion picture.

In lettering, the letterer must strike the right balance on the page, so that the reader can focus on the story. "When things look easy, that's usually because the person who's doing it has worked so hard, they make it look easy," says Eliopoulos. "You have to really buckle down and learn the craft. Lettering is deceptively simple. People think you throw a typeface on the page, you break it up into lines, you put a circle around it, you point a tail to somebody, and it's fine. In some places that works out fine, but when you learn the craft, going beyond and being artistic and seeing beyond just the simple typefaces is the 'art' of it."

In comics, the letterer will place the appropriate size word balloons, with the correct font, with the right spacing, with the right font size, with

the correct lettering container, with the tail pointing to the right character, juxtaposed on the optimal section of art. Follow all that? Good, because that's not all.

The letterer typically does this with multiple word balloons on multiple panels over multiple pages. On deadline.

Does it sound stressful? Well, that's because, like most jobs in comics, it can be.

As with most talent-dependent projects, comics can easily fall off schedule. It's not unusual for an editor to manage multiple creative professionals in different parts of the world. Any number of variables can play havoc with a deadline, so the editor must find ways to get a comic book schedule back on track.

Letterers are often the ones called upon to help make up for lost time so that a comic book doesn't miss a shipping date.

"Sometimes books are late, so you can have a bunch of people lettering the same book," says Eliopoulos. "In the old days, that was verboten. In a last-ditch attempt to get a book out on time, you might use a couple of different letterers."

To the casual comic reader, it may not be obvious, but every letterer has a style to their hand-lettered work. So this breaks the first rule of lettering, which is not to be noticed by the reader. When lettering shifts, even slightly, readers may pick up on the subtle change. This can break the flow of the story, taking the reader out of the narrative and back into the real world.

Computers and technology have helped make it easier for multiple lettering professionals to work on the same comic at the same time. "We had to letter one book overnight," recalls Eliopoulos. "I had four people letter five pages each. And since we were using the same font, it all pretty much looked OK."

Before everyone had a computer, comic art was shipped around the country, usually by FedEx or UPS. Long-established pros will admit that there was a bit of anxiety as original art was packed up and shipped, since packages can

sometimes be lost. Many pros scanned, faxed or photocopied pages between stages, but that could be time-consuming.

Now almost every comic book page is scanned and shared with the creative team over Internet connections, specifically FTP. New production processes mean that the publishing cycle has become much more efficient, shaving days and weeks off schedules.

Technology advances also mean that writers often get an extra look at pages before print. "Now, the writer and the editor have the ability to keep tweaking this book until the story is exactly what they want," says Eliopoulos. "As a storyteller, I think it's a good thing. It means you have the ability to put out the best product you can put out. Computers and lettering on the computer have helped writers do better work."

LETTERING BEFORE AND AFTER COMPUTERS

In the early days, comic books were hand-lettered. That is, it was done by a person who actually used a writing tool to draw word balloons on a page. Today this seems like a relic of the past, but the past isn't so distant that most of today's working pros don't remember it.

Check out original art from the mid to early 1990s and you'll see that hand-lettered word balloons have been either placed on original art or drawn directly on the page. Either way, the letterer probably used a specially designed tool called an Ames Lettering Guide. In the most basic sense, this little tool is like a ruler that enables letterers to draw line heights consistently, so that all of the words are the same font size.

If you have access to older original comic book art, go back and look closely at the pages. Usually there are faint pencil lines that indicate where the letterer drew the lines with the Ames Lettering Guide. Close inspection will also usually reveal dabs of white correction fluid.

To get a better sense of how challenging lettering can be, it's helpful to try hand-lettering a project yourself. You don't need anything more than a comic book and some paper to get started.

Spotlight: Chris Eliopoulos

JOB: Letterer (writer, penciller, inker, colorist)

LOCATION: Northern New Jersey

YEARS IN THE INDUSTRY: 20+

HAS WORKED FOR: Marvel, DC, Valiant/Acclaim, Wizard, Black Bull, Image, Dark Horse

CAREER HIGHLIGHTS:

- Owner of Virtual Calligraphy, one of the leading lettering suppliers for Marvel Comics
- Letterer of 106 consecutive issues of *Savage Dragon* (Image Comics)
- Designer of many industry fonts and comic book logos, including logos for *Savage Dragon*, *Venom*, *Guardians of the Galaxy*
- 2002 and 2003 Wizard Fan Award "Favorite Letterer"
- 2007 "Best Letterer" Eagle Award
- 2008 "Best Letterer" Harvey Award, for *Daredevil*

ONLINE AT:

www.desperatetimes.com

www.miserylovessherman.com

http://twitter.com/eliopoulos

Open to the first page and start to read the word balloons. As you read them, write the same word balloon on a separate piece of paper in the same approximate place on the page that it appeared inside the comic. Do this for all twenty-two pages of a comic book, and you'll see just how difficult it is to maintain a consistent size and font for your lettering.

Lettering has evolved over the years. Very early comics were clearly lettered without guides, which is why the font sizes on very old comics can vary significantly. But as modern techniques improved, so too did the control letterers had over their artform.

In the early 1990s, personal computers became more affordable, as did many software packages. New forms of design began to rise from this digital revolution, including desktop publishing. The desktop publishing revolution meant that artists and non-artists alike could access tools that would enable them to create professional designs for everything from newsletters to magazines and beyond.

As computers became cheaper and more powerful, many people in the comics industry took advantage of these new techniques. Despite the efforts of several trailblazers, computer lettering didn't catch on immediately. Often the digitally lettered comic book looked stiff and unnatural. It drew attention to itself in the way that drew the reader out of the story. It stood out for all the wrong reasons.

But over time, several innovators, including Eliopoulos, worked tirelessly at improving the craft of digital lettering. There would always need to be an art to lettering, but these innovators recognized the power of computers to streamline the oftentimes tedious process of lettering a comic book page. Looking back at the path from hand-lettered comics with Ames Lettering Guides to digitally lettered comics seems obvious now. It's like, "Of course we use computers to letter comics," but it wasn't always like that.

Now the Ames Lettering Guide is used in spirit, but not necessarily in practice. The concepts remain, but the tools have changed.

FONT MAKERS

Fonts have existed for many years, but it was the job of a mechanical typesetter to set up printed documents, including newspapers and books. These days, most fonts are created and maintained on the computer. Many comic books are lettered with fonts that are based visually on hand-lettered fonts.

Most computers come with a variety of pre-installed fonts. There is even a comic-bookish font called Comic Sans that comes with Microsoft Office. Despite being visually similar to comic book lettering, most professional letterers use customized fonts. Many of these proprietary fonts are created in the publisher's offices, so that their comics have a specific and distinct "house style" that doesn't look like it was part of a common software package.

FROM COLLEGE TO COMICS

Both Marvel and DC Comics have rich, hands-on internship programs. Many area colleges and universities participate in work-study programs for people interested in the comics industry, including the Fashion Institute of Technology in New York that Eliopoulos attended in the early 1990s.

As he does with many of his personal anecdotes, Eliopoulos brings a humorous twist to how he broke into the comics business. "There were advertising agencies where people had to dress up in suits and deal with corporate America," says Eliopoulos. "I walked into Marvel and a guy walked by wearing a ripped T-shirt, ripped sweats and flip-flops, and I went, 'Oh God, I've gotta work here!'"

As an advertising and graphic design major, Eliopoulos's portfolio featured art and designs that were created for class assignments. But Eliopoulos had a passion for lettering designs,

which caught Marvel's eye. "In college, I learned type design, the kerning—meaning the space between letters—what works, what doesn't, what to look for, how to make it better," says Eliopoulos. "They brought me in for the internship, and before I was even two weeks into the internship, they started giving me paying freelance work in the production department."

During those formative months and years, Eliopoulos was an avid student of typography. In fact, he still is today, noting that he carries a small digital camera around with him to photograph interesting signs and logos so that he can study them later.

"I hand-lettered books, and when you're doing ten, fifteen, twenty pages a day by hand, with a pen and ink, you learn to look at the type that you create as form, not as letters," he explains. "What develops over time is the ability to see … and to artistically graft … your thoughts onto the page."

Immediately after graduating, Eliopoulos had a job in the lettering department at Marvel working for senior letterer Kenny Lopez. These early experiences in the production department taught him key lessons about professionalism and respect for deadlines.

FROM STAFFER TO FREELANCER

In the industry—and in the pages of this book— there's a lot of talk about professionalism. Like

WANT TO BREAK IN? GET FIT!

Comic artists considering a college career may want to try getting into FIT. No, I didn't say "get fit." If getting into comics meant getting physically fit, we'd lose a lot of great comic creators.

FIT stands for Fashion Institute of Technology, located in the heart of New York City. Before you write this off as a school simply for clothing designers, consider the comic artists who graduated from FIT. Along with Chris Eliopoulos are many other distinguished alumni, including:

Billy Tucci—creator of *Shi*, writer/artist on *Sgt. Rock*, publisher of Crusade Fine Arts

Sean Chen—artist on *Iron Man*, *Wolverine*, *X-Men*, and many more

Bernard Chang—artist on *X-Men*, *The New Mutants*, *The Second Life of Doctor Mirage*, *Superman* and more

others, Eliopoulos references the freelancer's "triangle."

There are many variations on this triangle, but they all come down to a similar concept. Specifically, an editor who hires a freelancer can usually get two of three things out of a freelancer. If the three points are Good, Fast and Cheap, then they have to choose two. They may get three, but it usually comes down to a combination of two. If

AN ALL-NEW COLLECTION OF THE HUMOR COMIC!

Although probably best known for his award-winning lettering, Eliopoulos has built a large, enthusiastic audience for his comic strip work. IDW Publishing published a collection edition of his popular *Desperate Times* strips. Learn more at http://www.miserylovessherman.com.

Desperate Times © and ™ 2009 Chris Eliopoulos.

you want someone good and fast, they probably won't come cheap. If you want someone cheap and good, they probably won't be fast. Get the idea? Good.

The triangle works both ways, of course. If an editor wants to hire someone, they make some kind of mental picture of the triangle. It's often said, however, being "nice" can add weight to your triangle. Nice will not replace Good or Fast or Cheap. But people like to work with people whom they like.

"A lot of people forget the 'nice' part," says Eliopoulos, who has seen his share of people come and go from the comic book business. "Always having a good attitude and trying to be a team player is always helpful in any business, but especially in this business, where you're dealing with so many different creative and professional disciplines."

One of the reasons Eliopoulos has lasted this long is that he respects the triangle. Being a good, reliable staff letterer made it possible for him to break into Marvel right out of

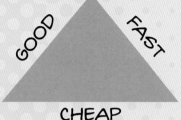

THE FREELANCER'S TRIANGLE

An editor can usually expect two of these three qualities out of a freelancer.

Eliopoulos has built a large, dedicated following from his Eisner Award-nominated work on Marvel's *Franklin Richards: Son of a Genius*. This all-ages comic tells the story of the son of the Fantastic Four's Reed and Sue Richards, and the boy's guardian robot, HERBIE.

college. Eventually he even managed to turn his staff work into ongoing freelance work.

Since he tended to be good, fast and nice, everyone was willing to work with Eliopoulos, including multiple editors at Marvel and DC. As a result, he had a front-row seat and was there to witness (and letter) comic book history, including the rise and fall of Valiant, the birth of Image Comics and Wizard Entertainment's Black Bull line, and the launch of Marvel's MAX and Icon publishing lines.

In 1998 Marvel was looking to streamline staff and production costs. Marvel no longer wanted the overhead expense of paying on-staff letterers. As a result, Marvel offered Eliopoulos a rare exclusive contract to letter a significant portion of their comic book line. So he formed Virtual Calligraphy, hired some of Marvel's former bullpen letterers, and launched an award-winning lettering and production studio.

On the creative side, Eliopoulos has been able to leverage his good reputation for being a reliable freelancer. In addition to his lettering work, he's been able to work on creative and exciting projects such as *Star Wars* (Dark Horse), *Franklin Richards: Son of a Genius* (Marvel) and even a September 11, 2001 tribute comic by Marvel. Eliopoulos has also been working on *Lockjaw and the Pet Avengers*, an all-ages comic for Marvel, and his daily webcomic, *Misery Loves Sherman*.

"I learned storytelling from lettering and production. I would paste up balloons on a page and learned through tactile learning," says Eliopoulos,

who believes that learning one element of comic book production made him better at writing and drawing. "Being good at one thing can always help you be good at another. Anyone who considers one thing 'beneath' them is too stupid to learn that everything can help them be better."

THE FUTURE OF LETTERING

Because he started out before computer lettering was popularized, Eliopoulos has hands-on experience with, well, hands-on lettering. The next generation of letterers are learning the craft on computer screens, which leaves them one step removed from the tactile experience of working with comic book art.

When he first broke into comics, Eliopoulos learned comic book production working in the renowned Marvel Bullpen. The industry was different in those days and production people usually worked inside the Marvel offices. This environment enabled Eliopoulos to rub elbows daily with many young and established comic book talents, including John Romita Sr.

As a letterer working in the Marvel production department, Eliopoulos was taught old-style lettering on comic boards, when Ames tools were used to get the appropriately ruled lines. He had the benefit of learning his skills from legendary letterers including Jim Novak, Bill Oakley, Pat Brosseau, Phil Felix and Michael Heisler.

Most Marvel Comics fans know that Stan Lee often gave his co-creators memorable nicknames. Many Marvel letterers favored a Hunt 107 pen for ink slinging. So, inside the Marvel

Bullpen, the letterers were called—you guessed it—The Magnificent 107s.

But these days, 107s aren't the tool of choice for professional letterers. In fact, most mainstream publishers are exclusively using digital lettering as part of their production workflow. Today, aspiring letterers don't even see original comic art, much less use an Ames tool and a Hunt 107 to place letters.

Adobe Illustrator software has become a popular lettering solution, and Eliopoulos's Virtual Calligraphy utilizes it for all of the books they letter for Marvel. This, Eliopoulos laments, may mean that computer-based lettering may eventually become less of an art form and more of a production task.

Eliopoulos published *Desperate Times* at Image and then later at After Hours Press. The collected edition was published by IDW.

Desperate Times © and ™ 2000 Chris Eliopoulos.

Even now, there are hints that his predictions are coming true. These days, many letterers are being asked to take one more step into the production process by "compositing" a comic for the printer (see "Compositing" sidebar).

Now, as the comics business shifts to a more digital workflow, there is a danger of losing the craft of lettering to standardized fonts. Many letterers coming into the industry are not creating their own fonts based on their handwriting, as Eliopoulos and other lettering pioneers needed to do. This creative shortcut may mean little to the average fan since good lettering is nearly invisible to them. But to the trained eye—or to the eye of readers passionate about the entire comic art package—there will be less art on the comic book page. If everyone's lettering is based on the same two or three fonts, the word forms that have been iconic to the comic book medium may lose their impact.

But technology has also driven many improvements in the publishing process. In the old days, writers would send a script to the editor, who would shepherd it through the creative and production processes. In many cases, that would be the last time the writer would see the comic book until it hit the stands.

New technology has made it possible for writers and editors to make changes and improvements to the final product without dramatically altering the publishing timeline. "Now, the writer and the editor have the ability to keep tweaking the book until the story is exactly what they want," says Eliopoulos. "It's another tool that helps writers and artists tell their story better."

And if your sights are set on lettering, get ready for plenty of tweaking. "I've done a number of books where I've—in essence—relettered the book five times, and the story is nothing like it was when we started," says Eliopoulos. "And to this day people ask me, 'Did you like working on that book? Wasn't it a good story?' And I can't even tell you what the story was about anymore because I redid it so many times that I lost the line of the story."

That said, being flexible and open to improvement is critical to the success of a letterer and his work. "You need to be humble. You need to be a listener. You need to understand that criticism is not a bad thing. If somebody is kind enough to give you criticism, it means they care enough to tell you how to get better," says Eliopoulos. "And if you think that you're so good that you don't need improvement, you're not a professional. I have been doing this twenty years and I still seek improvement in everything that I do. The minute

COMPOSITING

Any comic book going to a printer has to be assembled and prepped for the presses. Like many processes in the publishing chain, print preparation has evolved with technology. Most books are "pre-flighted" from computer formatting to printer formatting. For example, many monitors are set by default to RGB color format, but printing is separated in the CMYK format. It may seem like a minor detail, but it could have a dramatic impact on how a comic looks when it is finally printed.

In the past, a full production team was part of the in-house staff at publishing companies. These days some publishers are looking to outsource this kind of work to freelancers. This can help a publisher cut overhead costs.

Eliopoulos and his team at Virtual Calligraphy are among a cadre of letterers who are offering "compositing" services to publishers. Since they are already in the digital file, letterers can efficiently and effectively prepare a comic book page for the printer. Letterers who take this extra step can help streamline the process, which cuts the time that it takes a book to reach the stands.

THE LETTERER'S STAGE

Eliopoulos's studio is set up in a large room in his home, where he runs powerful Macs with his Wacom Cintiq electronic drawing tablet to letter comic books for Marvel. To the side is his well-used art table, where he writes, draws, inks and letters his popular daily webcomic, *Misery Loves Sherman*.

you're satisfied with your work is the minute you're out of the business."

Eliopoulos is always on the lookout for the next lettering talent. Specifically he hopes to discover, and perhaps mentor, an artist who cares about what Eliopoulos describes as "the beauty of the letterform."

Until then, expect Eliopoulos to remain one of the leading forces in the art, craft and business of professional comic book lettering. "I like being part of the team ... I like knowing that the writer feels that I have done his story justice. I love when an artist requests me on a book. That's what makes me happiest about this process," he says. "It's nice to know somebody appreciates that you've done a good job and that it's contributed to telling a really good story."

Misery Loves Sherman © 2010 Chris Eliopoulos.

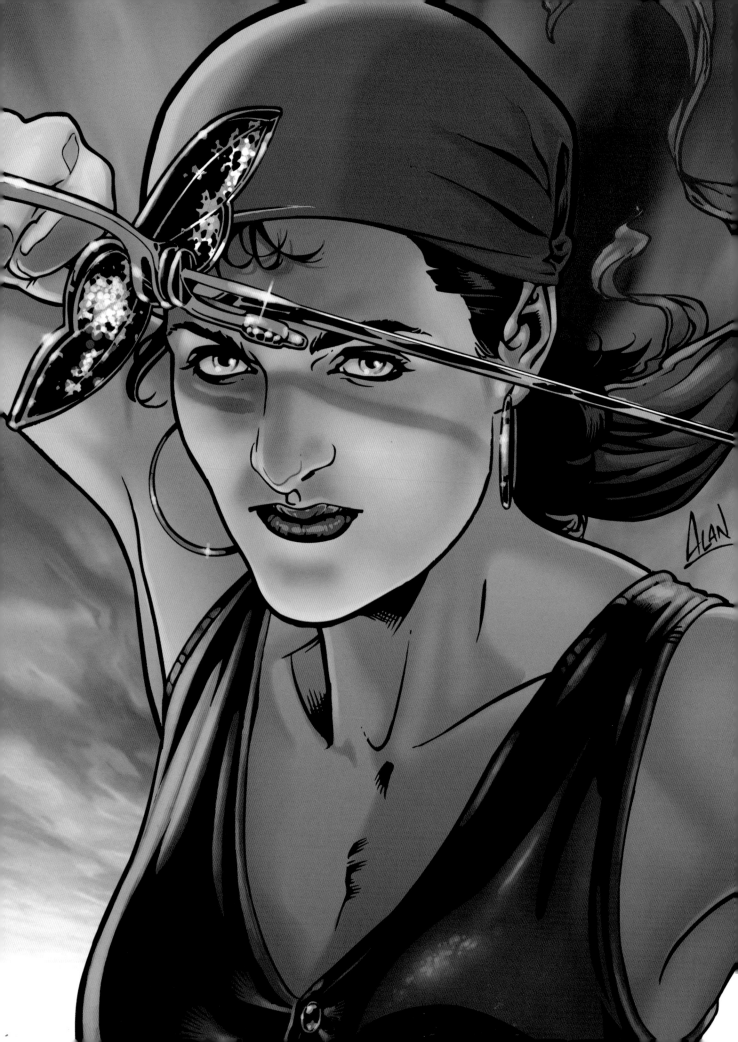

COLORING: A Multichromatic Look at Today's Technology

There's something about the colors in a comic book that people seem to remember. Ask someone who hasn't read comics in many years, and often they will wax rhapsodically about the brilliant colors.

That's because color seems to make the page come alive. Be it brilliant blues or garish greens, the colored page just seems to fit the comic book medium, especially in the superhero genre.

For many years, printing technology limited comic book color choices and techniques. So professional colorists adapted to the limitations and managed to create worlds that were populated with bold, brash color combinations. This is the memory many people have of comic books.

Now, of course, improved printing technology has almost completely unlocked the limitations associated with coloring. As such, coloring has been allowed to blossom into a separate and unique art form. Colorists—at one time uncredited in the credits box—are now integral to the aesthetic package. The best ones do more than just sign their name—they leave their artistic DNA on every panel.

And while color still leaps off the page—at least if that's what they want it to do—the colorist now controls that leap. Color is artistically managed and manipulated for maximum effect.

THE EVOLUTION OF COLORING

Of all the steps in the comic book creative process, it is coloring that has benefited—and in many cases suffered—the most. Improvements in printing technology evolved at a pace that took advantage of evolutions in personal computing. That is, as computers got faster and cheaper, they became better tools for creating complex coloring designs. At the same time, print technology improved at a pace that enabled comic book colorists to experiment with a wider, more complex color palette.

More colors meant that creators experimented with costumes, settings and other designs that explored greater depth and light sources. It also meant that the colorful costumes that people loved so much were able to grow and change. You see, the fact of the matter was that early printing technology didn't allow for a broad spectrum of colors. So, when early comic characters were created—like Superman—the artist had to consider what colors would reproduce well on the cheap newsprint that was popular at the time. Flat blues, reds, yellows and blacks were selected because of the relatively simple color separation technologies available to printers at the time. This is why, when people wax nostalgic about the comics they grew up reading, often they talk about the bright, vibrant colors.

And old comics were indeed colorful. Superheroes and villains often wore spandex-enhanced underwear adorned with a (usually) eye-pleasing combination of red, green, blue and yellow. Other times, the combination was, well, a bit garish and hard on the eyes.

So as computers became more efficient design tools, it was natural for comic book creators to experiment with different coloring techniques. Of course, what appeared on the bulky computer monitors wouldn't always translate properly to the printed page, so early coloring pioneers had to make adjustments to even approach the sophisticated designs they viewed on their screens. Fortunately, print technology evolved enough to show slicker, more accurate colors that almost reflected the complex images colorists were conjuring on computers. Even today, cutting-edge colorists are developing textures and tones that would be challenging for even the most experienced printer to effectively produce.

But back in the dark ages of computer technology, it was all about experimentation and exploration. Armed with little more than a mouse and some chuggy old computers, several technologically brave artists endeavored to see how far they could push the color envelope. If you consider that the computers that launched the coloring revolution are less powerful than some of today's mobile devices, you'll understand how difficult it was to actually get these machines to satisfy the grand visions of comic book creators.

HABERLIN'S BIG HAUL

It's ironic that computer coloring techniques were not developed by seasoned colorists with years of experience spotting colors on the page. No, like many pros, working colorists were busy with real deadlines, specifically the ones that paid the bills. It fell to younger, less busy comic creators to explore and expand the art and technique of computer coloring.

Even more ironic is that one of the industry's most influential coloring pioneers wasn't even a colorist at first. Brian Haberlin was a penciller who was looking for any way to break into professional comic book work. And it was a 3-D color rendering of Green Lantern—a superhero identified by color—that first got Haberlin noticed. It wasn't even the artwork that attracted the eye; it was the coloring.

"So, in 1993, a friend of mine was getting a table in the small press area at San Diego Comic-Con, and he wanted to share it with me," explains Haberlin. "I got this big, huge, giant inkjet print of Green Lantern with this 3-D modeled lantern behind him, and these big 3-D modeled, green, glowing wings coming out of his back, and I had a monitor up on the table that was showing stuff that I'd done, [including] a 3-D model animation of Spawn jumping down from a great height and landing."

For those of you reading this on some sort of e-reader, it's hard to imagine lugging a desktop computer to a comic book convention, or anywhere else for that matter. At the time, a good computer could run several thousand dollars, not counting the 40-pound computer monitor. Compared to today's affordable, lightweight laptops, original PCs were pricey, heavy machines that rendered art agonizingly slow. Hauling a computer and monitor to a comic show in 1993 would certainly get someone noticed. Fortunately, what Haberlin was showing on screen was enough to grab people's attention. "That was it! Everybody just came by and offered me work," says Haberlin. "It was much better than standing in line with a portfolio, apparently."

A PENCILLER TURNED COLORIST

Fortunately for Haberlin, the comic book industry was experiencing major upheavals. To most younger readers today, Image Comics is just another publisher with a focus on alternative superhero titles. But in those early days, nobody really anticipated what would happen when seven top comic book creators—Todd McFarlane, Marc Silvestri, Jim Lee, Rob Liefeld, Erik Larsen, Jim Valentino and Whilce Portacio—broke away from mainstream publishing deals at Marvel and DC, ultimately forming Image. Comics sales were sky high, and the stakes were even higher. For decades, New York City had been the epicenter of comic book publishing, but the Image Comics model of decentralized publishing threatened that longtime hegemony.

Spotlight: Brian Haberlin

JOB: Colorist (writer, artist, publisher, entrepreneur)

LOCATION: Laguna Niguel, California

YEARS IN THE INDUSTRY: 20+

HAS WORKED FOR: Marvel, DC, Image

CAREER HIGHLIGHTS:

- Owner of Haberlin Studios, one of the top coloring studios in the U.S.
- Owner of comics publisher Avalon Studios
- Former vice president of creative affairs at Top Cow Productions
- Former editor-in-chief at Todd McFarlane Productions
- Pencilled and inked *Spawn* for twenty issues

ONLINE AT:

www.haberlin.com

www.avaloncomics.com

www.digitalarttutorials.com

In fact, at one time, Haberlin had even considered relocating from California to New York to break into the legendary Marvel Bullpen. He was offered work under John Romita Sr. to become one of the elite art apprentices known as Romita's Raiders. But, like most early career opportunities, the temporary art-correction job was not financially attractive enough to move his entire life to the East Coast. Instead, he stayed in California and worked for a few years in Hollywood in the film industry. There he worked as an associate for Lorimar TV in the prime-time drama series development and comedy series department. During Haberlin's tenure

there, Lorimar produced hit shows like *Dallas*, *Perfect Strangers*, *Knott's Landing* and *Lois & Clark*.

But after a few years, Haberlin began to miss the comics business. With many Image creators living in and around the West Coast, it was no longer mandatory to go-East-young-man to break into comics. So like many aspiring comic artists, Haberlin worked on his pencilling portfolio.

Oh yeah, and he dabbled in coloring. Brian was curious about computers and what they could do for artists. Like creator Chris Eliopoulos, Haberlin recognized the true potential of the computer. It couldn't necessarily replace art talent or even a good eye for design. But it could, if managed properly, become another tool in an artist's box of tricks.

Again it's worth mentioning how primitive computers were at that time compared to the sophisticated digital devices we enjoy today. Early computers were fickle beasts that required care and cash to run. Lots of cash. And it meant that if you truly wanted to use your computer to generate art, you just had to keep trying new things. Yes, there were manuals and books, but this was at a time when these guides were frustratingly difficult to understand. This was before the Internet as we know it, so you couldn't seek help forums or video tutorials on YouTube. If you wanted to learn Photoshop, usually you had to buy it or borrow time on an institutional computer, then buy a book. Open book, begin reading.

Most people with early computer software were just happy to be able to change fonts or print a clever newsletter for school. That Haberlin not only drew on the computer, but also managed to electronically add color to his drawings, is amazing in and of itself. It's an achievement worth noting, but not surprising considering this is the same guy who lugged his creations (remember: big, heavy desktop and bigger, heavier monitor) to a comic book show and actually impressed well-known professionals like Image's McFarlane, Lee and Silvestri. And despite the fact that Haberlin hoped to break in as a penciller, it was his relentless pursuit of computer coloring techniques that helped him break into comics as a working professional.

RUNNING THROUGH WIDE-OPEN DOORS

For Haberlin, coloring wasn't his end goal—it was a means to an end. And, quite honestly, it got him a foot in the door at Image Comics. Haberlin's work was popular there, and he served many roles at Image companies, particularly with Marc Silvestri's Top Cow and in several creative roles with Todd McFarlane.

Most people would be happy enough just getting a foot in the door, but Haberlin proved his abilities in almost every aspect of the comic book process. He would go on to write, draw, edit and even publish comic books. "You meet so many people who say, 'I can do that, I can do that, I can do that, I can do that,' but you've got to prove something, and then you get the credibility," he says. "And then you get to try something else."

Haberlin was interested enough in every aspect of comics that he made certain to observe and learn from everyone he encountered. During his Top Cow days, the office, which at the time was shared with then-independent publisher WildStorm, had a modern version of the Marvel Bullpen, so artists could interact with and challenge each other. For Haberlin, it was a magical, creative time. "I can't imagine a better place to go and join because it was this old-office setting, so there were probably two offices that had doors that closed. All the rest of them were open-topped cubicles that you could see over," he says. "So you could walk around, you could say, 'OK, let's watch Marc [Silvestri] draw some *Cyberforce*' …. Right across from and facing Marc was Scott Williams. Scott would be inking *Pitt*, he'd be inking Jim Lee stuff, he'd be inking Marc's stuff … so you'd be getting an inking lesson from Scott. Then you'd wander around to the other side, and Jeff [J. Scott] Campbell was just starting on *Gen13*, and then Jim would be over there." The office ping-pong table saw plenty of action, an apt metaphor for the creative back-and-forth happening around it. There was a real energy, says Haberlin, of "Look what I can do, and watch, and see if you can do better."

This open-air creative process helped launch Image Comics into an amazing place in the pub-

lishing world. This loose collective of independent studios posed a serious challenge to years of Marvel and DC domination. Image produced amazing comics and nurtured some of the top talent working today. At the top of his craft in coloring, Haberlin believes part of his success is due to this open sharing of creativity and a deep, relevant understanding of the entire comic production process.

"It's really important—for me, anyway—to be able to do every aspect of it," says Haberlin. "As soon as I got to [the 1993 San Diego] Comic-Con, I didn't want to letter, but I wanted to know how to letter, how to ink, how to color. How do you set up—you know, back then—a Quark template, and all that stuff?" All the broad know-how he acquired undoubtedly benefited Haberlin, as he eventually went on to publish his own line of comics, after leaving his role as vice president of creative affairs at Top Cow. The Avalon Studios line would include such titles as *Area 52*, *The Wicked*, *Aria* and *Hellcop*.

Haberlin's Avalon Studios released several projects by new and established creators. *Hellcop* and *Aria* were titles that were visually arresting.

DOING IT ALL PAYS OFF

Being exposed to every step of the publishing process helped Haberlin since publishing comics can sometimes be a bumpy ride. The reality is that there's always some emergency that needs to be addressed. Knowing how to do everything in the creative and non-creative process helped get comic books to the shelf. For Avalon, he partnered with longtime comic creator David Wohl, who also worked in every corner of the business. At Avalon, having not one but two jacks-of-all-trades on staff made production snags large and small surmountable. "I had to know how to do the whole publishing process. David Wohl could do almost everything, too, which I always appreciated about David," says Haberlin. "If David needed to sit down and help letter something or help do production to get a book out that night that we needed to get out to the printer so it wouldn't be returnable, David could sit down and do that. If something screws up, like a guy is

sick, [David would say] 'OK, I'll finish inking that page.'"

Haberlin's professional flexibility would serve him well, as eventually his career took unique twists and turns. Throughout the years, Haberlin touched some of the hottest properties in comic books, and created more than a few himself. With Wohl (who also co-wrote), as well as Christina Z and Mark Silvestri, he co-created the 1990s breakout sensation *Witchblade*.

Haberlin eventually navigated Top Cow Productions—one of the most successful of all the Image studios—to land as its vice president of creative affairs. Because he was a highly respected visual artist, he was able to explore almost every element of comic book creation. "When you get to be very good at what you do, or very well-known for what you do, then most of the people who are really good want to work with you, too—so that's the advantage there," says Haberlin.

But despite his wide-ranging skills and experience, he admits it's still been tough at times to

SOFTWARE-CREATED SCENERY

In this flashback scene from Haberlin's 220-page graphic novel, *Anomaly*, the hero (Jon) is remembering an incident from when he was an Enforcer that cost him his career. "The large stone monoliths in the second panel were modeled in ZBrush," says Haberlin, "and then populated as an 'eco-system' in Vue XStream."

shake the "colorist" label. "The double-edged sword is that—you know, I co-created *Witchblade*, I did writing at Top Cow, I did editing at Top Cow, I did all this other kind of stuff, I did writing on my own line, and most of the stuff got reviewed very well, but people were still always, you know— 'the colorist,'" explains Haberlin. "It's a little bit of a velvet coffin at times."

Haberlin continues to run one of the top comic book coloring studios in the industry, Haberlin Studios, with approximately twelve freelancers and staffers working on his team.

A COLORFULLY BUSY WORLD

People who fantasize about a career in comics often dream without deadlines. They imagine themselves chatting amongst colleagues as they sketch happily on their favorite characters. Action figures, original art and music swirl about them in a symphony of creativity, positive energy and camaraderie.

Sadly, that fantasy is about as realistic as the superheroes they're drawing.

Creating comics does come with the kind of creative energy that most people dream of—that's true. But it also comes with a surprising amount of solitary confinement. Top comic creators must work hard to meet deadlines. Sometimes projects come screaming through the door with an insane due date. So, yes, while comic book creating can be fun, there's also a lot of work-related stress that comes with deadline-driven creativity.

In his own studio, Haberlin tries to move pages through the coloring process on a regular timeline. Most pages need to be colored in three hours or less, while maintaining the level of quality that has made Haberlin famous. To get a professionally colored page done in three hours, a colorist needs butt-in-the-chair, eyes-on-the-

Anomaly, page 2 © 2010 Skip Brittenham and Brian Haberlin. Art by Brian Haberlin and Geirrod Van Dyke.

In his own studio, Haberlin tries to move pages through the coloring process on a regular timeline. Most pages need to be colored in **THREE HOURS OR LESS,** while maintaining the level of quality that has made Haberlin famous.

monitor focus. "You've got to have some sort of a stopwatch by you and go, 'OK, you're going to kick ass on this panel and this panel,' and then where it's not really going to show, you're not going to spend the time," says Haberlin, who teaches his colorists how to identify the important elements in the page. This enables colorists to spend the appropriate time on each section for maximum impact. "And then if you've given yourself three hours to do this page and you're done in two, take that other hour and spruce it up and polish it up, and do the extra little bits," Haberlin says. "But you've got to pretend that somebody is there to grab that page out of your hand as soon as you're done."

Sometimes there is someone waiting to take your page even before you are done. As in other creative steps in the process, colorists are often called upon to make up for lost time on deadlines. If someone in the beginning or middle of the assembly line slows down or fails completely, there are only a few places where an editor can actually accelerate steps and catch up. One of the telltale signs of a broken process is when a large batch of pages gets delivered all at once. "Very often you get these logjams, where [you think], 'Why are we getting ten pages all at once? Because I know this guy didn't do ten pages all at once. He didn't sit down and ink ten pages today.' That's just people not really doing their jobs."

The reality is, Haberlin and his team are often forced to make up for lost time by working faster or later, or both. This is the kind of thing that makes working as a colorist—or any creative role in the comic book industry—so difficult.

HOW COMPUTERS CHANGED COLORING

In the early days of comic book creation, coloring was a non-digital process. Colorists worked with limited color palettes and had to be extremely creative about how to distribute those colors. After all, comics were intended as cheap, disposable entertainment. The paper they were printed on was on par with the Sunday comics, which meant that colors sometimes looked muddy as the inks bled across the page. It would be years before improved printing technology and paper quality would become the norm in the comics industry.

But as Haberlin was breaking into the industry, personal computers were becoming more accessible. Today, computers are ubiquitous. Many of us have at least one computer, maybe several, if you count mobile devices. But back then, computers were still pretty expensive, compared to current machines. "When I started, again—to set up a computer that could actually color back then, back in '93—it would cost you about ten thousand bucks to set up a computer that was capable of doing it," says Haberlin. "Now, a thousand bucks or even less, and you're all set."

Someone breaking in today as a colorist is facing a lifelong, continuous learning process to keep up with new technology. A professed learning junkie, Haberlin sets aside time every day just to experiment with new ideas and techniques. "I have a certain time every day when I'll just start messing around with something and I'll think, 'What if you do it this way?' And sometimes it's just a little technique that I'll put in my back pocket and really never use again, and just go, 'Oh, that worked, that was kind of cool,'" he says. "I have these huge piles of art in my studio that, every once in a while, if I have time, I'll flip through and remind myself, 'Oh, that technique was kind of cool, actually doing the color first and then printing it out and then drawing on top of it, that was kind of cool; that worked pretty well.' I just always am experimenting and trying new things. Always. And I love that stuff. I eat everything that's out there. I grab everything."

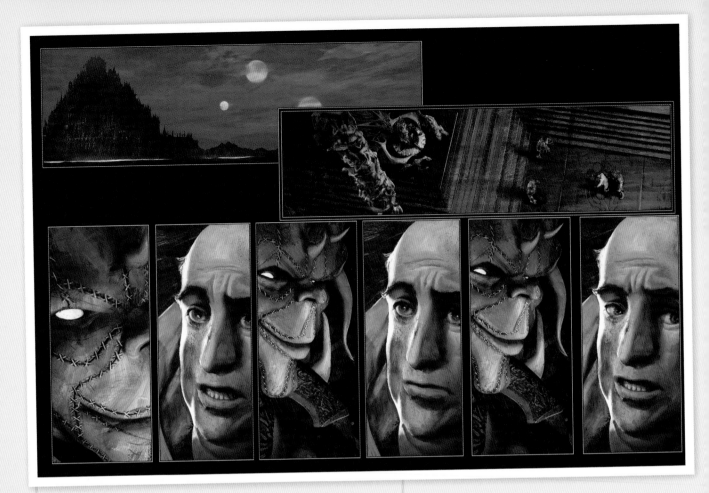

HAPPY ACCIDENTS AND PLANNED EFFECTS

These comics pages were done with Vue xStream, Poser Pro, Adobe Photoshop and Adobe Painter software. "The advantage of working with 3D is you really get to play with angles by moving your virtual camera around," says Haberlin, who admits the overhead view in Panel 2 of the page above was a "happy accident" that looked better than what he originally had planned.

On the comics pages shown on the opposite page, we see Erebos, the villain, violently rip into Jasson's thoughts to extract information. Haberlin points out the "power effect" is made of multiple colors: white, yellow, green and blue. "That variance is what gives it more heat in that last panel," he says of the top page. In Panel 1 of the bottom page, "a liberal use of the 'liquefy' tool was applied to warp the power effect."

This sort of relentless self-education has enabled Haberlin to incorporate advanced 3-D and other software-based visual solutions into his work. "The 3-D that I was trying to do back in the day has now finally come to the place where it really is a usable tool for helping you create that city street that you don't really want to draw," says Haberlin, "or even if you *do* want to draw it, you have this nice city street model that you can turn to any camera angle and light any way you want, and you can print it out and use it for reference or lightbox it, or even really cheat and just put it down. I never really approve of that kind of thing, but if you use the 3-D stuff, you make it dirty."

Cutting-edge software programs can help cut down on both the time and the tedium of certain tasks.

"A lot of the Marvel guys have been using SketchUp now for a long time to do these really tricky cityscapes that have all these crazy angles to them that would just take you a while to draw," says Haberlin. He recounts how programs like this helped him on a landscape-format graphic novel he recently worked on, which, when opened, spans thirty inches across the two-page spread. "I just did a battle scene in a fantasy thing, and with 3-D, I was able to put 15,000 of these troops on the battlefield," Haberlin says.

Anomaly, pages 130–132 © 2010 Skip Brittenham and Brian Haberlin. Art by Brian Haberlin and Geirrod Van Dyke.

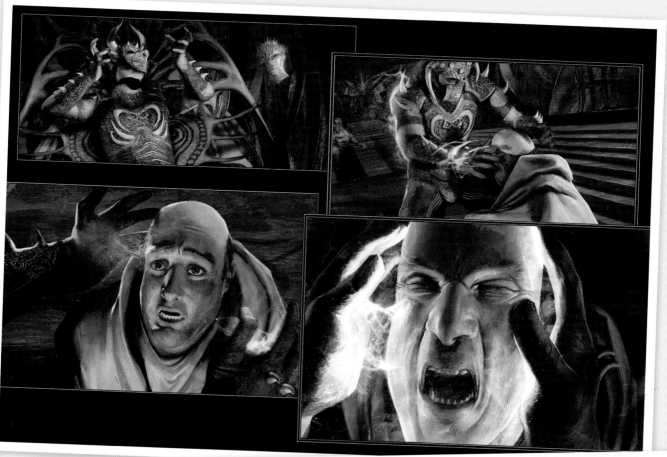

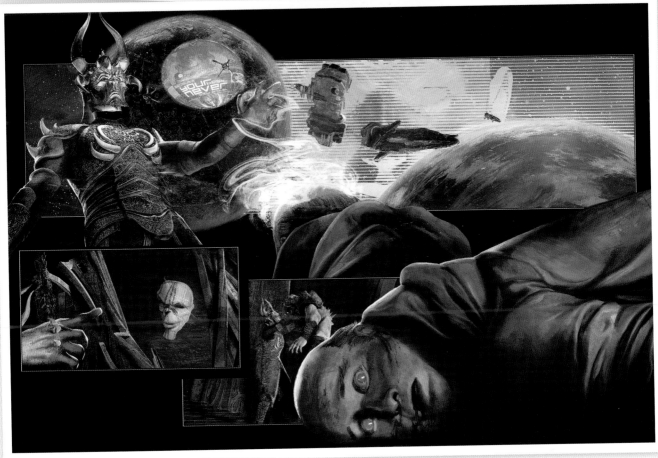

93

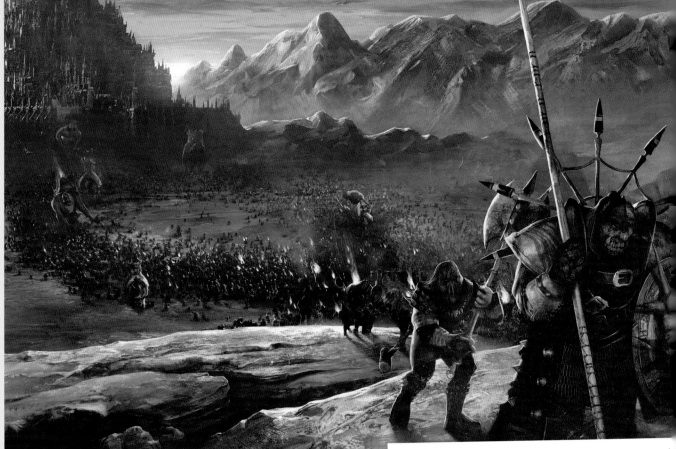

BUILDING AN ARMY OF THOUSANDS

For this epic battle scene, Haberlin created about twenty-five variants of evil army soldiers, including creatures and vehicles. He made the terrain next, and then used the 'ecosystem' feature in Vue 7 xStream to paint a cast of thousands following the contours of the terrain. The program, Haberlin says, was "a *huge* time-saver." At right is the digital pencil/ink stage, which Haberlin also worked on in Adobe Photoshop; below, the finished image, which Haberlin's collaborator on the book, Geirrod Van Dyke, digitally painted.

Wait, did he just say 15,000?! Yup. (See for yourself in the image above.)

"The software enables me to know how many I'm putting down," explains Haberlin. "It's kind of like the software you've seen in *Lord of the Rings* and stuff, where they're building these massive armies. The idea, though, for me, is that at the end of the day I want to be able to do these kick-ass pages that, normally, if I were doing it by hand, would take me a week. But [now] I can do them maybe in two days."

WHAT HASN'T CHANGED

These days, of course, technology touches every aspect of comic book production. From the very simple step of writing on a computer to the complex process of coloring a comic, the industry has evolved in step with the personal computer. But the basic philosophy hasn't changed much since the earliest coloring pioneers spotted separations. "I always believe a colorist should look at a page like a cinematographer. You're lighting the scene. You're providing the drama," says Haberlin.

As a result, the choices for a colorist involve a lot more than simply assigning colors. "When I'm coloring I have to think, 'OK, what's the lighting going to be like here? What color is the lighting going to be? What's the reflected light source

going to be? What's the shadow condition going to be?'" says Haberlin. "Let's not produce the same frickin' lighting that I produced five times before, you know?"

To keep himself fresh in a process that can be quite repetitive, Haberlin says that sometimes he would randomly choose a color. "If I was getting stale, I would just close my eyes, randomly point to a color and say, 'OK, that's the color scheme I'm going to make work for this page.'"

It's this kind of self-imposed challenge that helps keep Haberlin's pages fresh and vibrant. "You've got to do things to get yourself out of yourself. Or go, 'OK, I'm going to color every page of this book using a different tool than I normally do,'" says Haberlin. "But the fun part about being the colorist is really that once you get into the mode of it, you can have some music on, and it kind of flows. It's a little easier than staring at an entirely blank page."

Anomaly © 2010 Skip Brittenham and Brian Haberlin. Art by Brian Haberlin and Geirrod Van Dyke.

> *"I always believe a colorist should look at a page like a cinematographer. You're lighting the scene.* **YOU'RE PROVIDING THE DRAMA."**
> —Brian Haberlin

It's this kind of challenge that helps Haberlin and his team generate consistently exciting artwork and challenge the industry to do the same.

"One of the great things I had by working in that original studio back at Top Cow and Homage [Comics, a subdivision of WildStorm] was there was a strong belief in the studios that everyone's job along the way was to better the product, to enhance and make it better—never to just do it," says Haberlin. "I still believe that today. You can't color everybody the same, so with every artist, you need to find what is the thing that you can bring out of this guy that isn't there to begin with."

THE TOOLS OF TODAY'S COLORIST

While many professional artists favor Macs, Haberlin still prefers his PC. His is loaded with a state-of-the-art SSD (Solid-State Drive), which is quicker, quieter and more efficient than a traditional hard drive. Throw in a lightning-fast processor and 12GB of RAM, and he's got one speedy machine. Oh yeah, and he has multiple machines running simultaneously. And four monitors. Nearby is his Wacom Cintiq drawing tablet, with a pressure-sensitive pen that allows Haberlin to draw directly on the LCD display for more intuitive linework. (For more on the Cintiq, a mainstay for many of today's artists, see page 119.)

The gold standard for coloring and imaging software remains Adobe Photoshop, an amazingly deep and complex professional art tool. In addition, many colorists are experimenting with software that delivers the illusion of 3-D and real texture. Applications such as 3D Studio Max, Vue, Maya, Poser and Manga Studio are all used by professional colorists to produce unique visual effects.

COLORING FOR TOMORROW

Because he leverages technology every day, Haberlin is acutely aware not only of how it has changed over time, but how it will likely change in the future.

Back when Haberlin started out, many professional publishers purchased giant flatbed scanners to capture the 11" × 17" (28cm × 43cm) original art pages, rather than using a smaller scanner and stitching together the pieces. These full-page scanners of yore were big, slow machines. Today they are just slightly smaller, but much faster. "I remember the first one we bought at Top Cow was the size of a big table," he says. "When I started at Top Cow, even just CMYK-ing a book … to do the twenty-two pages, it would take six hours for the computer to process that stuff. Now it's in the blink of an eye."

Haberlin remembers the days when he would work with screen tone, X-Acto knives and electric erasers to get the right effect. And while he doesn't necessarily want to revisit the "good old days," he does recognize the value in having hands-on experience with actual art boards. "I've been to a few different workshops on digital, and there's really been a craving for the real hands-on stuff," says Haberlin. "Because anyone who works digital all day, there's something sterile about it. Whenever you get to get dirty, it's a lot more fun."

Haberlin shares with other colorists what he's learned and what he sees ahead in his own convention workshops, many of which I have co-planned with him in my role as an educational planner for comic conventions. As a rule, I try to book guests who will fill the appropriate size room. No matter where I put him, Haberlin's coloring classes fill the room. And even though these are double-long classes, nobody complains that they run too long. In fact, many people follow Haberlin out of the room and back to his table, where they can purchase copies of his coloring tutorials on DVD (see sidebar).

A true student of technology—and now a popular digital-coloring educator—Haberlin constantly keeps up on the latest software and hardware tools for designers and consumers. He anticipates that the current system of printed, bound comics will inevitably evolve as new technology becomes available. "I think there's going to be more devices we're looking at as opposed to the printed page so much. And I don't know what that device is going to be yet, but it's going to be something," says Haberlin. "I think an iPhone is a little small for it, but … even given the size of a Kindle or something like that with better color capabilities, we're looking probably at a change of format. We're looking at now more of a wide-screen format for everything."

And with different delivery and format changes, he suggests, will likely come comic book pages unlike any we've seen before. "I think you're probably not going to have so much the sequential pages anymore; I think you're going to have more panel after panel after panel after panel," says Haberlin. "They're going to flow more like storyboards. So occasionally, I think, with that format, it's not going to be a page sitting on whatever that [e-]reader is. Or not [the kind of] page we're used to looking at."

Multimedia elements may enter the mix, too, according to Haberlin. "I think, too, there's going to be more of a hybrid narration thing going on," he says, "with voice and maybe even a little bit of a soundtrack."

No matter what changes technology brings, Haberlin remains focused on the same core values that have guided his twenty-year career. "I always feel the colorist's job is to take it one step further. Improve it. A black-and-white page is going to go only so far," says Haberlin. "When the colorist sees someone is about to get murdered, or someone is telling someone a deep dark secret, and you light it the right way, you can have a huge amount of impact. You can have the same amount of impact a good cinematographer has. When it's done right, and when it's approached that way, I think you can have a huge impact. I think those are the guys who usually do the best work." 🗨

LEARN THE LATEST

Aspiring artists and working pros often turn to Brian Haberlin's Digital Art Tutorials, available at www.digitalarttutorials.com. These popular DVDs offer step-by-step lessons on how to achieve certain coloring and design results, starting for beginners and moving all the way up to highly skilled experts. Every technique is revealed in full detail, making these tutorials invaluable for someone who truly wants to generate professional-level work.

Art shown in Adobe Creative Suite 5 software screenshot ™ and © 2010 Brian Haberlin. All rights reserved. Used with permission.

FROM BOARD TO SCREEN

Even though he knows he will complete his art on screen, Haberlin still sketches out scenes on paper. Using two 11" x 17" (28cm x 43cm) bristol boards, he roughs out the scene, scans it and then begins the process of digitally manipulating the image. While the boards themselves are not fully finished art, fans still clamor to buy them from him at conventions.

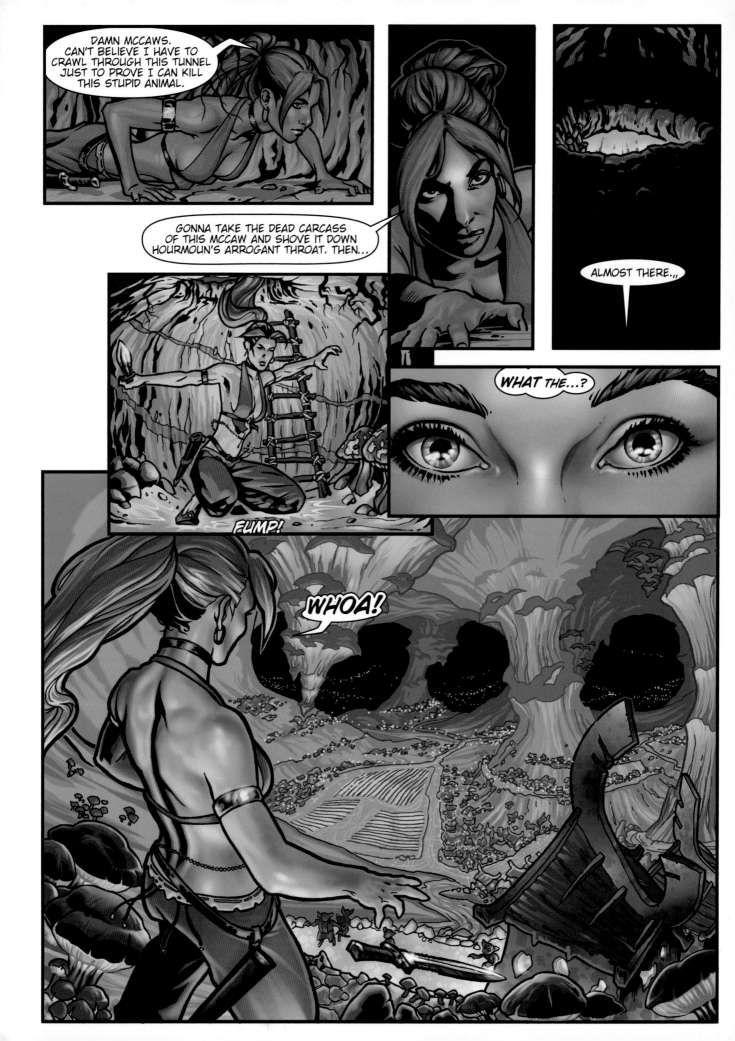

CHAPTER 7
OTHER ROADS IN:
Alternate Jobs in Comics

Comics, unlike many other industries, is not filled with folks who trudge to work full of grim determination. Many—if not all—of the people who work in this business are here because they WANT to be here.

This, above all, is what makes comics such a great place to work. People want to be here. They love what they do because, quite often, this is the realization of some wish they made in their youth. The comic book industry is a terrific business that crackles with positive energy.

If you look back at previous chapters, you will notice that some working pros actually broke in doing things that may not be what they are doing today. That's because people sometimes need to break in through the back door of the publishing house, rather than directly through the front. Some people get in through internships, like Mike Marts and Chris Eliopoulos. Others enter through alternate routes, like Mark Waid as a fan journalist.

Of course, not everyone even wants to work on the creative side. Or, as you probably realized from these chapters, is suited for art and editorial work. The hours can be extremely long, and if you're a freelancer, it can be quite lonely. You may even crave a job that offers somewhat "normal" nine to five working hours.

At the end of the day, of course, comics is just another form of publishing, a profit-based business that requires many types of working professionals. In this chapter are a few of the alternate jobs in comics that you may want to consider, as a stepping-stone for breaking in or possibly another comics career option.

INTERNSHIPS

If you've read other chapters in this book, you already know about the time-honored tradition of internships. At both Marvel and DC (and some of the larger independent publishers), interns are often invited to join the publishing process for low- or no-pay positions.

Often colleges and universities help place interns at companies, specifically to help students transition from academia into the business world. It's a good way to get a little bit of relevant work experience before jumping into a full-time career. It can be a complete waste of time for many people, as they sometimes take internships simply to fulfill a credit requirement. Or it can be a life-changing experience, since it can sometimes change the course of your career. Remember how a random internship tour at Marvel Comics changed the course of Chris Eliopoulos' life?

Some people leverage their internship for everything it's worth. An internship can have a ripple effect that can help propel your fantasy of working in comics into an actual career. Mike Marts used his internship to network with future employers, eventually landing as first the editor of Marvel's X-Men franchise and then later the editor of DC's Batman franchise. Marts started out as an intern with a clear eye to the future of his career as a full-time paid editor.

Interns are often given grunt-level jobs that are basic and administrative. This can be a way for a comic book company to save money on actually hiring administrative help, especially around the summer when many staff members—including editors—are on the road for comic conventions. Having a few interns around to handle administrative and detail chores can free up editors to do other, more engaging tasks.

But fear not, aspiring intern! There's more to this than meets the eye. It actually reveals an important fact about work: Everyone has administrative tasks. No matter how high up you go, there are details that require your attention. Learning the deep details of everything from filing to organizing can help you later in your career. It may seem menial, but it can help you to better understand the actual process of comic book creation.

It's worth noting something else here, since we're on the topic. If you've read this book's opening chapter, you know I've worked in the mainstream for years, but I also maintain a small publishing company on the side, where my partner Darren Sanchez (and at one time, Chris Eliopoulos) and I produce a small number of comics each year. We are, by industry standards, a small independent publisher. We're slightly larger than micro-indie (usually printing only one or two titles), but not quite as large as a medium-sized publisher (on a consistent publishing schedule).

Each year, we get résumés from people who want to get an internship at a publishing company. We're unable to take these interns, simply because we don't have a central office where we can keep someone busy. We've tapped people's help online, building our website and stuff like that, but we just don't have enough work for an intern.

That's a long way of explaining why you should focus your intern-aspirations on the mainstream publishers and the medium-to-large size independents. Indie publishers like Dark Horse, Dynamite, BOOM!, IDW, Image and Fantagraphics may have a working structure that will enable you to gain experience and begin networking your way into the industry. Some of these companies may pay modest salaries for interns, but don't be surprised if they don't. Back when I was at Wizard, we would take summer interns and online interns and pay them in free comics. It was a win-win situation since we got some extra help around the office, and the interns got free stuff. Quite a few people broke into the comics industry through the Wizard internship program.

If you're interested in working in comic books, it would be a solid foot in the door if you managed to land an internship. But the competition is often intense, even for non-paid positions. So if you're in college, try to leverage their resources to get you in the door. Or check out the publisher's website for details about interning.

WORKING IN COMIC BOOK STORES

Comic book stores are truly the front line of the comic book business. These are the trenches in which the retail war is fought.

I've heard many aspiring pros—writers and artists alike—scoff at the idea of working retail in a comic book shop. That, my fine friends, is just crazy talk.

Sure, the idea of working entry-level retail can seem, well, a bit un-glamorous. But it's a valuable experience in learning how the actual purchasing process works; how consumers weigh the pros and cons of their potential purchases. If you understand the retail dynamic (in comics or in any industry), it's likely that you will better understand the business decisions that must be made in producing a marketable product.

Len and Caren Katz, owners of The Joker's Child, a major comics shop in Northern New Jersey, agree that comic book creators can learn much about the industry working retail. "You get insight into what people actually buy," says Caren. "Decent art and a well-told story. If you deliver that, people will stay."

And, of course, the comics industry is built on long, ongoing storylines. Seeing steady traffic in and out of their shop since 1988, the Katzes respect the importance of strong cliffhangers that force people to get the next issue. "Cliffhanger stories mean that readers have to come back," says Caren. "This is an industry built on serialized stories. If stories were all stand-alone, we wouldn't have that draw [to get people back into the store]."

Working in a comic book shop can also give you a useful perspective on the competitive products on the shelf. As creators, we focus intently on the creative side of making comic books, since that's the quality product that we hope people will buy. But hoping and actually selling are two different things. Understanding the selling environment and the choices consumers have changes the dynamic of creating.

For example, at one time, comics were primarily sold in corner stores and newsstands. Comics were displayed on magazine racks and spinner

Len and Caren Katz in their comic book shop, The Joker's Child, in Fair Lawn, New Jersey. Check out their website at www.jokerschild.com.

racks. The display opportunity was a few inches near the top of the comic book cover, which is why many publishers would squeeze their company logo and the comic title logo as high up as possible. Comics were cheap entertainment, so they would draw attention to the price. When I was a kid, comics were "still only 25¢!"

Now most comics are sold in comic book specialty shops and a few bookstores. It's rare to see comics at a corner store, and if they are available, it's just a few mainstream titles—not the complete range of comics that are published by even Marvel or DC, much less larger indies. The retail paradigm has changed, and many retail locations take great pains to ensure that comics are displayed to entice shoppers. After all, publishers are putting much higher prices on comics, which means people spend more time thinking about their purchase. It's easy to buy a comic when it's only a quarter, but you definitely consider it more carefully when it's $4.99.

Covers are especially important, particularly in the comic book business where customers can make many impulse buys. "The cover is the first thing that catches the eye," says Caren Katz. "It's very important for the title of the comic to be prominent on the cover."

At The Joker's Child, they rack the comics so you can see the complete cover, not just the top

three inches. For the most part, they rack comics alphabetically, but they also make the extra effort of displaying the entire line of related titles. All of the Spider-Man titles are in the same general vicinity, even though the official title may be *The Amazing Spider-Man* (racked in A) or *Web of Spider-Man* (racked in W).

Plus, at The Joker's Child the Katzes have taken the time to learn my name and buying habits. If there's a new Spider-Man title or one-shot, they'll hold a copy for me. I'm not a weekly comics shopper, which means I may not be back to the store for two or three months. But since they know what I like, they hold it, without pressuring me to buy it. (I usually buy it, though, since they know what I like.)

This example is valuable, since so few comic book professionals buy their comics retail. Usually they get comps (a.k.a. complimentary copies) of stuff that their company produces. Plus, when you work in the business, it's common to freely share your product with other pros. So we are often a few steps removed from the purchasing decision process.

Working in retail can help you get a strong understanding of how comics are displayed, how people decide to make a purchase and how pricing can affect the decision at the point of purchase. Working as a convention dealer can be a similar learning experience, but tends to have a slightly different shopping paradigm.

If you're serious about breaking into comics, this can be a useful way to learn about the business. Incidentally, working retail was exactly how Mike Marts broke into comics. In the first chapter of this book, he talks about how Mark McKenna was one of his customers. They became friendly, and soon after, McKenna helped Marts land his Marvel internship.

Consider retail if you want to work in and around comics, particularly if you are looking for a stepping-stone into the creative part of the industry.

PRODUCTION STAFF

Comic book production offers an interesting and evolving opportunity for people who enjoy the technical aspects of publishing. In the early days, it was typically staffed by people with hardcore printing press experience. They understood the process of creating printing plates, color separation and printing presses.

Over time, many of the comic book industry's techniques have evolved to leverage advanced digital printing and production. Instead of working exclusively with mechanical plates and comic boards, today's production person works also with digital files. Often production people are working on computers, managing the digital workflow between traditional art boards and digital production elements.

As noted in other chapters, lettering and coloring are almost exclusively digital. The editors and writers work through email. Scripts are digital files that are emailed as attachments, so the writing is also software based. Digital inking is still in the early stages, but many people are trying to digitize this part of the creative process, simply to speed production and lower costs.

Looking toward the future, some artists, including Joe Quesada, are now working with digital original art. Pages that were once penciled and inked exist only as digital files.

These in-house factors affect how comic book production managers move a comic product from the creative stage into final format. But on the printing side, things are changing quickly as well. Early printing was managed on old-style web press printing machines. For years, these printers were based in the Midwest, the South-

west and in Canada. But now printing technology has evolved dramatically. It's not uncommon for comics to be printed overseas in print facilities in China.

In prior years, a production manager might hop a flight to meet with a printer or to do a press check of a particular product. Now, with modern digital technology, that time and expense is often no longer necessary. Many books are digitally proofed and approved on color-matched computer monitors.

As a result, many production managers are now people with strong technical and software skills. They often define and maintain digital production workflows, which include scanning, file transfers, backups and even digital corrections. There was a time when printing was a mostly mechanical technology, but now that has evolved into something that is almost entirely computer-based.

In chapter four, Rodney Ramos talks about his experience working in Marvel's production department as part of the legendary Romita's Raiders production team that specialized in art correction. This exposure gave Ramos a deeper understanding of the kinds of corrections required to properly prepare art for publishing.

Production roles vary by company, but they all serve the basic function of preparing comics for printing and in some cases digital publishing. This is often a career destination, not simply a stop-off before moving into something else. Production people may stay in this role for years, since the job is constantly changing and challenging.

Some of the people who move into production have an interest in writing and drawing, which helps them look at the product with a critical eye. Others are interested in the time-honored career of publishing, which is a course of study at some colleges and universities. Either way, it's a viable career path that can enable you to be part of the comic book publishing industry.

MARKETING AND PR

In the mainstream publishers and in some of the larger indies, you will often see a company spokesperson who handles most of the marketing and promotions. This can be an interesting and exciting career for people who love comics, but who also love the art of communications.

Over the years, the complexities of publishing comics have required the skills of a public relations professional. As comics expanded in the 1980s and exploded in the 1990s, it became clear that editors and writers needed a frontline face to talk to the fan press and the mainstream media. Fan magazines were popping up left and right, and many of them were quite professional. Fanzines evolved into prozines, which evolved into full-fledged consumer magazines. Now, as the industry continues to evolve, the print publications are being nudged aside by multimedia pro-quality websites.

As public relations needs change, the companies have found that they need marketing and PR professionals—sometimes entire teams—to manage constant requests for information. Usually ongoing communications are flowing to the fan press, including top sites like Comic Book Resources, Newsarama, COMICON.com, Comic Vine, Bleeding Cool, Sequential Tart and Comics Bulletin. But there are also many requests from sites that report on all types of media, including comics, such as Ain't It Cool News, Variety.com, EW.com, PopMatters, io9, Mania.com and IGN.

Just managing the day-to-day at those news outlets can keep anyone busy. But what about a

major news event? When Marvel and DC are releasing a crossover event, a major character change (death of Superman, death of Captain America) or even a movie premiere, this can be big news. This kind of news can reach global news outlets, including newspapers, magazines, television, radio and websites. It's not uncommon for mainstream publishers to retain the services of outside PR and marketing firms that help them manage mainstream press during major events.

Internally, there continues to be the need for an in-house communications or marketing manager. These people—depending on their level in the organization—may be handling press releases and mailing lists. Or they may have significant input on the direction of the company and the books that are published.

Many times, marketing and PR jobs are staffed by people with a background in related fields, including journalism. It's a natural fit since a journalist has a good sense of the kind of materials a reporter will need. From press kits to high-resolution images to video clips, a good marketing manager will know how to pull together resources quickly for the media. It's a good job for someone who loves comics and majored in communications, English or journalism in college.

In several cases over the years, we've seen fan-press journalists sit in the marketing seat. They often have good contacts in the industry, understand the business and have strong writing skills. It's a natural fit for a marketing position.

In some cases, marketing people help write ads and catalog entries for the major distributor channels. This part of the industry is also in flux, but as of this writing, Diamond Comics is still the biggest (some would say the only) comic book distributor in the industry. They produce a large printed catalog that helps retailers and fans decide what to buy. Often it is the marketing team that helps determine what is written in the short descriptions to get people to commit to an order. Again, this comes down to good writing.

If you're interested in marketing or already have experience, you'll still find that these jobs are tough to get. The major publishers do not need many people on staff. Just landing an interview can be incredibly tricky. If you're still young enough, focus on internships and fan journalism as ways to increase your personal network. If you're older and more experienced, again, the fan press is a good starting point. But you may also have luck if you attend the larger conventions and network your way into some face time with the marketing manager at the booth. You may not get much quality time, since that person will be running events at the booth, but you could get that crucial break to open a dialogue.

Marketing and other business-related departments can also be a door opener for other opportunities in comics. For example, it's well known that Peter David started out working in direct sales for Marvel. He focused on sales, but kept his eyes open for writing opportunities. When he saw an opening, he pitched the editors and landed a job writing *The Incredible Hulk*. He ended up writing the Hulk for twelve years, as well as other mainstream characters including Spider-Man, the X-Men and dozens of others.

So, if you're looking for something unique, explore the marketing angle. You could—like me—work on the marketing side for a few years and use it to explore other parts of the industry. The skills you learn will be useful no matter where you go, inside and outside the comic book business.

FAN PRESS

Like many businesses that thrive on the passion and enthusiasm of fans, the comics

industry has a typical love-hate relationship with the fan press. In some cases, publishers have a synergistic relationship with the fan press. They work together to release tantalizing information about upcoming projects. This is not exclusive to comics, incidentally. Just about every industry from film to music has some sort of fan press.

At the same time, the fan press rarely reports bad news. It's rarely critical of the publishing and business side of comics. The rare exception is from columnists and reviewers, who are expected to have an opinion of the product.

As noted earlier in the book, I broke into comics as a reporter. Unlike many in the fan press, I actually had experience as a newspaper reporter and a degree in journalism. So it's no surprise that I view the current state of reporting as less journalistic and more of advocacy. Reporters in this business tend not to report as much as they help comic companies get the message out about their upcoming projects.

That in and of itself is not a bad thing. The better news reporters ask good questions, specifically designed to help the consumer make a better buying decision. They shed light on good and worthy comic projects that might otherwise go unnoticed. In the best case, they actually ask interesting questions about how creators approach projects, dive deeply into their process, and even uncover some surprising information about the work and lives of creators. It's all in good fun, and it's often written to entertain.

Fan press may write news stories, be in on major industry events, and even develop interesting profiles and features. Often the fan press is comprised of fans who have good-to-excellent writing skills, but other times, there are bonafide journalists in the mix. These days, the era of centralized journalists meeting in a bullpen or newsroom are long gone. At Wizard, we had an editorial staff, writers and others who would collaborate in a bullpen. It was modeled after traditional media newsrooms, which have also become relics of the past.

These days, members of the fan press usually work for some sort of website that may also include multimedia, including video. They usually work solo from home for little or no pay. Some columnists and other news writers enjoy regular payment, but most typically do not. They do it for the love, for the network contacts or a myriad of other personal reasons.

Mark Waid is one success story who broke into the comics business working in the fan press, writing and editing for *Amazing Heroes*. It's interesting to see how Waid networked from one area to the next.

ONE FINAL NOTE

The comics business is both a very big and very small industry. It's big enough to accommodate many talents and skills; it's small enough to be a family-like environment where everyone knows each other.

If you want to work in comics, then you should try. As they say, life's short. If you have a passion, pursue it. Make it part of your life, even if it's not exactly what you hoped it would be. If you're going to be a marketer, be the best damn marketer you can be.

I love comics, and I imagine that you do as well. Whatever you do, never let go of that passion. It will see you through the good times and through the dark ones as well. It will help you hang in there when the salaries in comics seem smaller than the pay in other industries. Face it, if you're a good accountant, you'll probably make more money in banking than you will in comics. Do comics out of love.

Whatever you do, do it well. Bring everything you've got. 🗨

CHAPTER 8
THE TOP OF THE PYRAMID:
One-on-One With Joe Quesada

When it comes to dream jobs, there is no bigger dream for comic book enthusiasts than being the editor-in-chief at a major publishing company. Push all of the day-to-day tasks aside, and what you're left with is the ultimate story editor for the characters that you love. And love to hate.

As Marvel's former editor-in-chief—and now their CCO (chief creative officer)—Joe Quesada is the living embodiment of the comic fan fantasy. But he also represents the comic pro fantasy for many working comic book creators. This is because Quesada sits in the chair that guides the complete line of Marvel comics. Sure, he works together with any number of people, including Marvel's publisher Dan Buckley and managing editor David Bogart. But at the end of the day, it is Quesada's responsibility to lead Marvel's published books into creative directions that make people want to buy those comics.

Painkiller Jane © 1997 Joe Quesada
and Jimmy Palmiotti.

MARVEL KNIGHTS TO THE RESCUE

When Quesada assumed the role of editor-in-chief at Marvel, the company was floundering. The Image Comics explosion, the rise of the indie publisher and strong competition from across town at DC Comics had taken a toll on Marvel. Not to mention the questionable business decisions that Marvel had made over the years that seemed to distract the company from their primary focus of producing sellable comics.

Marvel and DC have an enviable advantage in comic book publishing. They own some of the most visible superhero icons, many of which have the advantage of being produced into movies and licensed properties. This helps them keep a core fan base of readers who will stick with a character or title for many years. But the collector's boom of the 1990s soured many fans. Variant covers, sky-high prices and a long line of comics that prioritized art over story simply drove readers away.

During this time Quesada managed to stay one step removed from the controversy. As an artist, he sometimes drew mainstream characters that were featured in, well, less than stellar stories. But as a creator, his work product was never in question. His art was, and still is, a reminder of just how good comic book art can be.

With writer and partner Jimmy Palmiotti, Quesada managed not one, but two major feats in the industry. First, in 1994, they launched and self-published their own alternative superhero comic, *Ash*, at their publisher Event Comics. Not only did the comic sell on the stands, it also sold as a movie property, giving them a view of Hollywood, which would serve Quesada well later in his career.

The success of *Ash* and several other career home runs opened the door for Quesada and Palmiotti at Marvel. They were both longtime freelancers at the company, but this time it was different; they would create one of the most popular and enduring publishing imprints at the seventy-year-old company. In 1998 Quesada and Palmiotti revamped a handful of Marvel characters for their Marvel Knights publishing line. And while it may seem obvious now to have used these characters, many of these characters (including their flagship, Daredevil) had lost their luster in the nineties. Poor storylines, ridiculous character reboots and tons of bad writing had damaged some of these properties so badly that it seemed unlikely that anyone could make them cool again.

And yet, Marvel Knights was cool. Really cool. And it wasn't just the characters; it was a cult of personality that made Marvel Knights the imprint that every creator wanted to be part of. The buzz around Marvel Knights seemed to eclipse the buzz around Marvel itself. Plus, people weren't just buzzing, they were buying, and Marvel Knights was the runaway success that Marvel needed to start getting back its mojo.

Off the page, Quesada and Palmiotti were expert networkers, hosting after-work Marvel Knights events that everyone wanted to attend. At remote conventions and in New York, they brought fun back to the business of publishing comics. More importantly they forged relationships that would help them both on their long, successful career paths.

AND AN ARTIST SHALL LEAD THEM

In other parts of the Marvel universe, Quesada was proving himself to be a surprisingly good writer as well. His work on *Iron Man* helped re-energize that character and franchise in ways that few people expected, leading to new life for one of Marvel's abused A-listers.

Epic internal struggles at Marvel led to editorial shake-ups, and when the dust settled, Quesada had been promoted to Marvel's editor-in-chief. He was, and still is, Marvel's only EIC who was first a freelance artist. The role of EIC typically went to a writer since it was assumed that writers could better guide the stories. But clearly the writer-as-EIC strategy wasn't working for Marvel, and Quesada became the company's agent of change.

As a staffer at Wizard, I witnessed much of this as an industry insider but as an outsider to Marvel. I was extensively involved with the New York community, but was neither a creator nor

Spotlight: Joe Quesada

JOB: CCO (chief creative officer), Marvel Comics

LOCATION: New York, New York

YEARS IN THE INDUSTRY: 20+

HAS WORKED FOR: Marvel, DC Comics, Event Comics, Valiant

CAREER HIGHLIGHTS:

- *Ash*, *Marvel Knights*, *Daredevil*, *Iron Man*
- Former Marvel editor-in-chief
- Co-founder of Event Comics

ONLINE AT:

http://twitter.com/joequesada

a Marvel staffer. But, like many industry professionals of the time, I was impressed that Marvel had promoted Quesada to take over the reins, but hardly expected it to become a long-term solution. In fact, no EIC there seemed to be a long-term solution since many of them lasted fewer than four years.

Quesada quickly fixed many of the creative problems at Marvel and set the company in new and profitable directions. And now, just over a decade later, Quesada is Marvel's chief creative officer. He continues to guide Marvel in unique and surprising creative directions, some of which the fans love, and others that drive them crazy. But, ultimately, Marvel's fans remain enthusiastically involved with both the characters and Quesada. More important, readers seem to be buying Marvel comics based on storylines (and great art), not out of some grudging habit.

Quesada managed to woo back creators who either had never worked at Marvel or had left Marvel to explore other creative opportunities. Because of his art abilities, Quesada brought much-needed credibility to the EIC role. And his work at Marvel Knights, *Iron Man* and other places gave him additional street cred that led to a near stampede of creators back to Marvel. The

company that helped define the modern superhero was once again the place everyone wanted to work.

Quesada's professional résumé is being constantly updated, refreshed and studied. He's leading the company, setting the creative tone and still managing time to create pages. What I write here is outdated by next week, since Quesada continues to invent and reinvent what it means to be a comic book creator and an EIC at Marvel.

I sat down with Quesada to discuss the craft and business of comic books for people like you who want to know more about the industry. And what the industry looks like when you're standing at the top of the creative pyramid.

BUDDY: *On a day-to-day basis, what's your involvement in the creative process?*

JOE: My general involvement is that I'm involved in everything. It's ironic; if I were to dig up a box of my old elementary school report cards and look at the negative versus positive comments I got from my teachers … the negative comments are the things I get paid to do now. [laughs]

New York City is an important part of Joe Quesada and Marvel Comics. Both look to the city skyline for superheroes and inspiration.

"IT'S IRONIC; if I were to dig up a box of my old elementary school report cards and look at the negative versus positive comments I got from my teachers … the negative comments are the **THINGS I GET PAID TO DO** now. Which is basically look out a window and daydream and make stuff up."

BUDDY: *Like what?*

JOE: Which is basically look out a window and daydream and make stuff up. And I remember getting yelled at tremendously in school.

No two days are ever the same for me in any given week. I was just talking to someone today about this. Today, I am looking over animation scripts. Tomorrow, I have our giant Marvel creative summit where I sit in with writers and editors and come up with the next two years' worth of stories. On Monday I fly out to LA, where I sit on the set of *Thor* and watch them film, and then on Tuesday we review the latest revisions on the *Captain America* script. On Tuesday I'm probably working on a new animated project that we're doing. So again, every day is completely different. But every day I have my hands in something creative … while we're just sitting here making stuff up.

BUDDY: *What administrative tasks do you do that are outside of the creative role?*

JOE: I have very little to do with the day-to-day administration of our staff other than to encourage them to continue to think in creative ways to make sure our stories are the best possible stories they can be. Things here in that sense are really lax because we have such tremendous staff. These guys have all grown up with me here at Marvel at this point, and we all sort of have the same goals in mind. Administratively, it's kind of running itself. I have two great executive editors in Axel [Alonso] and Tom [Brevoort] that know their stuff, they really do, so I don't have to look over my shoulder a lot. They come to me with their problems, and most of the time we just confer on where we're going with things. That's what

happens, and it does make life a little bit easier for me here and allows me to do other things outside of comic books.

BUDDY: *Now you mention two things. You mention your creators summit and you mentioned your editors. Who are you interacting with more?*

JOE: Both. I deal primarily with the writers who are writing the big books. The "Prime Movers," as we like to call them, because they're the ones who really generate a lot of revenue for us and occasionally track with the up-and-coming guys just to give them some guidance, but that usually falls more in the purview of Axel and Tom. With editors, I primarily deal with the senior editorial staff, which is Axel, Tom, Ralph [Macchio], Mark Paniccia and Steve Wacker. Everything from there goes down to the associates and then to the assistants who they deal with directly.

BUDDY: *So these guys come to you with the storylines that they're working on, and then you guys work it out, is that how it works?*

JOE: We're producing, on average, eighty books a month. It's very hard for me to get into the absolute minutia of every story, like the little elements of a story that an editor and a writer would be working on together. I deal with more of the macro-planning. Like "Where are the next six issues of adventures taking us?" As opposed to "What's happening in this one single issue?" Unless, of course, if there's a story element that needs my attention, where we're not really sure which way the story should turn, then I'll be called into a meeting to discuss which is the best way for these characters to interact.

I deal with more global stuff, as opposed to the smaller detail stuff, which I used to very early on. I would be involved with every little

Despite a busy schedule in his role as chief creative officer, Quesada continues to generate art and stories for Marvel. (As for the cat cozying up to his computer, we have nothing to say that's printable in this book.)

detail of every story, but it's just impossible for me to do; there aren't enough hours in the day. So that falls on the shoulders of my staff. And also, don't forget there's a lot of design stuff that comes through here, a lot of artwork that comes through here; I still do cover approval of all the covers that come through here, so I'm looking at artwork as well.

BUDDY: *You're also probably developing talent and giving them feedback as well. You can't separate yourself from your art background, right?*

JOE: One of the things that we work very hard at here at Marvel is developing the talent liaison division. In fact, C.B. Cebulski—he's one of the big talent scouts here—sent me an email yesterday with an astounding figure: In 2009 alone, 143 new creators got a shot at writing, drawing, inking, coloring or lettering a Marvel comic. The bulk of those tended to be new artists, but that's a pretty outstanding number. That's double what we did in 2008, so our talent division is out there, constantly looking for artists and writers. And when they do find that person that has that spark, and it comes across my desk and I'm asked, "What do you think of this guy, do you think he's ready?" That's when I sort of step in. Again, because of the growing needs of this job, I'm no longer doing conventions and portfolio reviews; I have other people to do that.

BUDDY: *Assuming now that you're one step away from that granular recruitment, what do you look for in your staff?*

JOE: In my staff? Incredibly energetic, smart people who understand story. You gotta understand story, you gotta understand how it works. I am the first EIC who is primarily an artist first and a writer second. But I think it's because of that that I come to this feeling that story is the most important thing in order to make the artist really shine. You have to give them a great story. Great artists are what attracts a reader perhaps the first time to a book, but it's a great story that keeps a reader coming back and putting down their money consistently because they want to read the story with the great art.

BUDDY: *Let's back up one second. You stated the obvious: You have the art background, but you've touched just about every aspect of creative and business, except for maybe lettering. How does that color what you do there at Marvel?*

JOE: I've been doing this for a lot of years, so I have a lot of knowledge of how to do this stuff. I think, more than all the art training and all the years of drawing and writing that I have under my belt, I think the most valuable learning experience I've ever had was being a self-publisher. Being a self-publisher really taught me how the machinery really works in comics, and what you have to do to become profitable, to market your books. And how to market your books really on no budget whatsoever. Which was a hallmark of Event Comics when Jimmy [Palmiotti] and I were doing it. Which, by the way, is also a hallmark of Marvel because we do great marketing on a very small budget. There are great ways to do that if

you are willing to use your imagination and be daring.

Those are some of the things that were very, very important to me because when I became EIC, one of the things that became very evident to me was that editors were working on books, and they might have known what their books were selling, but they didn't really know what their books were earning. That's something as a self-publisher you learn very quickly. You know this: How much money am I spending to make this, and what am I getting in return and is it really worth the while? So you may have a book here at Marvel that is selling a nice number, but you may also have upper-echelon talent on it and it's costing you a fortune to do the book. In which case, the book isn't really as profitable as, say, a book that might be selling less, that has lower-echelon or new talent that isn't earning as much as a superstar writer or penciller.

One of the things we did here, going back many years now, was to show editors not only what their books were selling, but what their books were costing to make so they had an idea of exactly how to appropriate their talent to a particular title so that they can go off and almost operate each character family as a separate independent company. Not independently creatively, like they wouldn't share ideas, but independent in the sense that they're responsible for their own A&E [art and editorial costs]. They know exactly what they're spending on a book versus what their books are making, and at the end of the day, we'd review. We'd say, "OK, look at where you're profitable, and where you're not." And we all really need to look at the bottom line. That's really one of the things that's helped Marvel become pretty powerful and profitable in this last decade.

BUDDY: *Why do you suppose that in editorial, even in comics in general, people are not really generally aware of the P&L [profit and loss] that's involved with publishing? Why do you suppose that is, and why did you have to introduce that?*

JOE: I don't know. When I started here, an assistant editor had the word "editor" in their name, but they were really just copy boys and girls. That's all they did. They were just sent out to make copies. They didn't actually get to edit books. They might get to do balloon placement, they might get to do menial stuff in the office, but they really weren't editors. And we looked around and said, "This isn't the way to produce editors." If someone's got "editor" in the title, they need to start editing books. So that was another big change that happened here. All of a sudden, with our assistant editors, we told our editors, and senior editors, "Listen, if you've got an assistant editor, then you HAVE to give them one or two books to start editing." It's not going to be the top book in the franchise, but they have to start getting their feet wet. Having them make copies doesn't train them for anything, and that's been very valuable for us as well.

So I think a lot of these things are just the outgrowths of a company that had been in bankruptcy. You're willing to do anything. But also, when you've been in bankruptcy, people are more willing to look in the mirror and say, "OK, how did we screw up here? What did we do wrong, and how can we fix it? Maybe there's a better way to skin a cat here."

That's been something that's been true of comics for many decades. And one of the things that's always bothered me about it is that so many things operated and were done simply because, "That's the way that Stan [Lee] and Jack

Even on his early work, like Valiant's *Ninjak*, Quesada drew incredibly detailed and impactful interior art and covers, which launched an early and passionate fan following.

BUDDY: *You've also got unit sales. You can be profitable in the short term with the hot talent team, but you're not going to necessarily maintain sales.*

JOE: No, you might not maintain sales. But you also know that big talent comes with a big price tag, so you're paying a lot more to get that book produced at the end of the day. That team will want the best paper quality, best colorist, and one thing leads to another. And it's understandable, everyone wants to work with the best, so it puts a bigger price tag on it. That's why you end up putting bigger talent on the bigger books—because it's more cost effective.

BUDDY: *Let's shift gears a bit and talk a little bit about the production process. A lot of people have talked in the interviews for this book about deadlines and missed deadlines. Why is it important for creators to enforce deadlines?*

JOE: It's certainly important—and I'll get flayed for this by the public—but the truth of the matter is that it isn't as important and detrimental as it used to be when we were in the newsstand business, and you would lose slots at the newsstand when books didn't ship. It is still important with respect to having a publishing plan. Whereas every book used to be slotted for twelve issues a year, we're much smarter with our publishing plans today. We look at our books and say, "This is a book that maybe we'll only slot ten times a year" because of the team involved. Or, because of the team involved, we can actually produce eighteen issues of this book a year. So we give and take depending on the needs of the creators

[Kirby] used to do it, that Julie Schwartz used to do it." When those guys were doing it back in the fifties and sixties, they were doing it for a particular reason that was appropriate to the fifties and sixties in a business sense then. But I'm sure if you'd pulled Stan Lee [aside] in 1964 and whispered in his ear, "By the way, in the year 2000 they're still doing shit the same way you do it now." He'd be like, "*What?* It's thirty-six years in the future, and they're still doing *this?* Are you kidding me? Why hasn't the industry grown?" [*Note:* See page 125 for Lee's actual present-day reaction to this.]

It was really the obvious things that had to be addressed to get people thinking creatively. It's part of the creative process, I think. Knowing your talent, knowing what your budgets are, and then coming up with a creative solution like "How do I make Deadpool really profitable?" It's very easy to put a superstar writer together with a superstar penciller, and watch it soar in sales. It's another thing to make it profitable.

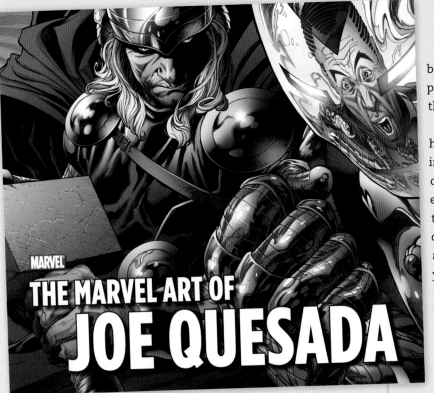

Some key pieces of Quesada's art are featured in this stunning 2010 hardcover. It shows the passion that he brought to the comics industry, especially to Marvel.

involved in order for us to put out the best product possible.

There are certain books that definitely do have to come out [on time], but it's become much harder for artists in this modern era to produce as fast as they used to in the sixties. This has nothing to do with work ethics of artists, nothing to do with anything other than the demands of the public with respect to what they expect from art in comics. If you look at the books from the sixties, the style was simpler; it was quainter. That had nothing to do with the skill of the artists in those days; it had a lot to do with "Hey, we've got to get it done, we've got to get it out the door." But it also had to do a lot with the expectations of the people that were reading books. Today you've got video games, you've got movies with incredible CGI, [a public] eye for detailing all this stuff, and realism that the viewer comes to expect. So, in comics, if we started producing

books with the same sort of coloring palate, printing process and art style that we did in the sixties, we would be extinct today.

So artists and production values have had to adapt to that. Coloring has become incredibly intricate, beautiful and three-dimensional and fully rendered on computers. The artists had to keep up with that, too. Back in the day where you could sort of fudge in a building in the background and be a little more impressionistic, now you've gotta get in there and really draw those buildings, draw that skyline, draw the detail, and the detail of the characters' faces and light sources and all these things. So the demand on the artist has become excruciatingly hard. Even when you have an artist who can produce a monthly book and can produce twelve books in a year, chances are after that year, they're going to need three months off just to get their heads together because it is such labor-intensive work that you suffer from burnout. It's a different era, and again, a lot more expectations from artists than ever before.

BUDDY: *Would you say that in the publishing portfolio, an event is probably more driven by deadlines than a monthly book? We think about these big events as where books have to come out at a certain time. There's probably a heightened awareness at that point.*

JOE: With the events, we do have to plan as carefully as possible. We had a bit of a problem with our *Siege* event in the sense that so much of it revolved around Steve Rogers, Captain America and the *Captain America: Reborn* series. We had a monkeywrench thrown into that when Ed Brubaker realized that he really needed an extra issue to finish his Captain America stories. The *Captain America: Reborn* story didn't finish when it should, but the *Siege* event started exactly when it had to, so we ran into a speed bump there in the sense that the stories overlapped and some fans

got upset. But it's one of those things … when you are doing an event, so much of your publishing plan—not just physically, but storywise—relies on that. Because when the event is over, you have writers who are now already working on stories that work off the new status quo that was set up at the end of that event, and you just can't stop that train. You could stop it, but you'd literally have to stop publishing for a month just to catch up, and you can't afford to do that.

BUDDY: *One of the things that people don't really talk about that much, but I wonder what influence it's had on your life being a performer, being a musician that got up on stage. What sort of impact did that have on the job you have now?*

JOE: It keeps you from being shy. Most people who meet me away from a convention or away from a stage are always surprised by the fact that I'm kind of reclusive; I'm kind of shy. I'm not the kind of person who walks up to a person in a crowded restaurant and starts talking. Onstage, I create a different persona, and I'm much more boisterous and outgoing. I don't get butterflies and things like that. It can be three thousand people or ten thousand people, it doesn't really matter to me—I just see a mass and go out there and do my thing, so it's helped me with that.

I think it's also helped me with respect to the editor-in-chief persona, sort of create a bit of performance art with it, but that's where the stage stuff comes in. I did that for many, many years, but the music end of it is very, very important when it comes to drawing and writing stories because I do sort of feel them as though they are musical pieces, with ebbs and flows and crescendos, especially when I draw—it's very rhythmic to me. When I write, it's got sort of the ebb and flow of a symphonic piece in my head. I think that's where music has really come in handy for me and helped me with my storytelling. Whether that's a good thing or a bad thing, someone else can judge, but for me, it certainly helped me with that stuff.

Published by Event Comics, *Ash* was a breakout indie publishing success, paving the way for multiple comic book spin-offs and even a TV show.

BUDDY: *You talk about the editor-in-chief persona, and probably the last BIG editor was Stan [Lee], and I wonder, what advice did you get from Stan, if any, and what advice did you get from any of the other editors. There weren't that many of them.*

JOE: I didn't really get advice from Stan about being editor-in-chief; I think it was the story advice from Stan about what makes a Marvel character a Marvel character, and stuff like that. And it was stuff I sought Stan out for and just talked to him about. I have two people that gave me advice. [Comic art legend] Neal Adams wrote me a wonderful letter the day I became editor-in-chief—and I still have it framed at my house—basically congratulating me, and his words of advice were, "Join a good gym, stay healthy because you are going to gain weight on the job," which he was right about, "and be good to the people you work for and work with." And that was an important thing. I am a firm believer in that, and it was really nice of Neal to say that. I definitely live by those words.

And then there was [former EIC] Tom DeFalco, who came in maybe week two on the job. Tom came in and congratulated me and said, "Listen, you have to understand you have to have a broad back for this job because you will get blamed for everything that is perceived as bad, and you will get no credit for any of the things perceived as good, and you'll have the world's biggest target on your back." That was pretty sage advice and I took that to heart, and [he] said if you can't handle

that, then don't do this job. I took it as a challenge. Just to say, "I get that, and I am going to have some fun with that as well." If I'm going to have a target on my back, then I'm just going to become a clown and have some fun with it, and that's worked out pretty well. We've had some fun with our fans, had some fun with our competition, and it certainly made the job interesting for me.

BUDDY: *Now flip it around. What if you were like "I've had enough," and were ready to go back to doing whatever, what advice would you pass along to your successor?*

JOE: Probably about the same thing. You've got to be ready to take on all comers. One of the important things that I had to learn on the job was … Stan had a mutant power. His mutant power was that he could write a small column, [*Stan's*] *Soapbox*, he could meet you at a show, and you end up feeling like you've known Stan for your entire life. That's his mutant power. No one I've ever known, myself included, have I ever met with that kind of mutant power … Stan created a lifestyle and that's something that companies pay people a lot of money to try to develop, but we have it in our DNA.

We have fans who want to know what it's like to be here, to read our books. They're all part of the [Marvel] Universe. It's one big thing and the readers are included in it, but we have to keep it alive. As writers, as editors, as artists who work at Marvel, the more we keep that alive, the more we let the fans in behind the curtain to see what's going on, the more they love it, and the more they want to respond by becoming a part of the family and igniting the creativity. They pay our bills and hopefully walk away with a smile on their face when it's all done. Anybody who takes over this job should never lose sight of that: The person who's actually reading these pages, they're the ones who are paying the rent. They're really the most important people in the mix.

BUDDY: *The fans don't take this stuff lightly, at least some of them. This is real for them; some of them are really into this.*

JOE: No, they're ALL very much into it, just to different degrees. I completely get it. You're not going to make everyone happy, ever. When it comes to Marvel decisions, if you read the Web, you'll make no one happy, ever. But that's OK because they keep coming back for more. As long as they're passionate about it, we're doing our job.

BUDDY: *The Web is a huge component of what you do. When we started out there wasn't even a commercial Internet, at least the way we know it. How has technology changed what we do in comic publishing?*

JOE: It's changed everything, and it continues to as we start to do motion comics now. It's changed everything from the creation of comics, the marketing of comics, to how we communicate with our fans. I think I embraced the Internet pretty early on; I was certainly on the Net when we were doing Marvel Knights here. I think I started when we were doing Event Comics, and there was very little on the Internet at that time. I could definitely see that this was going to be a tremendous tool, and I think I learned a lot of lessons early on in those days that, sometimes, those fans that are irate at some of the things that may be said or marketed or put out there, sometimes those are your best marketing agents. Those are the people who get the word out there about the product you are trying to put out. A little controversy never hurt anybody, and we like to play with that.

At the same time, when you look at some of the stuff we put out on Marvel.com, we're very self-effacing. We make fun of ourselves before we make fun of anybody else, and then we make fun of everybody else, too. To me, that's a part of it. Comics are fun. It's not serious business; it's a beautiful art form, and it's fun. The worst thing we've ever done in comics was we killed some trees to make funny books, but outside of that, it's all been good.

BUDDY: *What part of the Internet gets "weird" for you? Or does it at all get weird for you? You're living in public, and you've got a kid, you've got a wife. Is it*

weird? Do you find yourself trying to control parts of it in your image, or is it just that you have to let go?

JOE: I keep all my personal stuff off the Internet. If you ask someone what are my political beliefs, what are my religious beliefs, no one can tell you because I don't talk about that stuff. I don't feel it's my place to talk about that stuff; I'm a Marvel employee. I work for Marvel, and Marvel is not my soapbox—Marvel belongs to our readers. I don't get into the intricacies of my life. I'll talk about movies that I like, my baseball team that I like, but it doesn't get much deeper than that. I keep my family out of it because I don't feel that it's fair to my family at all to be involved in any of this stuff.

I've had maybe three occasions where things maybe got a little bit weird in fandom where authorities had to be called, but for the most part it's been nothing but a fantastic experience. You get the irate fan here and there, but they're fun to deal with and they're fun to get into an exchange with time after time, and everybody's got a point of view—they're reading the books, too. It's always pretty cool. I think as long as you tread carefully and you don't mix your business with your personal life too much, you're okay. It's not like I'm some huge celebrity or a major politician that I really have to worry constantly about things like that. Comic fans are very cool, and they're very respectful of what we do and our privacy.

BUDDY: *On the technology end on the creative side, how has comic production changed, especially from a publisher's/editor's perspective?*

JOE: We still do some FedEx. But scanners, electronic drawing boards, the Wacoms, the Cintiqs—all these things have so changed the way we do business. And, actually, every once in a while buys us an extra day here and there. I still draw on boards, but I probably do half on a Cintiq tablet. I'll usually do that when I'm on a crucial deadline, and, looking ahead, if it doesn't

Through Event Comics, Quesada and partner Jimmy Palmiotti developed a new line of original titles, including *Painkiller Jane*, which went on to become a Sci-Fi Channel TV series starring Kristanna Loken.

get to the inker by a certain day, it can screw up the entire deadline, so I'll just go digital and email it out. It's definitely helped on that front. As we start moving into motion comics—and who knows what else might be out there—it all changes so quickly that by the time your book comes out, all this stuff I'm talking about could be old news.

BUDDY: *Are we seeing the industry shift first from digital coloring, digital lettering, to digital inks? Do you think that's the next real direction?*

JOE: There is some of that going on. The only reason it is not completely converted over is because there is still a large original art market for comic book art. As an artist, I know when I do a digital piece that I'm losing out on significant revenue. If it's a Wolverine piece, I can probably sell that for a lot of money. Oh well, it's digital, there goes that. If there was no original art market, you would see

the comic industry probably become completely digital, with the exception of some people who just don't want to embrace the technology.

BUDDY: *This isn't just mercenary; this is literally part of the way that artists earn their living, right?*

JOE: Yeah! The thing is that, as a writer, if you're prolific, you can make more money than an artist can, simply because a prolific writer can write two, three, four books a month. The fastest artist maybe can do a book and a half a month. *Maybe* two books a month, but that's really pushing it. Those guys are few and far between. I would venture to say that the average speed of an artist is about six to eight weeks a book. You take that into account—twenty-two pages plus cover—the original art market does help a lot of artists get some extra income and keep themselves above water. Especially if you're plugging away and really trying to make a living.

BUDDY: *Theoretically, as you said, they could go to Cintiqs. There are a few guys—like Freddie Williams II and Brian Bolland—aren't they all-digital now?*

JOE: There are a lot more guys who do it now than others. I've adopted a philosophy where I'm doing a lot on the Cintiq. I haven't actually pencilled a 22-page story in a while, but I'm going to start one very soon. I think my philosophy is simply going to be—and it's very mercenary—but it's dollars and cents in this economy. There are certain pages that sell, and certain pages that don't. Pages with characters sitting around talking, nobody wants to buy those. Pages with superheroes swinging around, people want those. So chances are—just to expedite matters—the talking pages, I'll do those electronically. The other pages, I'm going to do those by hand. This way I can sell what I can sell and what's not going to sell—well, I got it done, and done quickly. I've heard of a couple of other artists when I mentioned this that were talking about possibly adopting this too, or are already experimenting with the Cintiq.

BUDDY: *In the end, as you mentioned in the very beginning, it will come down to story. It's how well you execute the story and can get the story that you want. It makes sense, right?*

JOE: Yeah.

BUDDY: *So tell me what part of your job do you like most, and the converse, what do you like the least?*

JOE: The part of my job that I like most is just showing up to work because I literally have a different thing to do every single day. No two days are the same, so I really do love my job. I really do. The part that I like the least these days is the traveling. These days I do more traveling than I ever imagined I'd be doing, so that becomes a drag, especially because I'm a bit of a homebody and I like spending time with my family. There are times when I have a drawing assignment to do, and I'll take a day off from work and I'll just sit at home, and wake up with my daughter, and she'll have breakfast, and I'll be drawing, and she comes home from school, I'm drawing and I come back and I think, "Yeah, this would be a good life, I can do this if I wanted to," but I'm still having fun doing the editor-in-chief thing, so I'll keep going for a little bit longer and see what happens.

BUDDY: *As editor-in-chief, what percentage of your job is working and what part is psychologist, where you're talking people off the ledge or trying to cheer people on?*

JOE: I used to do more of that than I do these days because I don't have as much interaction directly with our talent. The role of psychiatrist these days is falling more on our talent division and our editors, so there isn't a lot of that that I do. Quite frankly, I'm the one who needs the psychiatrist at this point. It used to be a lot—and I don't mean this as being detrimental towards talent, because I have been there—when you work day in and day out in your home ... and I know a lot of people say "Boy, that sounds great, working from home like that; sounds fantastic."

But when you're working from home, and you are staring at a blank page—whether it's in a word processor or on your drawing table—and you're looking at the same four walls every day, and you've got to crank something fresh and exciting out, it's pretty mind numbing. And every once in a while, you get the sense that you may go postal if things don't break just the right way.

During those freelancer days, I would go through fits of joy, fits of anger, fits of depression, fits of never wanting to draw again. It's a lot of being in your own head twenty-four hours a day. That's why we as creators, every once in a while, need the editor to come in and hold our hands, pat our heads and tell us it's going to be OK, or sometimes just call us up and say, "Hey, get your shit together, we need to do this," and they play bad cop. But again, I do very little of that these days because I'm not involved with those day-to-day dealings.

BUDDY: *I'm sure you stepped up from the earlier role where I'm sure you had to say "no" a lot to a lot of people. Was that a hard thing to sort of get [used to]?*

JOE: Yeah, it was, but a lot of it is that I don't have the direct interaction with every single creator coming up on our book. Back in those earlier days, I was dealing with every artist and every writer on every book, so a call from me was important. These days, now that we have our senior editors who are more the conduit with a lot of our talents, a call from me would just come out of the blue and be really foreign because I don't do the day-to-day dealings with them. There are certain talents who I do have day-to-day dealings with—we speak a lot—but it's just a matter of who's comfortable with who.

There are certain creators who are certainly comfortable with different editors more so than they are with me; those are the people that they want to talk to. They don't want to hear from me. I'm not that person who's been there in the trenches with them. I'm the guy who writes the column. ●

THE CINTIQ: TODAY'S TOP TOOL FOR ARTISTS

Let's face it: It's not easy to create art with a mouse. So Wacom developed the Cintiq electronic drawing tablet, a specially designed LCD touchscreen able to be drawn on with a special pressure-sensitive pen. This mouse-alternative device has been resident on desktops and even gaming devices (like the Nintendo Gameboy) for more than a decade.

The Cintiq is one tool that some comic book pencillers, inkers, letterers and colorists are using to streamline their workflow. For certain artists, the technology closes the gap between analog technology (paper and pen) and digital. In some cases, it eliminates original art boards completely. The Cintiq reduces steps in the creative process, which translates into greater productivity and speed for many artists.

So who's using it? Well, in this book we hear from Joe Quesada, who sometimes draws complete pages on the Cintiq. Brian Haberlin uses it as part of his suite of coloring tools. And Chris Eliopoulos uses one to place word balloons and other lettering assets for Marvel.

Sure, these are all top creators in their field, so they can justify the expense of snatching up the latest technology. But the prices of technology traditionally decrease as quality increases, so it's not hard to imagine that the next generation of artists is already learning how to draw on Cintiqs or some other similar technology.

Do the Cintiq and tools like it spell the end of the old way of creating comics? Nobody can really say, but the cost and quality of art technology will soon cease to be a barrier to experimentation.

Quesada at his own Cintiq.

STAN LEE

MEETS

SILVER SURFER

LEE
WIERINGO
JENKINS
BUCKINGHAM

MARVEL®
.com

1

CHAPTER 9
THE MAN HIMSELF: A Candid Conversation With Stan Lee

There's nothing that I can write about comic book legend Stan Lee that you probably don't already know. Former publisher for Marvel Comics. Co-creator of the Fantastic Four, Spider-Man, Hulk, X-Men and virtually the entire Marvel Universe. The rest is just a Google search away. So let me tell you a little story about meeting him.

Back in the late 1990s, when I was working for Wizard Entertainment, the company had just begun running the Chicago Comic Con. As part of the grand launch, Wizard brought Stan to the show. He would make a limited appearance, maybe sit on a panel or two, cut the inaugural ribbon or something like that.

It was a fairly standard appearance for someone like Stan Lee, who has been hailed as a living legend in the comic book business (more on that later).

For reasons I still don't know today, I led the team that managed the on-site security. It was a questionable role for a short, out-of-shape editorial person. But that's what it was.

We were all connected by headsets and had a pretty good sense of where each other was on the show floor. As a fan, you get a ground-level view of the convention floor, but when you work for a show, you often get a bird's-eye view from the show office. At one point, the radios grew silent. Individuals on staff were getting harder to reach on the radio. Not a good thing in a show with over 30,000 people in one room.

Seeking answers, I made my way into the show office. And there in the center of command central was Stan Lee, with half of the show staff sitting in a semi-circle around him. Someone gave me the universal "keep quiet" sign, and I sat down to see what was happening.

In that moment I saw truly and clearly for the first time what makes Stan Lee so special.

Marvel celebrated sixty-five years of Stan working at Marvel with the *Stan Lee Meets ...* five-issue series. Issues featured Stan in offbeat stories with the Silver Surfer, The Thing, Doctor Doom, Doctor Strange and other Marvel characters.

STAN LEE, CAMPFIRE STORYTELLER

Imagine for a minute that you're at a convention run mostly by comic book pros in their mid twenties and early thirties. None of us is especially young or old, and we've all been around for a while. We've met just about every possible industry professional. We've shop-talked over dinner, bent our elbows at the local pub, even gotten to know each other's loved ones. We're all part of a big, sprawling family of fans who've crossed over to being pros. After a time, we relate to these people as friends and colleagues, so we're no longer starstruck.

But Stan was different. Here he was, among journalists, convention planners and even jaded comic book creators, sitting and sharing stories. I can barely recall what all the stories were about, but I clearly remember feeling this magnetic pull to sit and listen.

At the time, Stan was probably already in his seventies. But he managed to tell stories with such impact that he literally had an entire room of people in their twenties and thirties momentarily abandoning their jobs during crunch time just to listen. Seriously, how many people in this age bracket will sit quietly engaged as they listen to a guy more than twice their age tell stories? How long would you sit before you started texting on your cell or scrolling through your iPod?

And, not because he was "Stan Lee, world-famous publisher" did we listen to him. Not because he was a guest of the comic con. Not because we were just being polite. We were listening because he was a phenomenal storyteller. Compelling, entertaining and downright charming. A world-class raconteur who knew exactly how to captivate the room.

It was this elusive X-factor that helped Stan shape Marvel Comics and the entire comic book industry into what it is today. There is no more central, pivotal and occasionally controversial creative individual in the comic book business.

Some creators are lucky to create one important comic book character in their career. Stan literally created hundreds of characters that spawned additional thousands. He broke rules,

Above: Stan at the 2009 Long Beach Comic Con, cutting the ribbon for the first annual show. To his left is Christina Arrobio-Zietsman of The Hero Initiative; to his right is comic-con organizer Martha Donato. *Next page, left:* Stan is awarded a certificate from the city of Long Beach declaring October 2, 2009 "Stan Lee Day." *Next page, right:* Comic book creator Jeph Loeb reading the Long Beach declaration to Stan.

created new paradigms for creativity, and adjusted society's perception of the entire art form. Based on his creative output as a writer and then his guidance as an editor and publisher, Stan may possibly be the most commercially successful writer ever. It is nothing less than, well, superheroic.

After a little while in that show office, the acute needs of running the comic con became too much to ignore. Stan had places to be, and we had to help him exit the convention. With the spell broken, Stan thanked us for our hospitality, and we thanked him for being Stan.

My team had to help Stan make it out of the convention and back to the hotel. It was a slow process because Stan graciously stopped for every person who wanted a picture or autograph. Stan was a rock star without any of the messy ego. The fans gave love, and he gave it right back.

EXCELSIOR! THE GODFATHER OF COMICS

Stan continues to give generously of his time and memories. He's now in his eighties, but he's fit, funny and amazingly sharp, as I rediscovered when I interviewed him for this book. I tried to go beyond the standard questions like, "How

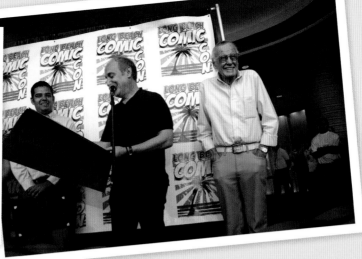

did you come up with Character A?"
That's been asked and answered already. Google it if you don't already know the history of Spider-Man, the Fantastic Four or any other segment of Marvel history.

The idea behind this book is to give you the insight and resources you need to succeed in mainstream comics. So Stan and I talked more about the craft and the business of comics, his experiences and philosophies, which I hope gives you a little extra edge in your career. Despite the fact that the comic book industry has grown in new and novel directions, Stan's advice and insight continue to be valuable. It's timeless and boundless. After all, Stan started things in 1961 that we still do today. The way we create, publish and promote comics is not all that different than how he did it fifty years ago. It was and will always be about storytelling. Strip away the medium—in this case, comics—and Stan "The Man" Lee is the consummate storyteller.

Sit down, and pay attention. The Man has stories to tell.

BUDDY: *Stan?*

STAN: Hello?

BUDDY: *Hello, how are you?*

STAN: Well, that depends how you're going to treat me.

BUDDY: *[Laughs] I think I'm going to treat you really well.*

STAN: Then I'm fine.

BUDDY: *Thank you very much for taking a few minutes to talk.*

STAN: You're very welcome. It's a great sacrifice on my part.

BUDDY: *[Laughs] I would agree! I'm writing a book right now that's about the craft and business of creating comics. And I wanted to get some insight from you. When you first started out at Marvel, you were quite young, and what I was hoping to understand was how much influence did you have on the process of creating comics as you developed and increased your roles there at Marvel. How did you influence the process, and what did you bring to it?*

STAN: Well, in the beginning when I started, I worked for a publisher called Martin Goodman; he owned the company. And I did pretty much what he wanted me to do. He'd say, "I want you to make up a couple of new Western heroes; I want to put out a few Western books." And then he'd say later on, "I want to do some animated comics," or "I want to do some teenage comics," or "I want some horror comics." Whatever it was, he would ask me to come up with the concept for different types of comics, and I would do that. I would present them to him, and he was either very easy to please or I just batted a thousand, but he usually OK'd everything I presented to him. And that's the way we worked. Never gave it much thought. You need another Western? OK, I'll come up with a Western hero. How's this? OK, fine; let's do it.

BUDDY: *But then in the sixties, your role grew exponentially. How did that process change? You obvi-*

ously had a lot more influence on what was released through Marvel, right?

STAN: Well, by that time, I was really in charge of the whole operation. Everything still had to be OK'd by Martin, but he automatically okayed everything, pretty much. Except when I wanted to do Spider-Man. He thought that was a terrible idea and didn't want me to do it. I don't know if you've heard this story, but there were three things he [didn't like]. I said I wanted to do a hero named Spider-Man, 'cause he said, "Let's get another superhero." I said, "OK, I've got this idea called Spider-Man. I want him to be a teenager with a lot of problems so that the young readers could empathize with him." Martin said, "That's the worst idea I've ever heard." He said, "First of all, people hate spiders, so you can't call a hero 'Spider-Man.' Secondly, a hero can't be a teenager. A teenager has to be a sidekick. And finally, you say you want him to have problems? Stan, he's a superhero. Superheroes don't have problems. Don't you know what a superhero is?" So I was really not exactly batting a thousand with that one. But we had a book later on that we were going to kill, and when you're going to kill a title, nobody really cares what you put in the last issue. So I featured Spider-Man in that one to get it out of my system. I put him on the cover. The book sold like crazy. So Martin came in to me a short time later when the sales figures came in, and he said, "Stan, you remember that Spider-Man character of yours that we both liked so much? Why don't you do a series?" And that's how it happened.

BUDDY: *[Chuckles] I guess that worked out pretty well.*

STAN: Yeah, it did.

BUDDY: *One of the things that was noted in your bio a couple of times is you were in the Army. When you came out of the Army, how much of what you learned there did you bring back to Marvel, particularly in an organizational/structural way, to run things over there at Marvel?*

STAN: I don't know. I never thought of it before. I learned a little bit about how to write a screenplay and a film script because I did a lot of that, but that didn't have too much to do with what I was doing at Marvel, and organizationally, Marvel was a very tight-knit organization and it couldn't—I don't think it could have—run much more efficiently than it did. We had—I was there, I had an assistant editor in the sixties, I had a production man, we had some letterers and a colorist on staff. We had one artist, John Romita, who was on staff quite a bit. Most of the artists were freelancers who worked from home. They'd mail their stuff in or bring it in. And that's the way we operated. We operated that way before I went into the Army, and we operated that way after I came back from the Army.

BUDDY: *Now a lot of people think of comics as separate from magazines, but you ran it very much like a magazine business, is that right?*

STAN: It is a magazine business. It's the same thing. You have issues that you must get out on a periodic basis; our magazines were all monthly. And you have to have them at the printer on time, you have to plan them ahead, you have to design covers for them—it's every bit a magazine business.

BUDDY: *And yet people today somehow think of it as not like the magazine business because we have the direct market. How do you think the direct market changed the way the comic book publishing business worked?*

STAN: I really don't know. Before the direct market, you had regular wholesalers who would send the books out to newsstands all over the country. With the direct market, you now have mainly one distributor who sends the books to comic book stores and whatever chains you can get into. I was never really that involved with the distribution, to tell you the truth. My job kept me so busy just producing the books that what happened after the book left the office on the way to the printer or engraver, that never con-

cerned me. There was always somebody else who handled that.

BUDDY: *But you must have, like any consumer, shopped newsstands. Obviously, you lived in Manhattan for a lot of your career. Did you see your work product up there, and did it any way influence the way you created other work product? Because there were other publishers even at that point, some of which…*

STAN: Well, the one thing we did was, covers in those days were much more important than they are today. Because in the early days, there wasn't the amount of fans that there are today. Comics hadn't become as big in the sense of fans who couldn't wait for the next issue all the time. So comics were more or less an impulse buy on the part of the public. A kid would say, "Gee, I'm gonna get a comic book," and he would go into the local candy store, as we called them—you know, little shops that sold newspapers and had a soda fountain and a big magazine rack. And they would look through the comics, and if a cover caught their eye, that would usually be the one they'd buy. So to us, covers were one of the most important elements in the magazine. And I designed all the covers myself. I worked very hard on the covers. And it was very important to us that our covers were colored in such a way and drawn in such a way that in some way they'd stand out from the rest of the magazines.

Now today, it's somewhat different. Today the fans are so strong in their convictions of what they want and don't want—for example, if somebody is a Spider-Man fan, he will go to the comic book store to buy the latest Spider-Man. It won't matter to him what the cover looks like. We won't have to figure "I hope the cover catches his eye," because he'll just say to the dealer, "Give me the latest Spider-Man." Or he'll look for that himself. Do you know what I mean?

BUDDY: *I do, yeah.*

STAN: Now they go to buy a specific book. Even if the cover is blank, there could be nothing on the cover, but if they want that particular book, they'll buy it.

BUDDY: *Even at a much increased price point, as well.*

STAN: Well, everything has gone up. I remember when a bar of chocolate was a nickel.

BUDDY: *[Laughs] Yeah. No more!*

STAN: It's all proportionate, you know. Comics are still, I think, one of the cheapest forms of entertainment.

BUDDY: *They're still pretty competitive.*

STAN: Yep.

BUDDY: *One of the things Joe Quesada mentioned when I was interviewing him was that he said that "Stan would be amazed if he knew that we're still making comics almost exactly the way that he was back when he started out." Are you surprised at that? Or is there just a core concept of creation that is universal, with some minor variations? Or are you surprised that they're making comics almost exactly the same way?*

STAN: Well, they're not making them exactly the same way, but I'm not surprised. I mean, they're using computers for the coloring and for some of the lettering, but basically a comic book is a script that's been written and given to an artist, and the artist illustrates it. And on the page, you see the illustrations with the dialogue leaded in. And that's what a comic book is, so that will never change that much. And so he's right in that sense, it hasn't; the basic formula of a comic book hasn't changed. But a lot has. I mean, the stories are now written for much older readers, for the most part. The coloring is so intense and beautifully done that some of the pages look like they ought to be hanging in museums. They look like real illustrations rather than just comic book artwork. And other than that, though, he's right. They come out every month, they're continued stories, they feature

superheroes, and they're written and drawn. [Chuckles]

BUDDY: *Well, you know, Mark Waid—I was interviewing several people, and they had mentioned you. He mentioned a very similar thing that you had mentioned, which is, you were not necessarily writing for, A, an older audience, and B, an audience that was an automatic purchase. And at a certain point, I would imagine, in the sixties or seventies, there was a tipping point, perhaps, where you became aware of the full continuity and the impact on the audience. Was there a tipping point when you realized, "This isn't disposable entertainment"?*

STAN: [Chuckles] Yeah, "You're not in Kansas anymore, Dorothy." Yeah, I realized that. It was after we did the *Fantastic Four*. That was the comic book that, for us, started the whole new trend. It really sold very well, and we started getting fan mail, which we had never gotten before. I mean actual letters from readers commenting about the stories. And the funny thing is, it started out most of the letters written in crayon. Then, after a while, they were written in pencil. Soon after, they were written in ink. Then we were amazed to find that a lot of the fan mail was typewritten. Then some of the return addresses were from schools, from high schools, and then later from college. So you'd have had to be blind not to realize that you were upgrading the audience.

See, what happened is when I started doing the *Fantastic Four*, my publisher had always, prior to that, said to me that he didn't want too much dialogue in a story. Kids didn't want to read that much. They wanted action. Just get a lot of exciting pictures and don't worry about characterization and all that stuff; just keep the story moving with a lot of action. Well, when we did the Fantastic Four for one of the first times, I decided I really wanted to write it as though I was writing a novel or a movie. I wanted to get real characters who each had their own personality and so forth. And I used whatever vocabulary I thought was appropriate. We really used college-level, or even above, vocabulary. If I wanted to use a word like "misanthropic," I'd use it, and I figured the kid

would understand what it meant through its use in the sentence, or he'd get it by osmosis—or if he had to look it up in the dictionary, that wasn't the worst thing that could happen.

So we started doing the comics in a different way. I started really writing them for myself. What kind of stories would I enjoy reading? And, as I say, the fan mail started coming in from older and older readers. So that was the point in the early sixties after we had done Fantastic Four, Spider-Man, the X-Men, the Hulk, Iron Man, Thor, Doctor Strange … Everything changed. We developed a real enthusiastic fan following, and I knew we were on to something.

BUDDY: *Did that increase the difficulty of writing and creating for you? Mark Waid addresses this. He said, "It makes it harder because now I know that everything I write is going to be polybagged and saved somewhere and cataloged." Did that add a pressure for you, or you didn't feel a pressure at that point?*

STAN: No, it made it easier for me because I was writing the way I wanted to write, and I never had in the past. No. I loved doing it that way.

BUDDY: *Let me transition to something else because again, Quesada had mentioned that one of the big Marvel myths that was created, perhaps in hyperbole or just to get people excited, was the concept of the Marvel Bullpen.*

STAN: Yeah, that's right.

BUDDY: *Can you explain what it was, and also what you made it out to be in the pages? Because as a kid growing up reading, you know, I believed it all. There was just a bunch of y'all hanging out in an office, working.*

STAN: Yeah, I wished it had been. Our office was too small for all of us to hang out. But I tried to make it seem as if we were all hanging out together; you're absolutely right. I wanted the readers to think we're just a bunch of wild guys and we're having fun doing what we're doing. Actually most of the guys were married men

"I wanted the readers to think we're just **A BUNCH OF WILD GUYS** and we're having fun doing what we're doing. Actually most of the guys were married men who lived in Long Island or New Jersey and commuted—not daily, but when their work was finished, they would come to the city or come to Manhattan where we were and deliver the artwork, and then they'd go back home again."

who lived in Long Island or New Jersey and commuted—not daily, but when their work was finished, they would come to the city or come to Manhattan where we were and deliver the artwork, and then they'd go back home again.

But we did have some, as I mentioned before, some people in the office. We had the letterers and colorists and production people. And there was always some freelance artist coming in delivering work and hanging around for a while. Sometimes there'd be a few artists there. Sometimes a guy would say, "Could I sit here at the drawing board for a few hours or for the day and work? My wife has company home and I can't concentrate," or something. But I wanted to make it seem as if we're all in one place having a hell of a good time. I just wanted to get a warm, family-type feeling for us. That's why I said we all work in the bullpen. It was just fun; I enjoyed writing about stuff like that, about the way I really wanted it to be. So it was, um… maybe… 60 percent true.

BUDDY: *So did you ever—and maybe you have—did you ever think about what a good marketer you were in terms of marketing not just the fun and perception of Marvel, but all around, marketing the product out of the marginal gutter of entertainment into something real? Did you ever stop and think about what a success you were as a marketer?*

STAN: Not then, but I realized it later. See, I've always loved advertising. I've always thought of Marvel as one of the world's great advertising campaigns that very few people were aware of. You know, even our name—we had been called

Atlas until we started with the *Fantastic Four* type of books. And I decided we ought to change our name because I loved the word "marvel"—which had been the name of Martin Goodman's first comic book, *Marvel Mystery Comics*. I loved the word "marvel" because I could play with it. I could come up with phrases like: "Welcome to the Marvel Age of Comics. Marvel Marches On. Remember, whatever you do, wherever you go: Make Mine Marvel." You know? I could come up with sayings and slogans, and I could call our fans Marvelites: "I want all you merry Marvelites to remember this…." You know.

And then I started the *Soapbox* column, where I talked to the fans month after month about anything at all. I didn't make it seem as if I'm just advertising the books. I might tell them that one of the artists got a new dog, and he's having a lot of trouble with the dog. Just anything I thought of to make them feel that we're all friends and that we're all sharing a little something that the outside world isn't aware of. And I did it very intentionally to give Marvel an image to make the readers like us, want to be part of us. And it made it fun for me because it was really sincere. I mean, I liked our fans, and I would have loved the idea—I did love the idea—that we were a tightly knit group who were all having a lot of fun together, and people who didn't read Marvel, they were unfortunate because they didn't know what they were missing.

BUDDY: *You know, here you have this unbelievable machine, and yet you probably could have landed anywhere and taken this same approach to marketing and advertising, and yet you sort of had ownership. You were the face of Marvel. Was this intentional? Did you*

want to be the face of Marvel? Or did you just realize no one else had the right face?

STAN: Well, yes. I was the logical person to be the face of Marvel because I was in a position to do all the things I wanted to do. I was able to write the *Soapbox* column; nobody could interfere with that. I was able to tell how to draw and write the stories. I was able to travel around and make speeches at different colleges and comic book conventions. I was able to promote the comics and make them move in the direction I wanted them to. And I felt I had a liaison with the fans, and I could talk to them, they could talk to me, we understood each other. I knew, or I thought I knew, what they wanted to read in our books, and I tried my best to give them that.

BUDDY: *Now, you mentioned something important, and I've actually asked a couple of the other guys this. There's an obvious loss of privacy as a person when you're such a public figure. How did you manage to keep yourself, who you are, separate from who you were perceived to be by the fans? Or was there no difference?*

STAN: I don't know how to answer that. I don't think I'm any different than the public image of me, if there is one. I don't think there are two Stan Lees, you know, the Stan Lee that goes out and tries to promote whatever he's selling and the Stan Lee that stays home and—it's just me; that's the way I am.

BUDDY: *I guess what I'm getting to is: I don't know how you vote; I don't know if you're Republican or Democrat. You've managed to keep—*

STAN: Oh, yeah, yeah.

BUDDY: *How did you keep that out?*

STAN: Well, I don't think it had any bearing on what I was doing. Like I never discussed religion; I never discussed politics as such. You know, I would never say liberals are better than conservatives, Republicans are better than Democrats,

or anything like that. I tried to talk in generalities. There were things I tried to express: I was against bigotry. I was against crime, but who isn't? I tried to just—general, good things that would be good for the reader without—it wasn't my place to tell anybody how to vote, or what to eat or drink, or where to live or anything like that. I wasn't a guru. My job was just to entertain people as much as possible. And my own life was pretty private. I wasn't out to promote Stan Lee, the family man; I was just trying to promote Stan Lee, the guy at Marvel.

BUDDY: *It's funny because today so many people put so much of their lives on the Internet …. It is different.*

STAN: [sounding sort of doubtful] Mmm.

BUDDY: *It's almost all about oversharing, right?*

STAN: Well, I now have a Twitter identity. I'm into twittering. But again, I do that just for fun, the way I used to write my *Soapbox*. I enjoy communicating with the fans that way. So I tweet every day.

BUDDY: *I know. I follow you on Twitter as well.*

STAN: Oh, really!

BUDDY: *[Laughs] Yes.*

STAN: So, wow … you're the one.

BUDDY: *[Laughs] Yes, that's me!*

STAN: [Laughs]

BUDDY: *You know, this dovetails into something that's really part and parcel to what I'm trying to get to in my book, and it's about professionalism, and it's not just the craft, but also the business. You obviously conducted yourself in a very professional way and obviously were very consistent. Did you see a lot of guys bomb out throughout your career who could have had a better career but they couldn't handle it professionally, or didn't handle themselves in a professional manner?*

Stan also wrote a popular holiday-themed children's book, *Stan Lee's Superhero Christmas*, which tells the story of a family of original superheroes who help save Santa after he's captured by the evil Ice King on Christmas Eve.

STAN: Well, that happens in every business. There are always people who sort of fall by the wayside for whatever reason it could be, whether they made wrong decisions, whether they drank too much, whether they were unhappy with their personal life, who knows. But, sure, I've seen guys who I think should have done better who didn't … but as I say, that happens all over.

BUDDY: *Did you have some sort of guide in your life that gave you the work ethic that you have? I mean, you know, you look at your staggering body of work and accomplishments. Was there an internal compass, was there someone driving you, was there a major influence on you?*

STAN: I don't know. I just always wanted to succeed, I think. And I married a gal that I was crazy about, and I always wanted to impress her! [Laughs] I wanted her to think I was pretty good, you know? But mainly, I think that when I was very young, it was during the Depression. And my father, who had been a dress cutter, wasn't able to get work. And he was unemployed for most of the time that I was growing up when I was a young kid. And I would see him night after night, reading the want ads, or day after day reading the want ads, and I felt so sorry for him. And I think I had this feeling that the worst thing in the world was not to be needed, not to be wanted by anybody.

So I think maybe—and here I am trying to analyze myself, but I think maybe I worked as hard as I did—because I did work hard—because I wanted to feel wanted or needed, and it's a good feeling for me. Even now, I love the feeling that I still feel I'm needed and I'm wanted in the work I do, and it's probably the reason I never tried in those early days—I was too dumb, or it never occurred to me to try to go into business for myself. You know, I was always just an employee, because to me, having a steady job was the peak of success. Because my father had never had a steady job that I could remember, and I felt so bad about that. So I was happy just feeling I've got a steady job, and I seem to be doing well, and they seem to want me. And I guess that was enough for me! My sights weren't set that high.

BUDDY: *Well, even if you didn't set your sights high, did you—and if this is too personal—did your father ever get to see the level of success that you would eventually reach, and—*

STAN: A little bit. A little bit. He died shortly after the *Fantastic Four* and the others, and I had a house in Long Island, so I was doing well. I mean, I was making a good living, and he knew about that, but … it wasn't anything like it is today.

Stan Lee's Superhero Christmas © 2004 Byron Preiss Visual Publications, Inc., and Stan Lee.

BUDDY: *Right, because you've made more than a solid living and obviously generated billions of dollars. You know, one of the things we've talked about—and again, I may have mentioned this to Mike [Kelly at POW! Entertainment]—I worked at Wizard with [former senior editor and the Hero Initiative's current president] Jim McLauchlin, and there was a sense … we were trying to analyze that you may have become one of the most successful fiction creators ever. Does that ever—does the weight of that ever hit you, and do you ever just sort of kick back and wonder how it all happened?*

STAN: Not really, no. It's a funny thing: See, I don't own these characters, the way that woman in England who wrote those books—

BUDDY: *Harry Potter.*

STAN: The Harry Potter. She owns Harry Potter. And Edgar Rice Burroughs owned Tarzan, and so forth. I don't own these characters; I have no control over them. And I wrote them, they caught on, but I don't have that kind of proprietary interest in them. And I guess I don't even have the amount of pride in them that I would have if they were mine. And I'm not saying that bitterly. I mean, I'm not looking to own them. I was treated very well, and I'm very happy that they're doing well, and I'm very happy that I had a hand in creating them. But I don't have that feeling that you—in fact, I think I forgot the question.

BUDDY: *It was the feeling of pride, that [you are] maybe one of the most successful fiction creators ever.*

STAN: I—very seriously, I never think of that. It never occurs to me.

BUDDY: *[Laughs]*

STAN: You know, that's very truthful. I don't think of that. I'm just a guy who wrote a lot of comic books. Luckily some of them caught on. One of the reasons they've become so big is the movies, which I had nothing to do with. [Chuckles] If not for the movies, who knows.

BUDDY: *Well, if not for the movies … but weren't you one of the early guys that recognized [the potential of] putting one of the Marvel guys on the small screen in the early days? Right?*

STAN: Yeah. Yeah. I was always working with them. That was fun, doing the cartoons … announcing them and doing some voices. Everything was fun. See, that's why I don't—to me, the fun part is the most important part. I mean, I don't sit back and think, "Gee, I bet I wrote more stuff than anyone else." It doesn't occur to me, really.

BUDDY: *You know what, you leave that to us guys over here who analyze everything.*

STAN: Oh, right; I do. [Chuckles]

BUDDY: *You know, I'm almost running out of time, but I wanted to ask you one or two quick things.*

STAN: Sure.

BUDDY: *This book is largely about the process. How important do you think it is for people who are working on, say, one thing—maybe their writing, maybe their art—to understand the complete process in a professional way?*

STAN: Well, let me put it this way: No matter what you're doing, the more knowledge you have, the better you'll do. Certainly if you understand the whole process of doing comics, you're going to be a better writer or artist. If you understand the whole process of making movies, you'll be a better screenwriter or a better actor or actress. I mean, whatever you do, if you understand the whole process of plumbing, you'll be a better plumber! The more you know, the better you'll be, because you also understand what goes into it, what the problems are, the problems that other people have, and how, if you do your work correctly, that may make it easier for the other people, and— Of course, an overall knowledge of everything in the field that you're working in is better than not having that knowledge.

BUDDY: *Do you suppose that was one of the things that made you a successful writer—that you were in the center of the hurricane there in the office and you were able to see all the moving parts? Do you think that helped you in some way?*

STAN: Well, let me put it this way: I felt I always knew what was difficult for an artist and what was easy for an artist, and I tried to know—all the artists that worked for us, they were all different people. And some were better at drawing certain things, some were better at drawing things a different way, and I would try—if I'm writing a story for one artist, I would try to write it a little differently than for another artist. I would write the story to play to the artist's strengths who I was writing it for.

And by the same token—well, see, I never wrote for another editor because I was the editor. If a writer is writing a story for a certain editor, he should know what the editor expects, what the editor prefers, what the editor would like to see. It makes it easier. Again, the more you know about the people you work with and about the whole process, the better it is for you. Of course.

BUDDY: *Sure, because this isn't—in a larger sense, it's not an esoteric exercise. It's a business.*

STAN: Everything is a business, if you think about it. Even if you're an artist working in a garret somewhere, just doing your own thing, you still hope that when it's finished, people are going to like it, and you're going to get some acclaim. Every writer hopes that people will care for what he's writing—you know, unless he's a complete nut. [Laughs]

BUDDY: *[Laughs] You know, looking toward the future, we've seen a lot of technology, and technology evolving faster and faster. What do you suppose we're going to be seeing in the future of comics?*

STAN: Oh, I have no idea. One thing that's becoming a little bit popular now are ... digital comics, I guess you can call them. We're doing one now with Disney; it's called *Time Jumper*. It's sort of a cross between—a combination of comic book artwork and animation. And you can catch it on the Internet or on your telephone. There'll be a lot more of that, where the comic strip is drawn, but there's also movement and you can hear the voices, and you can hear music. But it isn't really animation; it's drawings that are—they fiddle around in a special way with special effects, and you get a feeling of movement.

People are going to be experimenting forever with how to tell stories with pictures and art, and there will always be different ways coming along. But I think the basic comic book format, where you simply have some pictures on a page with color and dialogue balloons, I think that is such a pleasant and easy way to tell a story and to read a story, that I think it'll always be around no matter what other methods are dreamed up. Just like when television came along, everybody said that's the end of books; nobody's going to read a book again, but ... books are still being published.

BUDDY: *[Laughs] Yeah, right. Let's hope so; I'm working on one now!*

STAN: Oh, yeah. Well, do it quickly before that changes too.

BUDDY: *[Laughs] Well, I think we're going to see books like mine moving more toward the e-book reader model, so...*

STAN: That's right. And things like the, um ... iPad, where you go with the—what is it, Kringle or something?

No matter how busy he is, Stan always pauses to make time for a picture with a fan. In this case, the fan is author Buddy Scalera.

How many people get an action figure of themselves? Sure, there are people who get action figures of characters they play, but Hasbro made a Marvel Legends action figure of Stan, launched exclusively at the San Diego Comic-Con in 2007.

BUDDY: *The Kindle. [Chuckles] The Kindle.*

STAN: The Kindle. Well, I can't remember their names, but you know …. In fact, I just got an iPad the other day. I'm going to figure out how it works as soon as I get a chance.

BUDDY: *[Laughs] Do you think that—*

STAN: Maybe I'll be reading your book on it.

BUDDY: *[Laughs] I hope so!*

STAN: [Chuckles]

BUDDY: *Do you think that if you had this kind of technology, including, like, you know, file transfers and scanners, do you think that would have excited you if you were publishing and editing today, or do you think it would be one of those things that's just part of the process that blends into the background?*

STAN: It would have been part of the process, but it would have made life a lot easier. For example, I wish we had computers when I was writing stories. If I could have had a word processor, I could have written ten times as many stories.

BUDDY: *I bet!*

STAN: No, all of these things just make it better for a writer. And the idea of reference—you know, if I wanted to look something up, I had to go to the *Encyclopedia Britannica*, or I'd have to go to a library, or … now, it doesn't matter what you want; you just Google it, and you have it in five minutes or less than that. It's wonderful. I mean, computers are the greatest things in the world for a writer. You do all your research in a few seconds; you correct all your mistakes … I mean,

God! I think writers should just—whoever it is that discovered word processing should be tax-free for the rest of his life. [Laughs]

BUDDY: *[Laughs] And I think writing has evolved pretty significantly, but other steps in the process have even evolved more. Like, as you mentioned, digital coloring and digital lettering. And yet pencilling remains largely the same, right?*

STAN: What remains the same?

BUDDY: *Pencilling?*

STAN: Pencilling?

BUDDY: *Yeah.*

STAN: Yeah, well, somebody still has to put the initial image on the page. There are ways you can do that on a computer, too, but I think the pencil will hang around for quite a time to come.

BUDDY: *So any final thoughts or advice for the aspiring creator of the future?*

STAN: Learn as much as you can. The best thing anybody could have is knowledge, you know? If you want to be a comic book writer or artist, read a lot of comic books. See how it's done. See what you like the most, and what you don't like. But that doesn't mean just read comics, for God's sake. Read everything. And if you're an artist, study all types of art, not just comic book artwork.

And the main thing that I'd tell people is: Don't always try to write for an audience, to please an audience. The most important thing, I think, is to please yourself. If you can write something that you like, that you really think is great, none of us are that unique. If you like it, there must be a lot of people who have the same tastes that you have, and they'll probably like it, too. But if you try to write things that you say, well, "I think other people—I think the readers will like this," or "I think they may like this," nobody knows what other people think. You only

know how you feel. So if you please yourself, that's the first step to doing something good. And I'm sure you could have a big debate about that and a lot of people will disagree, but that, I think, that really is the way to go about it. You've got to please yourself with whatever you're doing. You've got to love what you're doing.

Of course, if you're stupid, it won't help. If you have no taste. You also have to have taste. And you have to study the field and be able to recognize what's good and what's bad. But by and large, I think when Stephen King writes a book, it's the book he wants to write. He's not thinking, "I think people out there will like it." This is what he wants to do. And when Mark Twain wrote something, he wrote what he wanted to write. And I think that goes for every good writer.

BUDDY: *And are you still writing what you like today?*

STAN: Yeah. Always. If I don't like it, I'm not going to expect anybody else to like it. It's got to excite me. I've got to be, "Wow, gee, I wonder how this is going to end! This is terrific!" Usually I never know how a story will end until I write it anyway.

BUDDY: *Which is the best way to go.*

[Both laugh]

BUDDY: *Well, thank you so, so much; I really appreciate it.*

STAN: All right. You're a good interviewer! I enjoyed it.

BUDDY: *Thank you very much. I hope to talk to you again soon.*

STAN: OK, and good luck with the book.

BUDDY: *Thank you very much.* ●

POW! IT'S STAN LEE AGAIN!

Stan Lee never stops creating. Even when other comic creators seem to have slowed down to rest on their accomplishments, Stan is still busy developing new ideas.

In 2001, Stan helped co-create POW! Entertainment, a Beverly Hills-based entertainment company. No stranger to promotion and hyperbole, POW stands for Purveyors of Wonder. And yet, considering all he's accomplished, it appears that it's not *just* hype and hyperbole—POW still packs a lot of wow.

When he launched the company, Stan Lee teamed with *Baywatch* actress Pamela Anderson to produce the animated feature *Stripperella*. The fun series about an exotic dancer who moonlights as a sexy superhero didn't last long initially, but it found new life on iTunes as a mobile comic series. More important, it helped show millions of Marvel fans that Stan was far more than just an icon of comic book history; he was a contemporary creator with fresh new ideas that would continue to challenge the industry.

POW! produced the reality show *Who Wants to Be a Superhero?* for the Sci-Fi Channel in 2006. The upbeat competition featured aspiring heroes who created an alter-ego persona and participated in challenges to reveal who had the character to become a character. Stan himself guided the challenges, and at the show's end he crowned a winner, who was then featured in a comic published by Dark Horse.

POW! currently has a full slate of film, TV, print and multimedia projects going, most of which include Stan's involvement as a writer or other creative force. Check out http://www.powentertainment.com for more.

CHAPTER 10
NOW, PUT THIS DOWN
and Get to Work

So you've read this far, and you're seriously considering a career in comics. Now what?

If you're the right age, you may already be looking up information about internships, which are a great way to break into the business, as we've seen with Mike Marts, Chris Eliopoulos and Rodney Ramos.

But what if you're not located close enough to pursue a staff job at Marvel or DC, who both have offices in New York? Sure, I am biased to the coasts, since I happen to live here on the East Coast. But the vast majority of this country lives on the rest of the map. In fact, many comic creators have both broken into comics and maintained a career in places other than New York and San Diego. The comics industry as a whole has grown over the years, so there are different staff jobs you can get around the country, for publishers like Dark Horse (Portland, Oregon), Fantagraphics Books (Seattle), BOOM! Studios (Los Angeles), and more.

If you're looking for a career with a traditional set of benefits—including a health care package—you should seriously consider a staff job. Of course, most, if not all, staff jobs will require you to work in some sort of office location, which may mean you have to be willing to relocate.

But as you know from reading this book, most of the people who create comics—writers, artists, inkers, colorists and letterers—are generally work-from-home freelancers. The idea of working from home appeals to a lot of people, though it's definitely not for everyone since many people cannot muster the discipline required to survive. Plus there's always the question of health care—most freelancers have to either buy health care insurance coverage or rely on a spouse with a regular day job. Again, it's not for everyone, but many comic book creators find a workable solution so they can follow their dreams.

THE ART OF BREAKING IN

Working as a reporter in the comic book industry, I had the opportunity to ask the "breaking in" question to dozens of comic book creators. How do you break into comics? We are, as fans and aspiring pros, fascinated with that question.

Growing up on comics, we were all inculcated into the idea of "secret origins." DC and Marvel based many of the motivations of their characters directly on the origin story. For example, it is the very origin of Batman—seeing his parents shot dead in Crime Alley—that makes him the vigilante later in his career. Likewise for Spider-Man, who learned "with great power also comes great responsibility" when he didn't stop that burglar who killed Uncle Ben. These formative events (a.k.a. origins) defined these characters and launched their respective crime-fighting careers. Today's writers understand this tradition and keep these origins in the fabric of their current stories as they continue to define who these characters are. These oft-reprinted tales are sometimes tweaked and modernized, but the core values remain the same.

In comics, the idea of an origin story extends beyond character into the actual creator. If you don't believe me, go to a panel at a comic show. If you have a creator up there, there's almost always someone who asks how he broke into comics. It's one of the few questions that has an answer that everyone listens to. And for good reason, right?

The breaking-in question usually elicits an interesting response and some sort of anecdote. The audience listens and relates to the information because, given the right circumstances, it could be their story. That could be them up there. It could be you.

In my experience, breaking-in stories often have common threads. And believe me, I have heard a lot of these stories because they have never stopped interesting me.

BE PERSISTENT

The next time you meet a working comic book pro, ask him about the times he's been rejected. Or insulted. It's not uncommon to hear stories about top pros who were met with rude and demoralizing rejection. But they are working pros because they didn't stop the first time they heard "no." They listened to the criticism, no matter how harsh, and tried to figure out ways to get better. That, and they didn't quit, even when it seemed like they'd never actually get their chance.

It is rare the creator who has broken in on the first try. They may tell you about that first engagement, but it's usually a streamlined version of the actual events. After being in the comics biz for a decade or more, it's easy for a creator to blur the lines between a few months and a few years. In many cases, however, persistence translates into time. Time honing your craft, time spent learning how the business works, time building your portfolio, and time banging down the door to get your chance to prove yourself.

There are a lot of people who would love to work in comic books. Often the work goes to the people who are determined to improve their craft and network their way into an opportunity to show their stuff. They didn't quit, and neither should you.

PRESENT YOURSELF PROFESSIONALLY

I am constantly amazed at how few people actually take the time to properly prepare for gaining work in this industry. Just because we're talking about the business of comic books doesn't mean that you shouldn't at least look like you take it seriously.

If you're applying for a job, you try to dress appropriately for the interview. If it's an office job, you're probably going to wear a well-pressed suit. If it's something more casual, like comics, you're going to wear ripped jeans and a stained X-Men T-shirt, right? Wrong.

The reality is that you need to polish your personal image before you step foot in the convention. You comb your hair and wear deodorant. You don't need to wear a suit and tie, but definitely consider something that suggests you care about your appearance. You can get away with jeans, but they'd better be clean, sharp and carefully paired with an appropriate shirt.

> Your entire portfolio should look **NEAT AND WELL-ORGANIZED**, and it should always feature **YOUR BEST WORK.**

You are selling something, which in this case happens to be your art or writing. But you are also selling the perception that you're prepared to get the work done. If you look sloppy, it may be hard for the hiring editor to take you seriously.

POLISH YOUR PORTFOLIO

Next, learn how to present your work. Most conventions offer some kind of portfolio review. You get a few minutes to show your stuff, so you need to be ready. For artists, it comes down to a handful of pages that show the best of what you can do. If you're looking to break in as a penciller, for example, you'll want to have around eight pages of completed sequential art. Make sure it's your best stuff, and be prepared to answer the question, "How long did it take you to complete these pages?" If an editor is asking, it's possible that your work is interesting enough for further exploration and the editor is trying to find out how long it takes you to complete a page of art.

Don't make excuses for your work. Don't put anything in there that isn't the best representation of who you are as an artist. All too often, I've heard people on the portfolio review line making excuses. "I actually have better stuff at home" or "I just sketched that quickly last night in the hotel room … it's not my best stuff." If it's not your best, it shouldn't be in there. Your entire portfolio should look neat and well-organized, and it should always feature your best work.

The same goes for all other visual artists. If you are breaking in as a colorist, inker, letterer or penciller, you're going to need a solid portfolio. Be prepared with a few sample pages that have your name and contact information on each page. (Writers: I'll get to you later in this chapter.)

I've seen nicely drawn pages get shuffled around in convention boxes, only to be thrown away later because nobody could figure out who created them. You don't need fancy business cards or binding, but it doesn't hurt to make your package look like something special. You don't want to make it too big. You only need a few pages with proper contact information, including name, email address and phone number to get started. If you happen to have a webpage or blog, or have art on a site like deviantART, you may want to populate your best work there as well. If someone comes looking for your work, your webpage is your virtual business card.

One more thing on portfolios: Remember to include samples of the kind of work you want to be doing professionally. Lots of people approach editors with beautiful pin-ups, but no sequential art samples. The editor may agree that the pin-up looks great, but you need to show that you can do the kind of panel-to-panel storytelling that goes into making a comic page.

IF YOU WANT TO BE A PRO, WORK LIKE ONE

Your goal going forward is to be able to create comics on the same kind of time crunch that real professionals do. In the case of pencillers, for instance, you'll need to be able to consistently complete a page of art per day. It sounds easy, but it's really a lot harder to do than you think. That's why you want to be building up your stamina now, so that when you get your shot, you're already physically capable of delivering the work on deadline.

NETWORKING AT CONVENTIONS

Many deeply creative individuals struggle with networking. It's not easy to walk up to someone and just start talking, particularly if you are the kind of person who feels most comfortable behind a drafting table or a computer keyboard.

At some of the conventions where I have planned panels (including New York Comic Con, Philadelphia Comic Con and Long Beach Comic Con), I have hosted a popular panel called Creator Connections. I like to think of it as speed dating for aspiring comic book professionals.

Creator Connections lowers the barrier to that first point of contact because, essentially, I am the person introducing two people. I take people who self-identify as writers and others who self-identify as pencillers, I introduce them and help them break the ice. At that point, they are free to talk, network and just become better acquainted. Believe it or not, I've been given copies of completed comic books that have come as a result of this kind of networking event.

But in the real world, this is not as easy. First off, we don't have these networking events at every convention. But that doesn't mean you can't actually network.

Start by walking up and down artists' alley. Don't be afraid to make eye contact even though the person at the table may be hoping that you will want to buy something. If you see someone is doing something interesting, ask them about their product. You may be surprised to find that they are interested in doing more work, and they may be looking to collaborate with another creative person. Maybe someone like you. If you like something they're doing, don't be afraid to buy a copy. In fact, it helps you get a better understanding of their work. Exchange business cards if you can. Find out if they have a website, and make a note to follow up the week after the convention. Suddenly you're networking.

Often this same approach will work with small- and medium-sized independent publishers as well. If you are looking to network or land some work, knowing what things they publish can be helpful. If it's a multi-day convention, you may be able to buy something from them, read

STAN LEE AND ME

When Stan Lee is around, it's OK to just turn back into a fawning fanboy. Here I am at Long Beach Comic Con 2009 getting Stan to sign my well-read copy of *Origins of Marvel Comics*.

it and go back the next day to discuss it. You'd be amazed at how much more attentive people are when they know you've taken the time to read their work.

Networking with mainstream pros is a little more challenging. You may meet someone at a convention, but outside of portfolio review, it may not be a good time to show them your portfolio. Sometimes just engaging and talking about comic book projects is enough to get a conversation started. After a little while, sometimes you can just ask if they'd mind taking a look at one or two pages in your portfolio to offer constructive criticism. Many will, some may not have the time, but you certainly want to be gracious and professional throughout the conversation. The trick of networking with working pros is just to take it slow, build a relationship, and show that you're a nice, professional creator.

Many people today have their own website, blog, or social network page (Facebook, LinkedIn, etc.). It's not unusual to close the loop on a conversation by sending a quick note after a convention. You may find that they respond and you can keep an open dialogue for future conversations.

COLD CALLING

If there's no convention near you, sometimes you have no choice but to do some cold calling. I

Most small and large publishers have websites. Many of the large publishers have detailed submission guidelines. They may include release forms and other types of paperwork that **YOU NEED TO SUBMIT** before they will even look at your samples. In many cases, it's made clear that they are not accepting any submissions. This may temporarily close the door for this publisher, but that **DOESN'T CLOSE THE DOOR FOR ALL OF THEM.**

don't mean picking up the phone and calling people, but email is a modern equivalent.

Most small and large publishers have websites. Many of the large publishers have detailed submission guidelines. They may include release forms and other types of paperwork that you need to submit before they will even look at your samples. In many cases, it's made clear that they are not accepting any submissions. This may temporarily close the door for this publisher, but that doesn't close the door for all of them.

For example, at After Hours Press my partner and I keep an open call for submissions on our website. Since we're both writers, we're typically not looking for new writers, but it's not a hard and fast rule. In our case, we're willing to check out a creator who handles writing and art, especially if they have a completely finished issue.

The rules of cold calling are a lot like contacting a prospective employer. Be respectful, relevant and brief. If you have taken the time to consider who will be receiving your email or snail-mail package, you are already ahead of the game.

Sadly, many people who write to us are just not showing they are professionals. In our case, our information, history and complete line of books are right there on our website. Yet, I still get emails addressed to "To Whom It May Concern." That's a blown opportunity to engage with someone.

Try an approach that shows respect for the person who may be opening your email. Address them by name, since this isn't a formal business, at least in my opinion. Then do something

that's so obvious, I feel silly even writing it: Tell them exactly why your comic will fit into their product line. This is hugely important. And even though it might cost you a buck or two, make sure you've read a few of their comics. I don't mean just looking at the covers on their website; I mean actually familiarizing yourself with their products. This will show them that you've taken the minimum effort of looking at their current published offerings. It's not necessarily a big deal for people breaking into the business as a visual artist. But it sure does help. And it's the bare minimum for a writer. A smart writer will look at the current books being published and find new and interesting ways of either selling one of their ideas or adding to the existing universe.

You'd be amazed at how many times I have received a poorly written, generic email addressed to multiple publishers. Something like, "All: If you need a writer, keep me in mind. I write good." And there will be a half dozen or more people cc'd on the email. I can almost assure you that this email will not generate actual opportunities in comics or just about anywhere else. Your email must speak effectively for you.

KEEP YOUR RANTS OFFLINE

Don't post tirades on a comic book message board. Like you, many of us publishers are fans and visit message boards. If you are complaining about us in public, we are not going to be rushing out to hire you.

First names are fine. We're not an overly formal business.

Nice setup. Often the best ideas start with a "what if" scenario to hook the reader.

Quick and to the point. Sharing the page count gives context to the potential product.

This tells me that you've familiarized yourself with what we publish.

In this case "completely written" is a good thing. It tells me you're serious about your work. If I am interested, I can ask you to mail me the script.

At this point, I'm thinking, "Yeah, stop by, introduce yourself."

A few sample pages and a cover won't clog my inbox, and it will give me an immediate mental snapshot of the kind of work you can produce.

If you have a webpage, a deviantART page or even a blog, include your link. It gives me a chance to check out what else you've done.

Sharing existing work—even just an ashcan or some sample pages—shows that you can actually complete pages.

Dear Buddy,

Have you ever wondered what would happen if scientists found a way to trap an entire city in a glass bottle? Imagine next if the only scientist with the secret solution to returning it to normal size were to suddenly disappear without a trace.

That's the premise of my new story *City in a Bottle*, which is a 64-page graphic novel that takes place in the present day.

I'm really excited about pitching After Hours Press. *7 Days to Fame* was a terrific story, which really made you think about reality television. And I love the hard science-fiction angle of *Impossible Tales*.

The *City in a Bottle* story is completely written, and I've drawn the first 30 pages. Attached are a few sample pages and a cover, so you can get a feel for the project.

Please let me know if I can provide any additional details. I see from your webpage that you'll be at the next New York Comic Con, so I'll be sure to drop by and introduce myself.

Thanks in advance for checking out *City in a Bottle*. If you'd like to see some work samples, I can send you a copy of *The Wizard of Arrgh*, which I wrote and drew.

Sincerely,

Joe Pro
www.joesprowebsite.com

ATTACHMENTS: 3 JPGs

LIKELY TO GET YOU NOTICED

MORE DO'S

DO mention if you're proposing a project that's already completed, or if it's an idea that you would like to pitch.

DO read your email aloud to see how it sounds before you send. Tweak it so that it's short, powerful and sells you in the best way possible.

DO proofread your email before it goes out. Spelling may not matter much to you, but it may to the editor you are writing.

DO be prepared for the next step. You may get a request from the publisher or editor for more information. Be ready with all of your ideas and synopses before you reach out to anyone.

If you aren't going to bother personalizing this, you missed a chance to sound friendly.

Yes, somewhere there are comics that need to be written or drawn. But I doubt anyone will be reaching out to you with this lame, generic opener.

How many indie comics make it to sixty issues? It's hard enough to get out a three-issue miniseries these days, much less a massive epic (by a new creator, no less).

Don't talk movies just yet. Save that for the movie people. We all want that option money—but, for now, focus on why it would make a great comic book.

If you're not familiar with anything we've published, then why would you want to work with us?

This is not a good way to start a business relationship. Save the financial discussions for later.

Skip the LOLs and emoticons. This is comics, but it's still a business. Until you know someone personally, keep it businesslike.

Too many. Just send a few images, and be ready to send more if asked.

To Whom it May Concern,

Please let me know if you need any comics written or drawn.

If you are looking for a comic, I have a massive story that will take 60 issues to tell. It would make a good comic, but it would make an even better movie.

Also, please let me know if I can write any stories for After Hours Press. I'm not familiar with anything you've published. Can I buy your comics at a regular comic book store?

How much do you pay per page? I'm also willing to work cheap…but not TOO cheap, LOL! ;)

Anyway, you haven't published anything too exciting, so maybe I can help put you on the map.

Bye,

Joe Nopro

Attachments: 18 JPGs

SURE TO BE IGNORED

MORE DON'TS

DON'T mass-email publishers and other creators with a general letter. Personalized letters have a much better chance of getting a response.

DON'T send a complete story. Not only does that expose you and the publisher to risk, it skips a step in your relationship.

DON'T attach gigantic image files. If your message exceeds 2MB, resave your artwork as smaller files. If they like your stuff, they'll request more.

DON'T get irritated if you do not get a fast response (or any at all). Not every publisher has the time or inclination to get back to everyone every time. Get over it and move on.

DON'T wait until you get a response to prepare your work for review. Have a properly formatted, one-page pitch ready that showcases your idea and your talents.

BUDDY'S RULE OF TEN: The first ten stories you write are just going to be crap, so you have to simply write through them. The ideas may be terrific, the characters may be well developed, the plotline may be tight, but it's rare that you nail all of them on the first try. It's better to write through your crap to **GET TO THE ELEVENTH STORY.** That's the one where you can look back and spot the glaring and subtle problems in your storytelli

BUDDY'S RULE OF TEN

I suppose I heard of the Rule of Ten somewhere, but I cannot remember where. Maybe it's something I absorbed while in college or reading books on writing or whatever. If I first learned of the Rule of Ten somewhere else, then it has long been internalized into my system; my apologies for renaming it and making it my own. I do recall reading a similar passage in Stephen King's book *On Writing* (a highly worthwhile read for writers, by the way), but I am certain that I'd had it in my head before that.

In many of the panels that I plan at conventions, I will stop for a moment and talk about Buddy's Rule of Ten. It goes something like this: I tell people that if they are sitting there in the audience thinking about the panel discussion, they are probably applying some of the ideas to their own story concepts. You may be a writer or artist, but in either case you always have something brewing, right?

In my Rule of Ten, their first story sucks. I'm not meaning that in any symbolic way, I mean that it sucks. It's highly unlikely that an inexperienced writer who has penned the first issue of a story is going to nail it on the first try. Statistically unlikely. In fact, it's unlikely that the second one is going to be much better. If you don't think it's true for you, then you're just probably kidding yourself.

In fact, I believe that the first ten stories you write are just going to be crap, so you have to simply write through them. The ideas may be terrific, the characters may be well developed, the plotline may be tight, but it's rare that you nail all of them on the first try. It's better to write

through your crap to get to the eleventh story. That's the one where you can look back and spot the glaring and subtle problems in your storytelling.

It's not your fault, and you are not alone. The reality is that every writer has to work through the clichés ("and he woke up and it was all a dream!") and the unlikely twists ("and he didn't know that there was actually a twin sister!") and the lame endings ("and then he woke up and said it was a dream, but it wasn't; it was a double dream that he had to wake up from!"). You have to write through that to help you understand why it was clever in the eighth grade, but how it's not going to work today.

Write your first full ten scripts and file them on your computer so you can easily find them later. Write them through completely and then save them. There's always a glimmer of genius in early scripts that you may draw upon later. This isn't just for writers, by the way; this includes all of you artists. One day, you will look back, open that file and be glad that you didn't publish the story.

Here's the thing: Every creator is in a contract with the reader. If you are a writer, you are essentially telling your audience, "Hey, I am the creator here. If you stay with me, I promise that in the end, it will be worth your time, money and attention." If you give the reader a solid, worthwhile story, then you've kept your contract. After all, the reader has to commit time, money and attention that could be spent elsewhere. If you keep up your part of the contract, the reader will continue to come back for more. If you fail to deliver, then the reader will not be interested in your next project. They're certainly not going to buy your next nine stories in the hope that you will get better by the eleventh.

Now if you've taken the time to write at least ten stories or draw ten issues, your work is ready for an audience. Don't kid yourself: You don't always get a second chance to make that first impression. Do it right the first time—or in this case, the eleventh—because your name is your currency. If you squander it because you don't have the patience to polish your craft, then you're going to constantly struggle to maintain your reader base. Don't publish your practice work. Practice in private until you are ready for prime time.

Your name is what will sell projects down the road. People will buy stuff because they know that you worked on it. Protect your name by only associating it with the work that represents who you are and what you create. Follow Buddy's Rule of Ten, and then thank me later.

Hold on to those first ten scripts or stories, though. Writing them helps you capture those ideas, which are probably packaged in writing and art that will mature over time and could be reworked later into a creatively satisfying product that helps define your career.

THE PITCH

For most people, the pitch is the most difficult part. But if you take the time to format your ideas properly, you may increase your chances of getting your ideas published.

Or not. I mean, the reality is that your pitch will probably get you nowhere near where you want to be. Most people's pitches to Marvel and DC are completely unrealistic and often conflict with the company's existing publishing schedules. That "Spider-Man in outer space" story may actually be pretty awesome, but they probably won't take a story like that from an unproven writer.

On the other hand, a well-crafted pitch can help an editor assess you as a creator. It can reveal that a) you're a smart, creative person, and b) you're someone they may want to try out in the future.

That doesn't make your pitch any less important. Since pencillers, inkers and colorists can be assessed visually, this section will focus primarily on writers (or people who are writer/artists).

To pitch your idea, you need three things:

1. **A tight, one-page written version of your idea.** If you are using an established character, such as at Marvel or DC, you should familiarize yourself with relevant continuity. Get up to speed with what's currently out and what's soon to be released. That's all anyone expects of you. Write your awesome story idea in a one-page synopsis. Make it clean, tight and interesting. Don't leave anything out.

2. **Samples of your work.** It may be unpublished, but you need at least one completely written script, so that an editor can get a sense of what you do. If you have any published work, have it ready to share.

3. **Other ideas.** Don't just go in with one idea; go in with two or three. You may not get a chance to tell them your other ideas, but it's good to keep them in your pocket in case they ask, "What else have you got?"

Usually pitches are mailed or emailed to editors. And then they just sit on a desk for a while, unopened. Everyone is overworked, and few editors have the time to open new, unsolicited submissions. Send them anyway since you never know who will open the envelope.

Sometimes pitches happen at comic conventions. If you can get a minute with an editor, you may have a chance to pitch your idea in person. If you can, rehearse your ideas in front of someone you trust. Don't just seek their approval; ask for feedback that will help you tighten up your verbal pitch.

You'd also better think about the entire story. Every twist and turn. Every nuance of character development. Again, it may not come up in conversation, but you do want to be ready if the editor starts asking you to clarify parts of your idea.

The editor may be willing to check out something that you've written and produced (even if it's an ashcan). He may not want to carry something back with him, but if he does, be sure to include all of your contact information in anything you leave with him.

Self-publishing sucks. It really does. I don't mean that in the it's-crappy sort of way. I mean that **IT LITERALLY SUCKS MONEY, TIME AND ENERGY** to do it right.

SELF-PUBLISHING FOR ASPIRING CREATORS

This is the part of the book where I am going to tell you how to avoid my mistakes, specifically in the area of self-publishing, a route you may be tempted to go in an attempt to get yourself noticed. It's easy in retrospect to see where I went wrong, so I shall pass down my sage wisdom and save you years of heartache and possibly thousands of dollars. Ready? Good, let's get started.

FROM THE PORTFOLIO LINE TO THE SELF-PUBLISHING SEAT

Every year I see fresh-faced hopefuls clutching their portfolios, hoping for a shot at the big leagues. It's statistically impossible for all of these thousands of people to break into the business since there are few job openings and opportunities every year. As a result, thousands of artists and writers go home dejected. After three or more years of hearing, "You're getting better, come back next year," it is hard to get back to the art table to try again. Believe me, I know the feeling, and I know plenty of people who know the feeling.

It's hardest, I believe, on writers. At least as an artist, you get immediate and specific feedback on your work. As a writer, you can't find anyone who will read your script to see if they even like your work. It's one of those chicken-and-egg things. Nobody will read your script, so you can't get published. And since you're not published, nobody wants to give you a chance. It's a classic circle that you need to break.

The best way to show what you can do is to make a comic. Few editors will read your scripts, but some of them will read your comics.

SELF-PUBLISHING SUCKS

Self-publishing sucks. It really does. I don't mean that in the it's-crappy sort of way. I mean that it literally sucks money, time and energy to do it right. And it also sucks money, time, and energy to do it wrong (then your book also sucks in that crappy sort of way).

First off, let me say that I don't think any small publisher has the formula that makes it all work. Anyone who tells you that they know what they're doing is either lying or just doesn't know what they don't know. Even experienced publishers continue to learn on the job since the industry, the market and the public's tastes continue to change.

In my experience I've had many good social experiences with small-press publishers, but no good business experiences. In fact, of all the comics I've written for small publishers, only two have actually gotten into the books on the stands.

Since the early days of the Internet, we've seen lots of virtual "studios" pop up. These are often just loose partnerships of like-minded creators who hope to self-publish their way into mainstream comics. Given the chance, they'd give up their virtual studio and start freelancing for Marvel or DC. Or even larger indies like Dark Horse, BOOM! or someone else who will help them earn real money, rather than just hemorrhaging their own.

Sometimes these studios decide they are going to become publishers. Again in my personal experience, I've observed that many of these micro-publishers are just making it up as they go. They're trying, like you, to figure out how to actually make and publish a comic for profit. Usually they are able to get an issue or three out before they realize that this is more difficult and expensive than they'd realized. The problem with this is that sometimes they have your original art. Or you've signed some sort of contract with them that allows them to have partial ownership or control of your project. This, I can tell you from experience, can sometimes turn into a long, drawn-out process that takes months or years to

fix, especially if they have your original artwork and you want it back.

That's not to say that there aren't good indie and micro publishers out there. There are good ones. I know a few guys from the artist's-alley world who are honest, hardworking comic fans who just enjoy publishing new books. These folks are hard to find, but when you do manage to work with them, it's a great experience.

MY STORY AS A RELUCTANT SELF-PUBLISHER (OR, A BRIEF HISTORY OF AFTER HOURS PRESS)

I am a reluctant publisher, one of many in this industry who takes a personal financial risk to ensure that my vision makes it to the page. I'm willing to pay for that kind of personal control, but I am also willing to simply create comic books and let someone else handle the publishing part.

If you really want to know, I became a publisher quite by accident. Back when I was working as online editor at Wizard, I set my sights on writing comic books, and I sold an idea for a three-issue miniseries called *Necrotic: Dead Flesh on a Living Body*. The publisher I first approached liked it, and we worked with an artist to get the book off the ground.

It took almost six months to produce and ultimately deliver the book to the publisher. To our disappointment, he never actually published it; it just sat there on the shelf as they published other titles. After a while we got frustrated and heard of another small publisher who was open to new ideas, but only as small graphic novels. We got our pages back from the original publisher and pitched to the second.

The new publisher liked the book, but balked at the number of pages. We had three complete issues with 22 pages each, which added up to 66 pages. If we included all of the pages of the story, the graphic novel would have to be 72 pages, and the publisher wanted a 64-page graphic novel. We agreed to remove two pages from the story, and the publisher solicited it in the Diamond

Necrotic was the first book published through After Hours Press, a company we launched just to put this graphic novel out for a convention. We named it After Hours because all the work occurred at night after our day jobs. *Necrotic* continues to sell at conventions, no doubt in part because of the amazing cover by Alan Evans, who is also the cover artist for this book. Learn more at www.ahpcomics.com.

Comics catalog. Our team celebrated and agreed to exhibit our new comic at the Wizard World Chicago Comic Con. By this point I was already getting writing work at Marvel Comics, and I hoped that it would spark sales for *Necrotic*.

However, when the orders came in, they were disappointing, and the publisher informed us that the book would be canceled.

But I had made a promise to the other creators. If everyone worked for free, we'd have a book ready for Chicago. But with the publisher stepping back, there was no chance of this happening. So I reluctantly went into the Bank of Dad and asked for a loan.

With some cash in hand, I went to my office mate Darren Sanchez, who happened to be Wizard's production manager at the time, and asked him if he could quickly print *Necrotic* so it would be ready for Chicago. Then I asked my friend Chris Eliopoulos to create a logo for my new company, After Hours Press. Everything fell

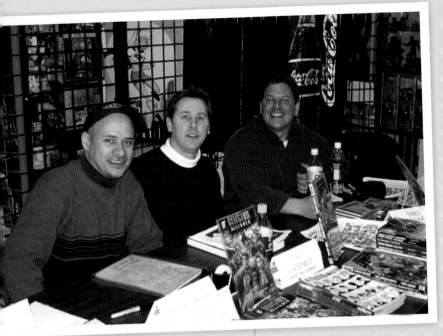

From left, Darren Sanchez, Chris Eliopoulos and me at an After Hours Press appearance at Jim Hanley's Universe comic book store in New York City.

into place, and just like that, I was a publisher.

Of course, there were many mistakes along the way. One of the big ones was that we hadn't actually completed the comic. The art was done, but we never bothered to have it lettered. So in a late-night marathon Chris lettered the book, Darren put it together for printing, and I waved my arms and made everyone crazy. Then, as an inexperienced publisher, I upgraded the paper quality, the cover stock and just about everything else you can imagine to drive up the unit cost of the comic. (Why I added UV coating to the cover, I will never really know. It's not like the comics are sitting out in the sun.)

The worst part was learning the way Diamond Comic Distributors—the only major comic book distributor in the U.S.—had structured comic sales for publishers. First off, Diamond took 60 percent of the cover price. So if your comic was $1.00, then Diamond would give you $0.40 per issue. Second, Diamond required you to distribute it to the distribution locations around the country. That means for each issue you ship, you have to send it to multiple locations, which adds cost to each issue.

That's when I realized why the previous publisher had decided not to print the book: For every issue Diamond purchased, we were literally losing money on each issue. On a comic with a cover price of $6.95, I was getting around $2.80, and I would have to ship the books, which cut a few more cents off the profit. Unfortunately, with tax and shipping from the printer, I would actually be losing money.

But I had made a promise to the team, and everyone was planning to meet at the convention. I began writing the checks, which I knew would amount to paying the distributor to put my comics on the shelf. Painful? You bet. Don't forget, I had to borrow money from my father to actually lose it at Diamond.

By the time the book was ready to ship to Chicago, it was already running late. There's a window of opportunity from when you receive your Diamond orders to when you can ship your book. We'd lost time as the last publisher was considering killing the book, then we had to scramble to get the book published. This, of course, led to the inevitable rush charges, rush shipping and anything else that can go wrong to increase the cost of producing the book. Money was flying away, and I actually had to borrow even more money for a book that I knew would lose money. It wasn't one of my proudest moments as a publisher.

In the end the books shipped. Darren got the comics to the Diamond distribution centers on time and we had boxes to sell in Chicago. I think we sold a whopping six copies, including one to a friend who purchased it out of sympathy.

The story doesn't end there since I had to quickly learn the ins and outs of invoicing, reorders and everything else that goes with self-publishing. Oh yeah, and I owed my father a rather large chunk of change.

Soon, however, I had other ideas, including my *Visual Reference for Comic Artists: Vol. 1* CD-ROM. You may be familiar with my photo reference books through F+W Media's IMPACT Books comics instruction line. Well, those CD-ROMs came before the books. In fact, I tried to pitch the CD-ROMs to different publishers since I had no intention of self-publishing more comics through After Hours Press.

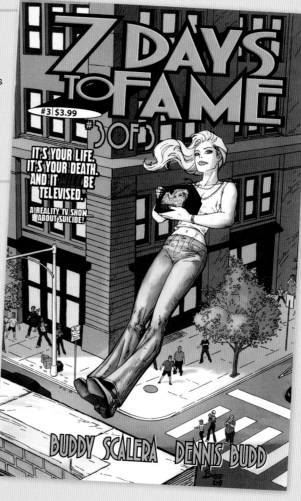

But as fate would have it, nobody wanted my CD-ROMs, at least nobody who was a publisher. So I revved up the After Hours Press logo and self-published the first of three CD-ROMs, which eventually was discovered by Pam Wissman at F+W, who published this book and many others through IMPACT.

In the meantime Darren and Chris became my official partners at After Hours Press. Chris published a few issues of *Desperate Times*, which was at Image Comics for a few years. Darren published *Celestial Alliance* and *Foxwood Falcons*, which would secure us our first Hollywood option. The money Darren received for the option helped pay for the money he spent on printing. If the comic becomes a movie or TV show, it could be very profitable for him.

Over the years we have published a handful of comics and graphic novels, including my own screenplay-as-a-comic, *7 Days to Fame*, which was also rejected by other publishers. We published a few one-shots—a self-contained comic book story with a complete beginning, middle and end—including one or two by people other than Darren, Chris or me. Here and there, we've taken on custom publishing projects. Primarily we've focused on producing high-quality, custom comics for people who want their property made into comics. We've also been hired to do uncredited work on other people's comics, mainly to help them bring a comic project to completion when they didn't know how the whole process worked. By design, we've led a rather modest existence since all of us have kids and maintain full-time jobs.

We've had our share of successes and more than enough money-losing failures to know that self-publishing is harder than it looks. It's also expensive, especially if you publish color comic books, like we prefer to do. Through it all, I've always been reluctant to actually publish a comic, since I know that it is a large, expensive, time-consuming commitment.

That said, it's worth talking a little bit about self-publishing, and how it may work for you.

WORK HARD, WORK FREE

Creating comics isn't a sprint, it's a marathon. In fact, it's a marathon where you hand the baton to someone else and they start *their* marathon. I truly believe that you have to work hard and work free for a while to build your portfolio. You literally need to do something, anything, to build up a body of work that shows you can run this.

The biggest musicians and rock stars of today didn't get there overnight. Usually it takes years of sacrifice and hard work just to get to the point where you can perform your music. The Who didn't get to play in front of the Queen of Eng-

land on their first gig. It took them decades of hard work to get to that point, and they still had to work hard to put on a good show. (Note #1: I've used that line in panels and discussions for years, but have no idea if The Who actually ever did play for the Queen. I don't much care, either, since it's the analogy that's important. Note #2: The first five people who email me with the correct answer will win some sort of prize. I'm not kidding.)

As far as gaining valuable experience and getting yourself out there, I am personally a big fan of self-publishing. It gives you a ton of hands-on knowledge that will help you later in your career. My experiences publishing *Necrotic*, the CD-ROMs and everything else has helped inform how I act as a professional. It gives you depth and perspective that will help you later in your career.

Getting started is easy. First, you just need to make some product. If you have no product, nobody has anything to buy. Do you know what sells best for me at comic book conventions? I'll tell you. The stuff that sells best is the stuff I have for sale. The stuff I haven't yet made … nobody wants to pay for that. This is a business that thrives on the exchange of a few dollars for a few pages of completed work.

So if you haven't completed your brilliant comic book story yet, you should get cracking. If you're a writer, this is an ideal situation since you can actually write your entire story before you start looking for collaborators. This is that perfect time when all you have is your idea and your script, and all is good in the world.

Remember to also match talent to task. Don't hire a quirky artist who likes funny animals and expect him to be able to instantly adapt to your superhero space opera. Find the right art team for the project, mash it up and make a comic. That's the short version. The long version tends to be a little more complex, but you get the idea. (If you do not, then go ahead and start Googling to see if The Who actually played in front of the Queen of England. It's a good distraction until you get back on track.)

If you work hard and manage to get yourself a completed comic, you're going to need to decide on the format. First, you need to decide if this is a traditional print comic book or a comic that will be posted online as a digital comic. Either is fine, you just need to understand the differences beyond the obvious ones of distribution channel.

SELLING PRINT COMICS

Doing a print comic means that you can look at two specific options. The first is just selling it directly at comic book conventions. Some people do pretty well at that, selling enough books to cover the expenses associated with traveling to a comic con and renting a table. There's generally nothing wrong with this, but it does limit your visibility dramatically.

If the goal is to get the comic into mainstream comic book stores, you will need to work through Diamond Comic Distributors. This, as noted in my own self-publishing adventure, can be a difficult challenge. Diamond reserves the right to reject any product that they don't like or that doesn't sell enough units to make it worthwhile for them. This can be tricky for a small self-publisher, since Diamond has to focus their attention on the big companies that make them the most money. As noted before, you need to be prepared for Diamond's discount terms so that you know how to price your comic properly for the marketplace.

There are many ways to approach this, and you can find information online that will help you. (Diamond's website, www.diamondcomics.com, is a good starting place since they offer information and resources for people who want to publish comic books.) The most straightforward way is to determine what your cost per issue will be by adding up your art and editorial (A&E), production, promotion and printing costs, and get a basic number. If you want to start with a rule of thumb, use 1,000 issues as your starting point. It's unlikely that you will sell that many, but you always print more than you initially need so that you have issues for conventions and just to save. Divide your total costs by your 1,000-issue print run, and you will come up with an average cost per issue.

MATCH TALENT TO TASK. Don't hire a quirky artist who likes funny animals and expect him to be able to instantly adapt to your superhero space opera. Find the right art team for the project, mash it up, and **MAKE A COMIC.**

Now that you have a price-per-issue, you can figure out how much to set your cover price. If you set it at $2.99, Diamond will be giving you $1.20 per issue; they'd be taking $1.80 per issue. If that doesn't cover your cost per issue (i.e., you're losing money each issue you sell), then you need to consider increasing your cover price. If you aren't too intimidated by spreadsheets, visit **http://creatingcomics.impact-books.com.** You'll find a spreadsheet that has all kinds of magical formulas that make the computer do all of these calculations. Check that out since it may help you run the numbers.

GOING DIGITAL

The costs associated with printing and distributing a physical product can be prohibitively expensive. Remember, Diamond is the primary distributor of comic books in the U.S., which means you have to follow their specific rules. There is no true competitive incentive for Diamond to lower prices or make things easier for indie publishers. The market, the shelves and everything else are structured to support the primary publishers in the industry. It makes sense, of course, because most retailers make their bread and butter on Marvel and DC, and a few strong indie publishers.

Compare this to publishing online, which is virtually free. The new digital publishers are literally scrambling to find enough quality content to become a key destination for people seeking out comics. The old barriers—print cost and distribution challenges—are falling as digital distribution emerges from infancy.

Digital printing is a good way to get your comics out there, but there is an obvious shortcoming: Namely, you're not getting a printed comic on the stands. For many people, this is the primary reason to publish comics. Trust me, there's something satisfying about holding a printed copy of your work in your hands. The future is likely to offer a more robust digital platform, so more people will experiment with digital comics. Don't be surprised if popular digital comics migrate from the screen to the shelf, as many people will continue to prefer a printed comic.

If you're a creator starting out, digital publishing is probably a good way to get your work out there. But even though it's digital, you need to follow the same rules of creativity (including Buddy's Rule of Ten!). In fact, you should follow them even more carefully because whatever you publish electronically will never really go away. Old printed comics that were not very good have a nice way of fading away into the quarter back-issue bins. Online, everything is always available. Bad product can haunt you forever, so you want to make sure everything you publish is the best you can do at that particular moment in time.

SO IS ALL THIS WORTH IT?

If you're following along here, you may think that self-publishing is too difficult and not worth the effort. That may be true, especially if you are considering the profits and losses (P&L) of the actual comic. The reality is that many people lose money self-publishing, not just me. In fact, if they sat down and really calculated the cost of producing their comics, I would venture to say that many self-publishers actually lose money. Many people forget to add up all of their costs, including shipping, convention costs, promotional costs, and so on.

At the end of the day, I really don't want to publish more comics, but I do it because I figure that I'll make my own comics the top priority for the entire publishing company, which in this case is After Hours Press. When Darren and I

do a comic, it's our top priority because we are focused only on our own books. As soon as you start to work with an independent publisher, your work becomes one of their priorities, but not their top one.

In some cases small publishers take on your comic purely for marketing reasons, namely that it will round out their publishing plan and make it easier for them to solicit their own title in Diamond. Then your book becomes a platform, not really a priority. If you self-publish, then you learn more, you set the priorities, and you succeed or fail based on your own talent and effort.

Oh yeah, and if it hasn't already become abundantly clear, you get to unload lots of your own money in the self-publishing process. Which leads to the inevitable question: Why do it at all?

Let me make you feel better about all of this. For starters, you need to remember why exactly you are self-publishing. There's a good chance that you aren't getting the break you want. The best way to show that you are prepared to make professional comics is to show people your work. So, if you are like me, you're willing to make an investment in yourself, literally and figuratively.

You need to consider these expenditures as marketing expenses. You are paying money to promote your personal brand. You are paying for an education, which will help your future career, that you cannot get in a traditional educational setting. If you won't invest a few bucks on yourself, why should others invest in you?

Like I said before, you could work with an indie publisher. If you manage to hook up with a reputable small publisher, then you may have a good experience. If you can get your proposal accepted by a mid-level publisher, then you're going to be in better shape. Yet, if your experience is like mine, you're going to find that it's frustratingly difficult to get anyone to even read your proposals, much less publish them. For me, "next" was always just biting the bullet and starting a new publishing plan.

NOBODY KNOWS ANYTHING

"Nobody knows anything."
—William Goldman from
Adventures in the Screen Trade

Nobody really knows what will produce a money-making hit. If they did, they would do it over and over. Instead, good movies are sometimes hits, and other times bombs. Same goes for bad movies. There are bad movies that make money, but nobody is really sure which ones will make or lose money until they are actually done counting the profit and losses. Nobody has a magic formula either. What works on one movie may fail on the next.

Similarly, there are lots of very successful comic books out there—some by top-name talent, and others by complete unknowns. Comics has just as many one-hit wonders as any other industry, including music and movies. Nobody really knows how to make a hit comic book. If I did, I would be publishing hit comics, right?

So, yeah, nobody knows anything.

The best thing you can do is try your best and hope your idea and story make it from your brain to the page. Every creator in this book has had projects that transitioned smoothly and logically from their mind's eye onto the page. And no doubt, that's one of the reasons they are included in this book. But if you ask them, they will admit their share of disappointments and failures. It just sort of comes with the territory when you work in a collaborative and creative industry.

Every once in a while, the moon and stars align, allowing someone to beat the odds. People publish hit comics, which opens the doors of opportunity for them. But they often find that it's harder than it looks to repeat that success. The important thing is to learn from your mistakes. Apply those lessons to what you're doing now and make incremental improvements.

A CRUSADE OF EXCELLENCE: A SELF-PUBLISHING SUCCESS STORY

Back in the early 1990s, it seemed that everyone with an idea was banging out pages and getting their comic published. The conventions were packed with people hawking poorly conceived and executed comic book ideas.

Billy Tucci, a freshly minted graduate of the Fashion Institute of Technology and a former Army Ranger, was trying to get his comic book, *Shi*, published. It was a unique project that mixed Eastern martial arts, unconventional page layouts, and a complex, intellectual storyline.

Despite tight, polished art from a new creator, Tucci was unable to secure a satisfactory publishing deal. So, out of frustration he started self-publishing through Crusade Fine Arts, a startup he launched out of his home in Long Island, New York.

Not only did *Shi* take off, it catapulted Tucci's company and career. Soon *Shi* was selling out, making it a hot, back-issue collectible. Every issue after that also continued to sell, allowing Tucci to expand Crusade. He created offshoot series featuring other characters in the *Shi* universe. There were manga versions of *Shi*. There was even a movie optioned.

Soon Crusade was expanding to include comics by other creators. But by this point, the market was beginning to roil under the weight of the collectors' craze. Comics that should have sold did not. Comics that were laden with gimmicks often did. Many of the new titles from Crusade could not survive in this unpredictable market.

Billy Tucci | photo courtesy Crusade Fine Arts

After a few years of brave experiments, including crossovers with mainstream Marvel characters and a comic book-based game called "Battlebooks," Tucci got back down to basics. Even though he had some impressive successes, many of his fans wanted him to get back to the art board.

Returning to day-to-day comic work, Tucci has continued his success. He continues to produce *Shi*-related products, which pleases his dedicated fan base. Plus he brought those fans over to his pet project, a *Sgt. Rock* miniseries for DC Comics. A critical hit, *Sgt. Rock* cross-pollinated DC fans back over to his Crusade empire.

Talent, hard work and a little bit of luck helped Tucci to emerge as one of the true success stories in independent self-publishing.

MAKING A CAREER IN COMICS

If you're truly considering a career in comic books, then you need to consider your definition of success. Your long-term goal should be to earn enough money to support yourself—and maybe even your entire family—on the money you earn making comics. If self-publishing showcases your talents enough that you get an editor to give you a chance, then you've taken the first step on the long road to success. Success may also be a solid career as a freelancer. Writers, in particular, can work on multiple projects inside and outside the comic book industry.

You should feel inspired to know that many people make their living creating comics. It's sometimes stressful, frustrating and disappointing, as we've learned from the professionals featured in this book, but all of them are committed to making comics, despite the occasional deadends, roadblocks and hurdles. They love the medium of comics and have dedicated their careers to contributing to the comics we all enjoy.

If you're considering a career in comics, and you've read this entire book, you may already recognize something that's crucial to this discussion: You didn't choose to work in comics. Comics chose you. If you're unable to see that clearly, let me clarify it for you. If your every waking moment is consumed with the idea of creating comics, you've been chosen to tell stories. There are other things you could do to earn a living, but it seems that comics is your calling. If that's how you feel, then that's probably because you've been chosen to make comics.

Don't be fooled by large lines of people who are waiting for portfolio review. When you consider the number of people who live in this world, the people who want to make comics is still a relatively small population. If you surround yourself with like-minded people who also want to make comic books, it will seem like there are a lot of people who want to make comics. In reality, if you counted every house on a suburban block, you'd find that an infinitesimal percentage of the people in those houses dream of making comics.

Our ancestors were compelled to tell stories in words and pictures. They didn't create comics in a traditional sense, but the basic idea of documenting a story using the shared visual language of the day remains the same.

You, my friends, are all descendants of that Neanderthal cave-painter who decided to document his stories and ideas on walls made of stone. You can pretend you don't care, but then you're just giving up on a talent, drive, vision and creative inspiration that's wired in your DNA. It's a relatively rare storytelling gene that few people in this world actually cultivate. Even when life seems too difficult to bear, you need to remember that there is something in you that needs to come out, to be shared. Your job is to study the craft and business of storytelling so that you can effectively tell your stories in comic book format. It may not be perfect, but you need to keep working at it until you've told your story with power and impact.

It's the reason you're reading this book rather than doing something else. You know that deep down, you want to learn all there is to know about making comics. If you've made it to this point in the book, then I hope you've made up your mind to focus your attention, energy and passion on taking in all you can about comics.

And then just do it. Actually go out and make comics. Make them badly (in private) until you make them well and publish them. Don't quit. Never surrender. Don't give up on your dream. If you give up, then you give up on a gift of creativity. Do it because life is too short, and what you create is your legacy to the world.

Stories matter. They can change people's attitudes, perspectives and opinions. You matter because of your storytelling gift. You are a storyteller, so tell stories. It doesn't matter if they are small, personal stories seen by just a handful of people or big, bombastic tales that are part of a twenty-issue crossover featuring spandexed superheroes. You are always a storyteller, no matter what part of the story you touch.

Study the art form. Be the art form. Make comics.

—Buddy Scalera, 2010

RESOURCES FOR CREATORS

RECOMMENDED READING

BOOKS

Buckler, Rich. *How to Draw Dynamic Comic Books*. Clinton, New Jersey: Vanguard Productions, 2007.

David, Peter. *Writing for Comics & Graphic Novels*. Cincinnati: IMPACT Books, 2009.

Editors of *Wizard*. *Wizard: How to Draw, Vol. 1*. New York: Wizard Entertainment, 2005.

Eisner, Will. *Comics and Sequential Art: Principles and Practices From the Legendary Cartoonist*. New York: W.W. Norton, 2008. *Graphic Storytelling and Visual Narrative*. New York: W.W. Norton, 2008.

Howe, John. *John Howe Fantasy Art Workshop*. Cincinnati: IMPACT Books, 2007.

Jones, Gerard and Will Jacobs. *The Comic Book Heroes: The First History of Modern Comic Books from the Silver Age to the Present*. Roseville, California: Prima Lifestyles, 1996.

King, Stephen. *On Writing: A Memoir of the Craft*. New York: Pocket Books, 2000.

Lee, Stan and John Buscema. *How to Draw Comics the Marvel Way*. New York: Simon and Schuster, 1978.

Madden, Matt. *99 Ways to Tell a Story: Exercises in Style*. New York: Chamberlain Bros., 2005.

McCloud, Scott. *Making Comics: Storytelling Secrets of Comics, Manga and Graphic Novels*. New York: HarperCollins, 2006. *Understanding Comics: The Invisible Art*. Northampton, Massachusetts: Tundra, 1993.

McKee, Robert. *Story: Substance, Structure, Style and the Principles of Screenwriting*. New York: Regan Books, 1997.

Miller, Brian and Kristy Miller. *Hi-Fi Color For Comics: Digital Techniques for Professional Results*. Cincinnati: IMPACT Books, 2008. *Master Digital Color: Styles, Tools and Techniques*. IMPACT Books, 2010.

Quinn, Pat. *Basic Perspective for Comics & Illustration*. Florence, Kentucky: Blue Line Pro, 2003.

MAGAZINES

Comic Book Artist (TwoMorrows Publishing, www.twomorrows.com)

Draw! (TwoMorrows Publishing)

Write Now! (TwoMorrows Publishing)

MULTIMEDIA/DVDS

Digital Art Tutorials by Brian Haberlin (www.digitalarttutorials.com)

How to Draw Comics the Marvel Way (DVD) by Stan Lee. Starz/Anchor Bay, 2002.

Stan Lee's Mutants, Monsters & Marvels (DVD) by Kevin Smith and Stan Lee. Sony Pictures/Creative Light, 2002.

On the Page script consultation and screenwriting classes podcast with Pilar Alessandra (www.onthepage.tv)

WEBSITES

deviantART
www.deviantart.com

Digital Webbing
www.digitalwebbing.com/talent

Ted—Ideas Worth Spreading
www.ted.com

GOOD CAUSES

Comic Book Legal Defense Fund
http://cbldf.org

The Hero Initiative
http://heroinitiative.org

Give now. Because everyone deserves a golden age. Visit http://heroinitiative.org.

SELF-PUBLISHING BUDGET GUIDE

So after all you read in the last chapter, you're still considering self-publishing? Well then, remove your artistic beret and put on your business hat. Publishing is a business, and you'll want to start by thinking more like an accountant—at least for a little while.

Following are the steps you should take to figure out what it will cost you to print your own comic, and to decide if it's what you really want to do. Don't be afraid to ask someone for help with the numbers. (Later, I'll lead you to a little worksheet I devised to make the calculations easier. Yes, I really am incredibly nice to you; let's not forget it.)

STEP 1: GET YOUR PRINT COSTS

Find out how much it will cost to print your comics. You may aim for a short run of 100-200 units, but that will increase your cost per unit. If you go for a medium-sized print run (1000+) or a larger print run (3000+), your cost per unit will be lower.

Your cost per unit can range anywhere from less than a dollar to more than three. It all depends on how many pages you have, the paper quality, whether you use color and so on. Every little choice you make will directly affect the cost per unit.

For now, just get costs for a couple of different print runs. If you are only selling at conventions, you won't need to print as many as you'd need to if you distribute through Diamond. (*Note:* There are many comic book printers. I suggest that you Google "comic book printing" and review all of your options. Ask for samples, talk to other indie publishers, and decide which printer will give you the service you desire.)

Be sure to ask about shipping costs. If you work with Diamond, you will have at least two shipping costs: one to ship your books to Diamond and the other to ship the extras to you. Ask about shipping because this is often a surprise number for most people.

STEP 2: ADD UP PRODUCTION COSTS

Even though you will be doing some of the work yourself, there's always some cost involved in producing a comic. I like to use Microsoft Excel to calculate my out-of-pocket expenses, but you can use other spreadsheet tools as well (such as Google Docs).

Add up the following out-of-pocket (OOP) expenses:

- Cover
- Plot/script
- Pencils
- Inks
- Letters
- Colors
- Printing
- Shipping
- Marketing
- Other incidental expenses

Got your total? Good, that gives you a baseline cost.

STEP 3: CALCULATE THE COST PER UNIT

This is a little tricky, but you can do it. I did it, and I'm no math whiz. So you can do it too.

The calculation goes:

Production Costs + Printing Costs ÷
Number of Units = Unit Cost

Now, if you gathered costs for multiple print runs, then you will need to run this math for each of those print runs, which will give you several different unit costs.

So let's just say for argument's sake, you are looking at anywhere from $1.50 per unit to $2.00 per unit. Your actual number may be different, but this will give us a starting point for the next step.

STEP 4: ESTIMATE YOUR PROFIT FROM DIAMOND

Diamond (as of this writing) gives you 40 percent of the cover price of your comic. They keep 60 percent, which they split with the comic book retailer.

To save you some time, I've broken down a few numbers for you.

Cover price:	You get:
$3.00	$1.20
$3.50	$1.40
$3.95	$1.58

STEP 5: COMPARE UNIT COST VS. PROFIT PER ISSUE

Now, take the unit cost you calculated in step 3. Compare that unit cost to the amount you get from Diamond in step 4. The first thing you will notice is that your cover price has to be pretty high just to break even, right?

So, pick a cover price. It's probably going to be something like $3.99 or higher, just to break even. But never fear, there's good news at the end of this little exercise, so hang in there.

STEP 6: FIGURE OUT HOW MANY UNITS YOU MUST SELL

It's hard to see the real picture until you calculate the actual number of units you need to sell to break even.

So, take the amount you get from Diamond from step 4. Then divide that number by your total costs from step 2. This will tell you how many units you need to sell just to break even with Diamond.

STEP 7: PLAY WITH THE COSTS

Every indie self-publisher I know has wondered how they are going to break even publishing comics. In many cases, you cannot. But if you're creative, you can find ways to make it work.

Now, go back and look at the cost per unit for higher print runs. See how much you save with a thinner page stock. Figure out if you can live with black and white. All of this will help you get your numbers down.

Plug in new numbers, and try again. Try raising the cover price a few cents to see how you can increase your profit from Diamond.

STEP 8: COME TO TERMS WITH PROFITS & LOSS (P&L)

This, my fine, furry friends, is a basic P&L analysis. This is the kind of thing that mainstream publishers do all the time. They are considering many more variables than we are here, but you get the idea. It also sheds light on why comics are so expensive, right?

Now that you have your little P&L sheet, estimate your losses, your break-even point, and your profits. If you are

"in the black" (i.e., making profit), good for you. Go forth and solicit your book, publish and be merry.

If you're like me, you're probably "in the red" (i.e., losing money). Then you have to decide why you are self-publishing. Is it because you want to get out there and prove yourself? Well, then you may want to consider this a marketing expense. Or just your hobby. Everyone has a hobby, and this may be yours, which means you don't necessarily have to be profitable.

If you are trying to establish yourself as an indie publisher, you may also be forgiven if you view this as a marketing expense. It's OK for new businesses to lose money. Many businesses have a five- to seven-year business plan in which they estimate when they will make profit. You probably don't have that much time, especially if you are

Cashing In on Your Collectibles

If you're trying to scrape together the cash to self-publish, try selling some of your collected stuff. I'm not kidding. Seriously, you may love that *Incredible Hulk #181* (first appearance of Wolverine), but do you still "need" it? How much money could you get if you sold an expensive comic? How much if you went to a local convention and sold a chunk of your comics for a dollar each? The truth is, you probably have some money locked up in those long white boxes. If you sold a bunch, could you then justify the expense of self-publishing?

While you consider your answer, go online and look up Kevin Smith (the movie director and comic book writer). Research his story, and you will discover that he sold his comic book collection to fund his first movie, *Clerks*. He went on to make several movies and even earned enough money to open his own New Jersey comic book store, Jay and Silent Bob's Secret Stash (www.jayandsilentbob.com).

155

spending your own dough. But if you allow yourself a year or two of losses, you may find that one day you *can* make money. It's all up to you, but it's important to be honest with yourself.

STEP 9: DON'T FORGET CONVENTIONS

Let's say you've decided to move forward. And like many small indies, you've realized that you are going to lose some money.

Don't fret too much. There's still the comic book convention scene.

At comic conventions, you can often get an Artist's Alley table. Smaller shows tend to be fairly inexpensive ($25 to $50 per table), and this can be a direct line to your customers.

So let's just say your cover price is $3.95. With Diamond, you'd be getting just $1.58 per unit. At a comic con, you can sell that comic for full cover price (if you choose). Even if you sell it at half the cover price, you still get $1.97.

How much were you set to lose on your first issue? $200? $300? Maybe more? OK, now, how many issues do you have to sell at full price to make up that shortfall?

Conventions can be a wonderful experience for self-publishers. Not only do you get to meet your audience, you also get the opportunity to make back some money.

Do you have original art from your comic? Maybe you can sell that. You may not get much per page, but it's a nice way to recoup some of your production costs from step 2.

STEP 10: DO IT AGAIN?

Now that you've been through the entire process once, you have to decide if you are ready to do it again.

Remember when you dreamed up that sixty-issue space opera? Maybe you should rethink that storyline to tell it in smaller chunks of three to five issues. It's possible—but not probable—that you will draw enough of an audience to effectively launch an ongoing series.

The rule of thumb is that your first issue in a series will be your highest seller. Your second issue usually only garners about 50 percent of the orders that the first issue got. So if you sold a thousand of Issue #1 of *The Ongoing Adventures of the Amazing Self-Publisher*, then you're statistically likely to sell about five hundred of the second issue. Sorry.

It doesn't get much better for the third issue, which often sells only 50 percent of the second issue. Yeah, now we're talking about 250 units. Meh. Hey, nobody said it was going to be easy.

It's possible that with good marketing and some buzz that you can beat the odds. It happens all the time. There are always breakthrough products that surprise the marketplace.

If you do decide to take the step and publish another comic, like many other self-publishers you may find that it gets a lot easier. You know the process, you learn where to cut costs, and you start to have more product to sell at conventions.

Run the numbers on your own potential comic by going to http://creatingcomics.impact-books.com for Buddy's downloadable self-publishing worksheet (in Microsoft Excel).

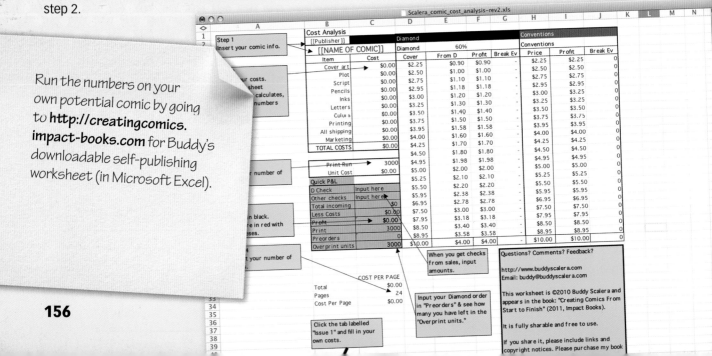

MORE CREATING COMICS ONLINE

We tried, but we just couldn't fit it all into one book. So, we've developed an exclusive online resource just for you. Visit http://creatingcomics.impact-books.com for bonus videos, pictures and more interviews. Best of all, it's all free!

Digital Comics Exclusive

Get the lowdown on digital publishing—where it's been and where it's going—from **John Cerilli**, vice president of content and programming for the Marvel Digital Media Group.

Videos

Watch two demonstration clips by colorist **Brian Haberlin**, which he narrates himself as he sketches and colors professional comic book art.

Photos

Find more photographs including candid shots of comic creators at work and play.

Comics

See step by step how creator **Chris Eliopoulos** writes, draws, inks and letters a complete comic strip.

Publishing Advice

Download a spreadsheet that will help you break down the costs plus the potential profits and losses of self-publishing your first comic book.

Sneak Previews

Check out images from Buddy's upcoming photo reference book, *Comic & Fantasy Artist's Photo Reference: Giant Collection*, out in August 2011.

Visit **http://artistsmarketonline.com** to find the right market to sell your work. It's a comprehensive reference guide for emerging artists, designers and photographers who want to establish a successful career.

INDEX

IDEAS.
INSTRUCTION.
INSPIRATION.

Supercharge your drawings with the power of photo reference! Learn to capture accurate lighting, foreshortening and body language in your drawings with Buddy Scalera's ultimate photo reference series.

ISBN-13: 978-1-60061-003-5
Z0999 • paperback
• 144 pages

ISBN-13: 978-1-60061-004-2
Z1000 • paperback
• 144 pages

ISBN-13: 978-1-58180-758-5
33425 • paperback • 144 pages

ISBN-13: 978-1-60061-687-7
Z4812 • paperback • 192 pages

ISBN-13: 978-1-60061-022-6
Z1306 • paperback • 176 pages

ISBN 13: 978-1-60061-855-0
Z5423 • DVD running time:
79 minutes

ISBN 13: 978-1-60061-859-8
Z5427 • DVD running time: 52 minutes

These and other fine IMPACT products are available at your local art & craft retailer, bookstore or online supplier. Visit our website at www.impact-books.com.

IMPACT-BOOKS.COM

- Register for our free e-newsletter
- Find awesome comic, fantasy and sci-fi art plus videos and deals on your favorite artists
- Fun and newsy blog updated daily by the IMPACT editorial staff